BBC BOOKS

STEVE EVANSON

COAST
AND BEYOND

KT-376-656

**Revealing the secrets of our coastline …
and our neighbours' too!**

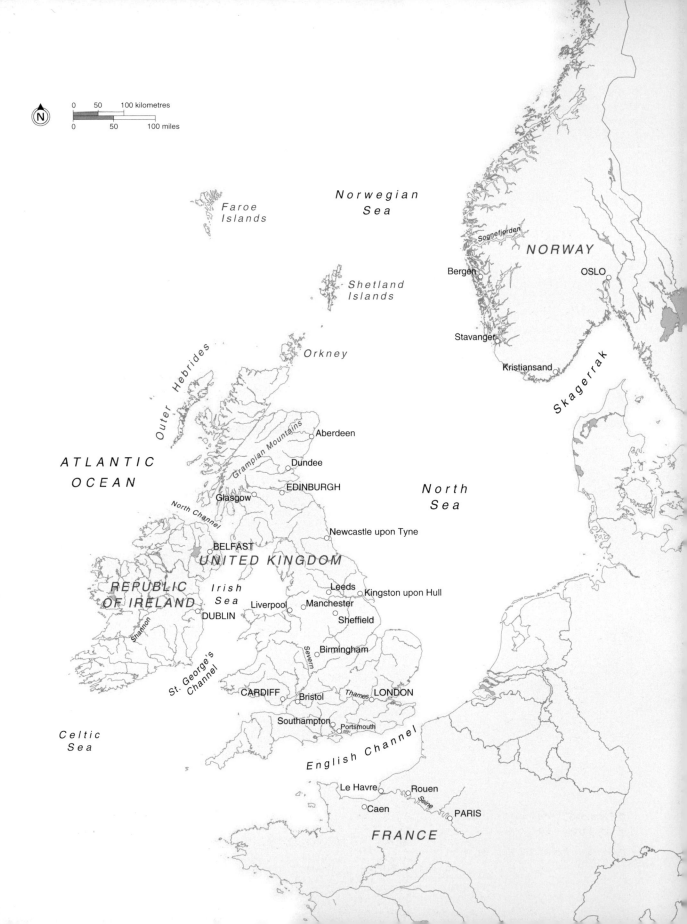

Contents

◄◄ Page 1: Sunrise over Howick, Northumberland, where our Stone-Age ancestors first built homes.

◄◄ Pages 2–3: Aberdaron Bay is situated at the tip of the Lleyn Peninsula in North Wales, a stretch of outstanding natural beauty.

Introduction

That great adventurer of the age of Empire Rudyard Kipling asked, *'What knows he of England who only England knows?'* It's a question that could equally apply to any of the countries that share the British Isles because our stories don't stop at the sea that surrounds us; it's where they start.

Back in the beginning, some 10,000 years ago, as the ice retreated, people began to arrive by boat, and on foot, because then we were linked to Europe by land as well as water. The first settlers clung to the coast for comfort; the dark heart of Britain's heavily wooded interior made a marginal existence much more attractive. Gradually the oceans swelled up in the big thaw until eventually sea encircled the early Britons and we embarked on our adventure as islanders. Many centuries later Roman conquerors came, followed by Norsemen raiders, and in the turmoil of battle nations took shape. Those infant states squabbled across our shores until ultimately an alliance was forged that gave birth to the British. Later, Britain fought France in the New World and relatively recently – when it seemed the whole world was at war – the beaches of Normandy united us all in liberty and fraternity.

This chronicle of ages is written into the fabric of Britain and the blood of its people, carved into our coast and beyond. So as we search for the echoes of that epic saga we can't confine ourselves to one coast, we, like our ancestors, must cross the sea to meet the neighbours who share our story. The ever-expanding exploration of our shores and those that surround us is a journey I've been on since 4 July 2004 when I became a founder member of the team who make *Coast*. We come from every corner of the United Kingdom, each of the nations contributing their unique cultural perspective to uncover the connections among the people of our isles. Together with experts from the Open University, our presenters, contributors and viewers, we've produced an extraordinary encyclopedia of the British experience and beyond.

Now I want to share that knowledge with you. Along the way I'll flag up a few firm '*Coast* Favourites', stories that strike a special chord in the hearts of *Coast* lovers everywhere. There are tales close to home that reach far afield, like the silent-movie set born in bohemian Brighton that thrived long before Hollywood ever made a movie. Monastic marvels that mirror each other on either side of the Channel aren't the only divine sights to saviour; there's also a seal sanctuary on our eastern extreme, and a dolphin haven way in the west. We venture into the lair of the Vikings on the shores of Norway and the Faroes for stories of incredible beauty, bravery, endurance and sometimes sheer exuberance, including a rollercoaster ride on the Norwegian road across the Atlantic.

Following in the footsteps of Norman conquerors we discover how the legacy of their invasion littered our landscape with the castles we love. War has always stalked our shore but it's also a strangely liberating space where people feel free to express themselves in endless inventive ways. We'll encounter canny cod catchers, super-smart shipbuilders, the earliest of farmers and aviators, and the staunchest of swimmers. Play for high stakes with the gamblers who risked their reputations betting on a chic French resort, meet a media mogul who bank-rolled an extraordinary building on the Welsh coast for his American mistress, and there's the talented Mr Kipling himself having an electrifying encounter with an underwater railway. As we track along our coast we also explore some achingly beautiful estuaries, reveal ugly scenes of famine and exploitation, set sail on majestic transatlantic liners, and puff through Scotland's Western Isles on those toughest of little tough nuts the 'Clyde Puffers'.

Looking across the water, having reached the edge, we're at the start of an adventure we can all share. *Coast* often visits places that are open for everyone to enjoy, so at the end we invite you to explore more with an essential guide to the sites where you can witness first-hand the story written on our shore.

◀ Looking outwards, the possibilites are endless. Amlwch on the north-eastern corner of Anglesey, once a major port for the global copper trade.

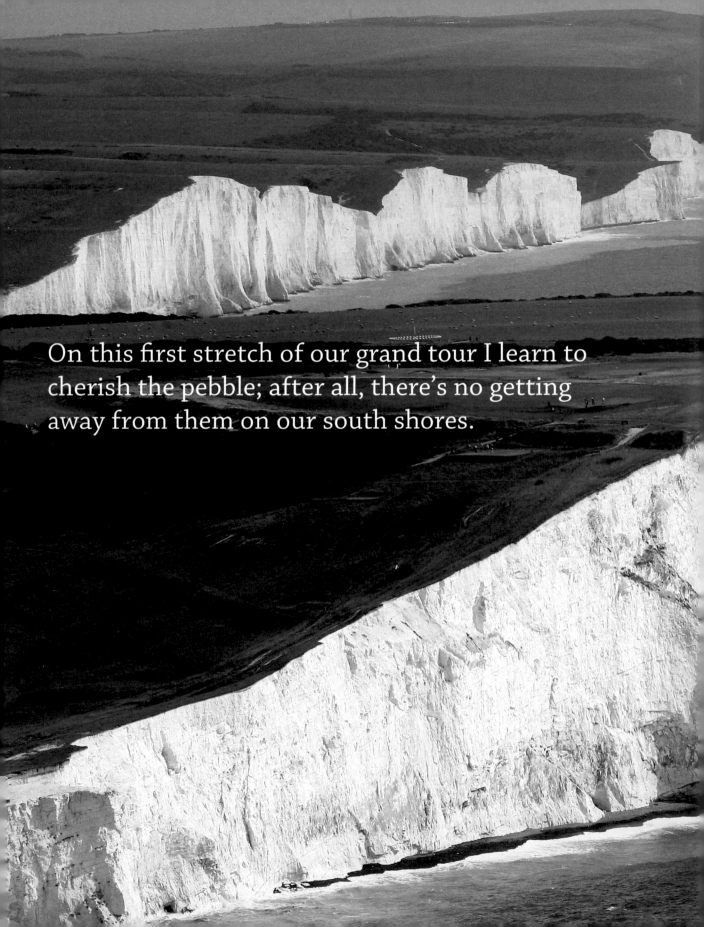

On this first stretch of our grand tour I learn to cherish the pebble; after all, there's no getting away from them on our south shores.

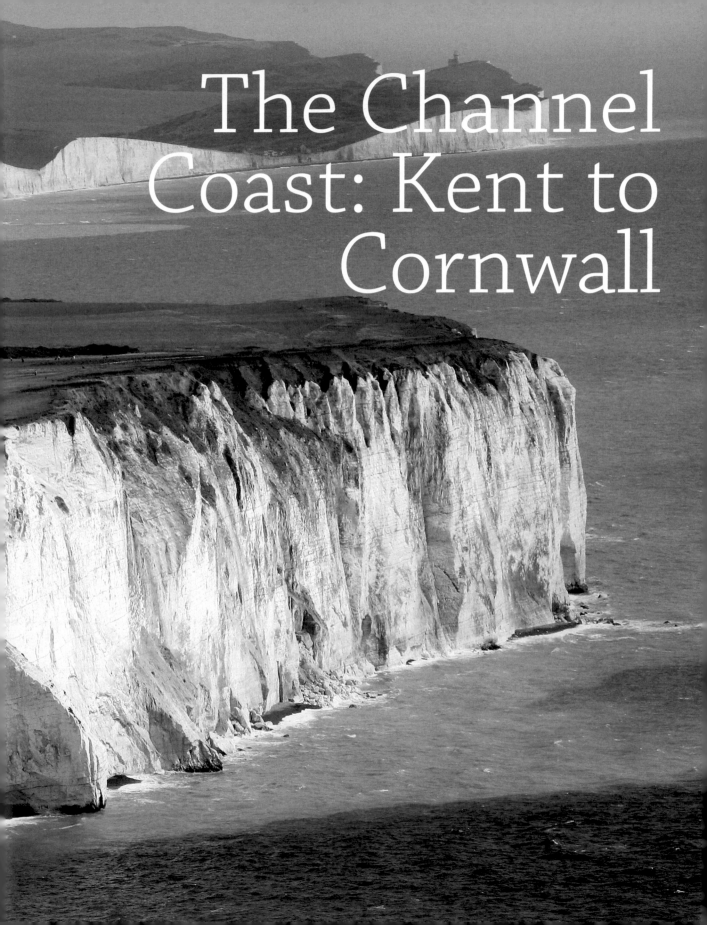

The Channel Coast: Kent to Cornwall

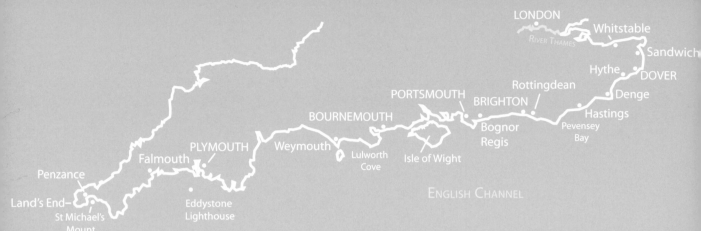

LONDON
River Thames
Whitstable
Sandwich
Hythe
DOVER
Rottingdean
Denge
PORTSMOUTH
BRIGHTON
Hastings
BOURNEMOUTH
Bognor
Regis
Pevensey
Bay
PLYMOUTH
Weymouth
Lulworth
Cove
Isle of Wight
Falmouth
ENGLISH CHANNEL
Penzance
Land's End
Eddystone
Lighthouse
St Michael's
Mount

Sandwiched between sea and sky, much of this coast is a thin filling of shingle, shifted by tides into vast crunchy headlands and beaches. It might be tender underfoot but, as we'll see, the locals have some ingenious solutions for making themselves feel at home.

On our journey to the lighthouse that tamed the Eddystone reef we'll explore a lost world on an isle where dinosaurs roamed. We're making silent movies in Brighton and trying to detect the sound of approaching bombers above the croaking frogs on Romney Marsh. We hover above the sea, glory in the glamour days of steam and discover an electric railway that ran underwater. And we encounter some strange structures: off-shore steel behemoths that inspired the design of our oil rigs, and onshore tiny shrines constructed from oyster shells.

◄◄ The Seven Sisters, a spectacular series of white chalk cliffs that run between the towns of Seaford and Eastbourne in the South Downs.

The pearl of Kent

Welcome to Whitstable, where the fashionable fast food of choice is the oyster. This busy harbour town on the north Kent coast is well endowed with wild native and cultivated species. There are hotspots at various points around Britain's coast but the oyster beds of Whitstable are probably the most famous anywhere on the south coast. The conditions particularly favoured by the native oyster are a good clean supply of seawater, and the right balance of minerals often found at the mouths of rivers. Oysters are cheap protein as well as a tasty treat, a morsel of consolation for the Romans stationed to the far-flung foreign outpost of chilly Britannia. A thousand years later, by the time the Normans had washed up on these pebbled shores, the local fishermen were giving thanks for their catch with a festival. You can still go along to the blessing of the sea today.

Whitstable enjoyed an early commercial advantage, with hungry pilgrims flocking to Canterbury just a few miles away and London a short trip by river – both ready markets for its prized oysters. The Company of Free Fishers and Dredgers was formed in Whitstable some 400 years back, to protect the oyster beds from disturbance as these meaty molluscs are very sensitive to environmental changes and susceptible to diseases, so the crop from year to year can vary greatly and sometimes disappear entirely. Disease

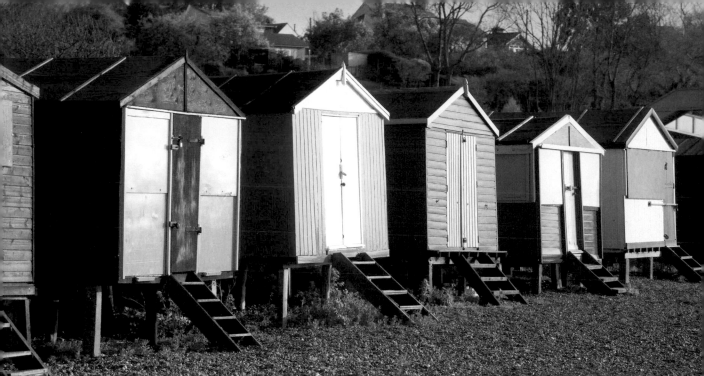

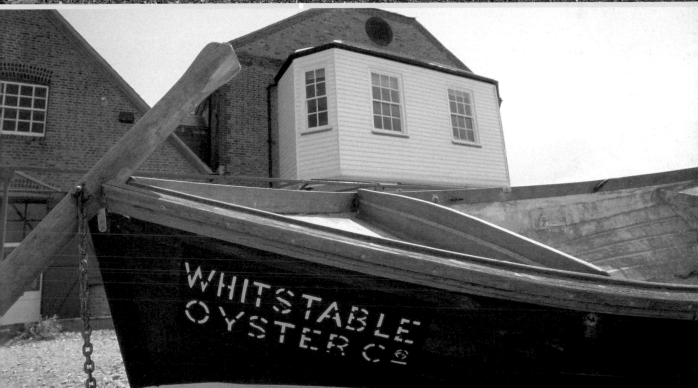

⋏ Colourful and compact, a hut is no longer the fisherman's shed but a room with a view for commuters wanting to feel a different kind of crunch.

⋏ You cannot go far in Whitstable without sight of the oyster. It is served in restaurants, takes centre stage in a festival and blessed by the fishermen.

and poor weather in the mid-nineteenth century so badly affected the oyster beds that what was once the food of the poor became a delicacy enjoyed only by the wealthy, and it still has the aura of being the preserve of the privileged.

Pollution and overfishing almost finished off the oyster population in the twentieth century but they are returned in rude health, and that's cause for celebration. The seas are clean here, and warmer winters have meant that the *Crassostrea gigas*, a cultivated oyster, has started to self-seed on the oyster beds.

Whitstable's oysters may be multiplying but its beach huts aren't. These limited-edition boxes by the sea are still little pearls of the town's property market. Originally the huts were used as shelters and stores by the local fishermen; now they are more likely to be bolt holes for city folk. It seemed the world wanted a jaunty wooden box for a spot of sea-gazing after artist Tracey Emin sold her Whitstable beach hut to Charles Saatchi; gone was the granny image: suddenly the hut was hip. Just as distinctive and characterful are the alleyways that snake through the town down to the sea; some with extraordinary names: try Squeeze Gut Alley! As the town grew, a multitude of these alleys provided access to the sea – and presumably easy escape routes – for Whitstable, like most Kentish coastal towns, has seen its share of smuggling.

The sea and seafood seem to unite this quaint little town. The celebration of the oyster is a week-long highlight in the Whitstable year, complete with fish-slapping dance. The organizers have also come up with other novel entertainment ideas, including a seashore safari and a mud tug of war with teams getting down and dirty in the low-tide mud. A unique feature of the festivities is the Grotter, a curious beach construction that looks something like the nose of a large artillery shell. In fact a Grotter is a two- or three-foot-high dome made from shells – oyster shells – crudely or sometimes expertly fashioned by the local kids. 'Remember the Grotter!' was the cry in Victorian times of youngsters standing proudly by their oyster towers. It was a juvenile money-making enterprise along the lines of 'penny for the Guy' on Bonfire Night. Grotting sounds innocent enough but apparently it got out of hand, requests for cash began to sound more like demands, and in the late 1960s the nuisance Grotters were purged from the streets.

Grotters are now safely confined to Reeves Beach, where classes in construction are run during the oyster festival. In the evening the Grotters are aglow with candles although the junior craftsmen are probably blissfully ignorant of the divine inspiration for their little shell shrines. The festival takes place as near as possible to St James's Day on 25th July. According to the gospels, James was a fishermen, one of the first disciples of Jesus, and he is the patron saint of oystermen. Tradition has it that his remains are buried in one of the holiest sites in Christendom, the Cathedral of Santiago de Compostela, in Galicia, northwestern Spain. The scallop shell found on those shores has long been the symbol of St James; here on the shores of Whitstable oyster shells stand in for scallops in the shrines to the saint. Connections carried coast to coast by the early pilgrims.

Sandwich and herrings

Whatever schemes we are busy hatching the coast has a mind of its own. Hundreds of years ago Sandwich was a major port but now it lies a couple of miles back from the sea. Gradually the harbour silted up as nature redrew the coastline. Before they became land-locked the sailors of Sandwich spent a good part of their time in a traditional Southeast pastime, fighting the French. They weren't the only ones: Sandwich was one of the

CAPTAIN MATTHEW WEBB

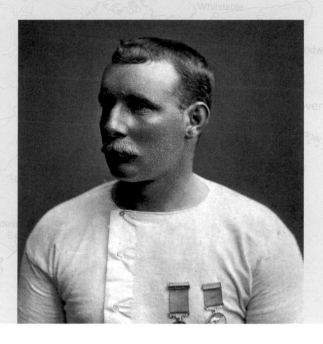

I find it puzzling that with so many ways to cross the Channel some people prefer to swim. The first of many was Captain Matthew Webb, a Shropshire lad, who, aged 12, enlisted for a maritime career, and eventually was inspired to become a professional endurance swimmer in 1874. On 24 August 1875 Webb, coated in porpoise oil, dived into the water near Dover's Admiralty Pier for the first recorded swim of the Channel. Nearly 22 hours and several jellyfish stings later he waded on to the shore at Calais. Such was the measure of Webb's achievement that, despite numerous attempts, the feat wasn't repeated for 36 years. Ultimately it didn't do Captain Webb much good: he basked briefly in the fame but by 1888 he felt compelled to try to recapture the headlines. In the shadow of the Niagara Falls suspension bridge he began to swim towards the Whirlpool Rapids, watched by thousands of onlookers. He never made it.

original 'Cinque Ports' (*cinque* meaning five) dotted along the Kent and Sussex coast: Dover, Hythe, New Romney and Hastings were the other members of this Confederation. Their role was to provide men and ships to control the important sea routes across the Channel, defend the realm against raids by the French and also to convey the king, his entourage and his armies to and from the Continent. In return the five towns were granted certain privileges including the right to organize a large annual Herring Fair. No one quite seems to know when this royal arrangement with the Cinque Ports was first ordained but the so-called 'ship service' was well established after the Norman Conquest in 1066.

By the sixteenth century we'd got our act together sufficiently to start a proper navy. England's rulers began to look elsewhere – especially to Portsmouth, a large natural harbour for bigger warships – and nature took its toll on the Cinque Ports too. Like Sandwich, Hastings, New Romney and Hythe all lost their harbours due to storms or slow silting up. Only one of the original gang of five ports – and the only one with a harbour – is still battling with the French ... Dover.

On the strait and narrow

The battle that Dover is currently fighting is to cope with the amount of traffic passing through its docks to and from France. The port is the narrowest Channel-crossing point linking Britain with the Continent, making Dover strategically vital – a fact not lost on the Romans when they came to conquer, or the French, during the Napoleonic Wars especially, or the Germans, during the Second World War. Now around 18 million people a year take the ferry and more than 200 million people have crossed using the Tunnel since it opened in 1994. For an island people unsure about our union with Europe we do love to pop across and visit the neighbours. Strange, then, that the Hovercraft – to my mind the most glamorous way to cross from Dover to Calais – shut up shop in 2000. As a child growing up in the late 60s and early 70s I thought by now we'd all have our own 'Hovercars'; how come the future turned out so dull? What went wrong with the hovercraft?

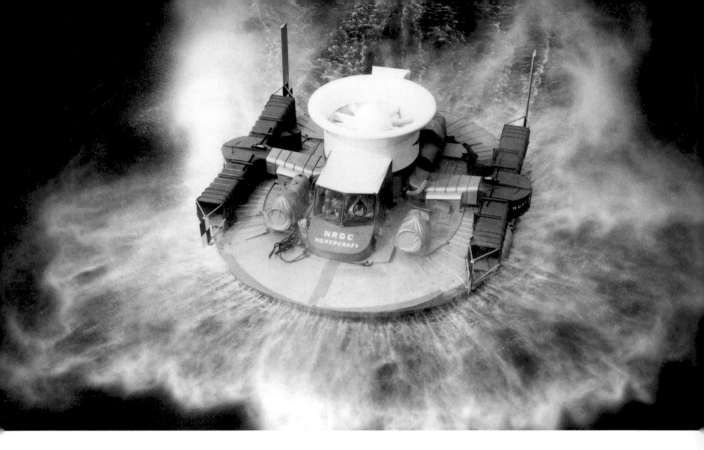

An e-mail from a viewer got us thinking about the fate of the Dover hovercraft service. Come and film the terminal, the viewer said, the concrete is rotting and it is going to be pulled down. Dover's Port Authority didn't want us to feature the old hover terminal; *Coast* didn't fit in with their redevelopment plans. But not everyone fell out of love with the hovercraft: former crew members and enthusiasts helped us piece together the story.

Riding the waves

Rewind to 1953 and engineer Christopher Sydney Cockerell is playing with a hairdryer, a tin can and a set of scales. He's about to discover how to make heavy things hover. Cockerell's eureka moment was to realize you could increase the lift by using two cans, one inside the other, and blowing air down between them. That double skin forms a curtain of air, which holds high pressure inside the can. The idea took years to develop, and Cockerell had to sell personal possessions to fund his invention. The first full-size hovercraft made its maiden flight across the Channel on 25 July 1959, with Cockerell on board, acting

▲ Brainwave: the hovercraft was one of the most successful inventions of the last century, developed by its inventor from tin can to commercial flight.

as movable ballast. The rubber skirt that produces the curtain of air is also flexible enough to cope with waves; well, up to a point: the biggest craft could still only operate in waves up to around 10 feet high, which are not unknown in the Channel. That didn't stop Cockerell drawing up plans for a massive hovercraft capable of crossing the Atlantic driven by nuclear power. Fuel was a problem: the hovercraft ate it up, but still the service could compete. At its best it was quicker than the Tunnel, with a record crossing of just 22 minutes to Boulogne in 1995. But the final nail in the rubber skirt was the end of duty-free sales within the European Union in 1999. Remove the profits on takeaway booze and cigs, and the economics didn't add up. The final flight from Dover to Calais was on 1 October 2000, although the Dover–Boulogne service continued for another five years. Yes, it was noisy, bumpy, and you couldn't walk out on deck, but for some of us the end of the service meant the twenty-first century wasn't the future we dreamed of.

The 'sound mirrors'

At Denge Beach on the headland of Dungeness stands a collection of huge concrete reflectors that were abandoned by their creator. The very sight of them stirs the soul. One of these 'sound mirrors' is as high as a house, a bold arc, 200 feet long. When I met Richard Scarth, who had worked tirelessly to uncover its history, I had a feeling if we could find other tales as good as this *Coast* would be a successful series.

Air raids on our cities killed around 1,500 people in the First World War. Military command was in no doubt bombers in a future war could kill millions, so how to stop them? Early warning was crucial but radar hadn't been invented in the early 1930s, leaving two options for locating the enemy: see them, or hear them. Major

William Tucker's concrete mirrors attempted to collect the sound of an approaching plane and reflect it via a movable listening trumpet to the ear of an operator. Tucker's apparatus actually worked, but only just. With unimaginable tenacity he and his team refined and tested for 20 years. At best they could identify and track planes about 20 miles away. Operators strained to hear, fighting the mind games of spurious sounds, as minutes became hours. Their years of devotion were gone in a heartbeat; radar eclipsed the mirrors within a few short months of their development. By 1937 the noise of planes was still being reflected by the mirrors but there was nobody left to listen. Tucker was told to blow up his redundant sound mirrors; he never carried out the order, and no one seemed to care.

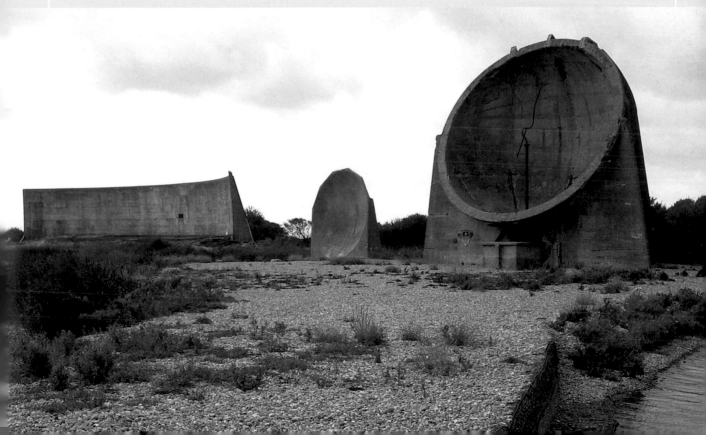

MAUNSELL ARMY FORTS

We've all done a bit of building beside the sea. Fortunately planning permission doesn't apply to the average sandcastle. Countless properties developed each summer are swept away with every tide. But just a few miles offshore at Whitstable some temporary structures have stood the test of time and tide.

The Maunsell Army Forts were the brainchild of Guy Maunsell, conceived in 1941 at the height of the Nazi bombing blitz on Britain. Great rivers like the Thames and the Mersey were used by bomber pilots to navigate their way to the heart of a city. Maunsell realized the need to build a first line of defence offshore. His forts were gun platforms designed to sit on soft sand in shallow water at the mouth of a river estuary. Each

one consists of seven individual steel towers. Once they were linked by aerial walkways, so that men could move between them from the central-command tower out to the anti-aircraft guns. Although they were not positioned until 1943, 22 aircraft and around 30 'flying bombs' were shot down from Maunsell's forts.

Building the forts miles out to sea in the flightpath of the Luftwaffe posed some obvious problems. Maunsell's big idea was to prefabricate his towers in the relative safety of a dockyard. He designed them to be towed out and sunk so that their legs settled on to the seabed, naturally adjusting over time to the shifting sands of the estuary. Dropped on the seabed in seconds they have lasted for over 65 years.

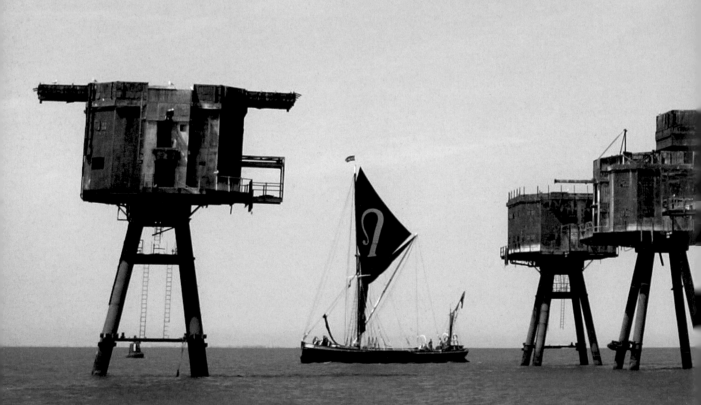

Maunsell was adapting an idea he had pioneered for a series of Navy Forts to be stationed further out to sea to deter the Germans from laying magnetic mines. The plans were submitted in November 1940, but the Admiralty didn't accept Maunsell's assertion that flooding the base of the fort to stabilize it on the seabed would work. When the moment of truth finally came in February 1942 it seemed the doubters were right: a mistake by the officer deploying the first fort caused it to flood unevenly. The structure tilted alarmingly but such was the robust nature of Maunsell's design it righted itself, and his concept was vindicated.

The delays in deployment meant the Army Forts had a relatively quiet war but in the 1960s these sturdy structures became the launch pad for an invasion that would revolutionize our airwaves. Abandoned by the military, pirate radio stations moved in: Screaming Lord Sutch first broadcast from one of the forts in 1964. Government legislation finally put an end to the pirates in 1967 when Radio 1 was born. The new BBC pop station had been on air for a couple of years when oil was discovered in the North Sea. Engineers, faced with the monumental task of siting drilling platforms in those hostile waters, turned for inspiration to the pioneering work of Guy Maunsell. Maunsell died in 1961; he never saw the North Sea littered with structures that bear a remarkable resemblance to his Army Forts, nor heard the pirate broadcasts from his wave-swept tower in the Thames Estuary.

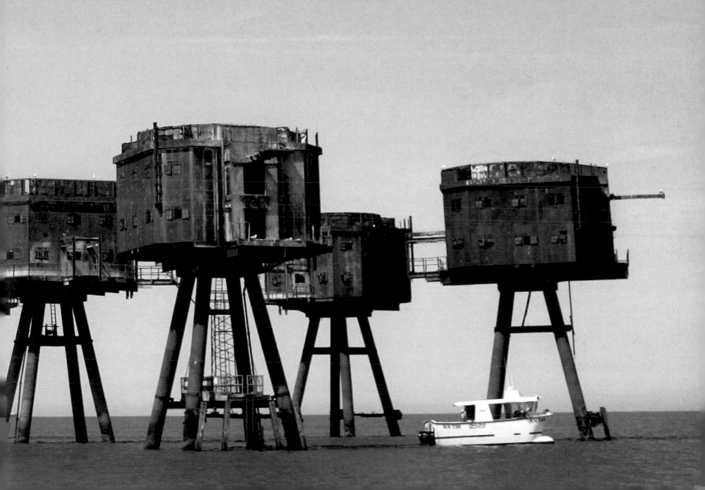

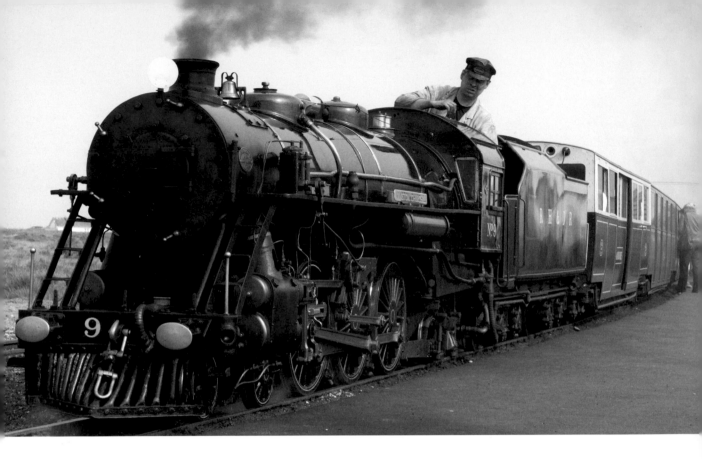

Romney, Hythe and Dymchurch Railway

▲ The world's smallest public railway still makes the news: the launch of a new shuttle service in 2009 coincided with the opening of Romney Warren Halt, the first new station in 80 years.

The scientists building the sound mirrors were horrified to discover a new railway was about to shatter their silence. As it turned out, the boffins learnt to live with the noise of the Romney, Hythe and Dymchurch Railway; in fact, it came in very handy for the daily commute to their previously isolated site. The train line linked Hythe to Dungeness, 13 miles away across the marsh, and was opened in 1927, the same year in which Major Tucker began planning his 200-foot concrete mirror on the shingle. In keeping with that curious construction this is a railway with a difference: real steam and diesel locomotives pull luxury carriages between real stations but at 25mph on a line just 15 inches wide: the whole thing is one-third full size. It's a mainline in miniature and it came about through big money.

The railway was the dream of two extremely wealthy racing drivers, Captain J.E.P. Howey and Count Louis Zborowski, whose other claim to motorized fame was owning and racing the Mercedes from the film *Chitty Chitty Bang Bang*. They were inspired to build a fully working express railway that ran on 15-inch gauge, and they had the money to fund it. Sadly the Count was killed while racing in the Italian Grand Prix but Howey went on to fulfil their dream, commissioning Henry Greenley – the leading model engineer of the day – to design the locomotives. The line had to be requisitioned as part of the war effort and was extensively used during the building of PLUTO, the Pipe Line Under the Ocean, that fuelled the Allied invasion. In peacetime the line reopened and publicity from its war effort paid dividends and people flocked to take a ride. Its fortunes faltered in the 1950s and 60s through lack of investment but returned in the 70s thanks to the input of another wealthy man, Sir William McAlpine. The line is one of the mini man-made wonders of the world and its destination is one of nature's more wonderful works, Dungeness.

Dungeness: pebble heaven

Perhaps one of the few places a tiny railway and huge concrete ears could seem perfectly at home together is in the odd landscape of Dungeness. It's a vast layer of pebbles, which look as if they've been squashed by the huge sky. The pebbles are mostly flint, washed out of the soft chalk cliffs near by, and nature has swept them tidily to form a flat headland jutting into the sea.

Standing on the great stretch of shingle you feel like a little bug on a massive patio, but there are plenty of other creatures to keep you company. There are many rare species of bee, moth, butterfly and beetle, and myriads of migratory and coastal birds fetch up here. It's a lonely place with a sense of other-worldliness to it. Some have sought refuge from the pressures of the modern pace; there is no permanent settlement as such but a scattering of wooden houses and a few

converted old railway coaches, mostly owned and used by fishermen. The most famous of these is the property of the late Derek Jarman, the artist and film director who moved here at the end of his life and created a pebble and driftwood garden, perfectly encapsulating the bleak, beautiful surroundings.

Behind Dungeness, Romney Marsh is home to its own hardy breed of sheep, known as Kents. Their thick fleeces protect them from the heavy rainfall and winds that whip across the flat landscape just beyond the bank of shingle. There are imported critters too who also love this damp marsh, and – like those planes

▼ Locals describe Romney Marsh as 'a gift from the sea'. This fertile reclaimed land is now defended from the sea by the shingle bank that is Dungeness.

Hastings: small is beautiful

Tucker was trying to identify – you need your ears not eyes to locate them. Hungarian Laughing Frogs have, as their name suggests, a loud and distinctive voice. Apparently these foreign frogs had a bit of help hopping over the Channel. The story is that they escaped from someone's garden in the mid-1930s, around the time when Tucker and his men were using their sound mirrors to listen for bombers. It struck me as ironic that those mirrors were trying to detect tiny sounds yet they were lodged on the noisiest of footings: every step you take on the shingle is so deafening as you walk around Dungeness; it's hard to hear yourself think, let alone the faint sound of an approaching plane. Perhaps it's just as well the listeners packed up before the noisy frogs became established. But the fishermen remain, high and dry on land, adapted to life on the sea and the shingle, a hint of what's to come further round the shore.

Hastings, the French and 1066, some rather obvious cross-Channel connections suggest themselves. But it's not quite that simple; the Normans weren't really French (more of that in Chapter 3) and maybe the invasion wasn't actually at Hastings. Many believe the Normans landed at Pevensey Bay, a few miles west, though there certainly was a battle, and an older struggle still rumbles on in Hastings: man versus fish. For over a thousand years the two sides have been at it, so I guess you'd have to call it a score draw. The coastal conditions around Hastings ensure a level playing field, meaning there's always fish to fight another day.

▼ Hastings's colourful fishing fleet is committed to sustainable fishing and its traditional methods are raising the profile of locally sourced food.

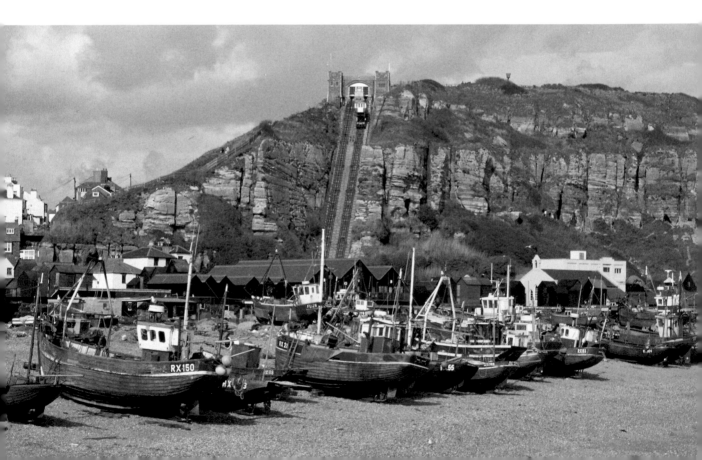

THE COLOURFUL LANGUAGE OF CUTTLEFISH

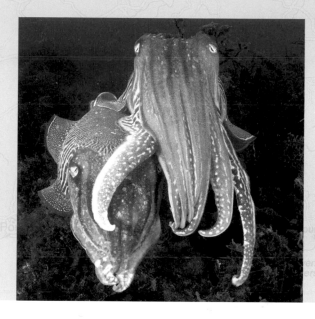

Of all the things I was expecting to find off our coast when we started the show, cuttlefish weren't on the list. I didn't even know what they looked like. I now know that cuttlefish aren't fish at all but molluscs, part of the same family as squid and octopus. There's a surprising number of them off the south coast of England. As the sea warms in spring, cuttlefish come to the shallow waters of the Channel to mate and lay their eggs. They have an amazing ability to change their body colour and patterning to mesmerize their prey, camouflage themselves or communicate with one another. But they're not simply beguiling: a beak as sharp as a parrot's and a venomous bite can finish off even tough customers like crabs.

The first problem the fishermen face is the lack of a harbour – it's had several since the 1500s, all short lived – which is why unsheltered Hastings is home to the largest beach-launched fishing fleet in Europe. It's a great sight for visitors: vessels marooned on the shingle beach called the Stade, a word used in these parts before 1066, meaning landing place. Since medieval times fishermen have enjoyed the right to free use of the beach to launch their boats. And they're cute, colourful boats, the kind a child draws. The need to winch those boats high and dry limits the size of craft: none is more than 30 feet long. As a result, they carry limited gear and fish only a few miles offshore. So no factory ships here, this is an ecologically sound industry: round one to the fish. Other drawbacks are more familiar, like the quota restrictions that bestow the bulk of the cod catch on the French. It's an all-too-familiar tale of woe but no matter, the fisherfolk of Hastings soldier on, a marginal existence in every sense.

On the plus side they've learnt to vary their tactics for different catches: pots for cuttlefish, trammel nets for Dover sole; so round two to the fishermen. And the sweet irony is that their low-intensity traditional fishing methods and small boats have recently paid dividends. In 2005 the Hastings fisheries for Dover sole, mackerel and herring were certified by the Marine Stewardship Council. The award recognizes sustainable, eco-friendly fishing methods. So hopefully the battle to land fish will continue for at least another thousand years.

Cuckmere Haven, Seven Sisters and a couple of movies

As you work your way westward from Hastings, shingle beaches surrender again to chalk cliffs. When you reach Cuckmere Haven their grip on the coast is broken as the river meanders spectacularly down to the sea across a large, open plain grazed by sheep. Looking back you are treated to a magnificent view of the Seven Sisters. Somehow this is how you expect the white cliffs of Dover to look, but Dover is so developed the pure sense of nature is diminished. The Seven Sisters don't disappoint though; they're a

favourite movie backdrop: the opening scene of Kevin Costner's *Robin Hood: Prince of Thieves* showed the beach at Cuckmere Haven, which is apt because the shore has seen plenty of smuggling; while the nearby coastguard cottages featured in the film *Atonement*. The thought of life there with Keira Knightley helps the hero to face the horrors of war. This is a fantasy location with a great view that may one day be swept away by the realities of coastal management. There are plans to end the protection of the area from flooding. At present an artificial pebble bank prevents seawater from entering the flood plain, but the increasing costs of its repair and the rise in sea level put its future in question. If the area is returned to its natural state the cottages may not survive.

Rottingdean and the talented Mr Kipling

The next big puncture in the inflated chalk landscape of the South Downs is a deep-sided dry valley where the pretty village of Rottingdean falls down into the fold. It's the stuff of picture postcards – and the Domesday Book. Having perhaps surprised themselves with the last-minute victory at Hastings, the Normans suddenly found themselves with a country to run. They decided to send the bean counters out into the land, to take stock and list everything of value. Rottingdean, a small farming community, made the grade. There followed a land grab on a massive scale and the kingdom was carved up by the conquerors. The Domesday Book notes that by 1086 the town was the property of William de Warrenne, a Norman baron, who was made Lord of Lewes. His support for the invasion came at a price: out of the deal the Anglo-Saxon denizens of Rottingdean got a new church, built of flint and Caen stone from across the Channel, and a new language to learn. For 800 years they got on with it, and then something exciting happened.

Son of the British Empire, world traveller and famous poet and author Rudyard Kipling came to live in Rottingdean in 1897. *The Jungle Book* had been published three years earlier and the good folk of Rottingdean went celebrity crazy. The owners of the local pub spied a business opportunity by offering customers the chance to catch a glimpse of the author, or of his house at least. A double-decker bus was laid on so people could gawp over the wall of Kipling's garden. Maybe that's why the great man started to holiday in South Africa. When Kipling was in town he sought solace and respite from the maddening crowds by fishing off the end of the pier. To keep the fans at bay he would ask the coastguard to intercept autograph hunters. Stationed at the entrance to the pier Kipling furnished his chum with copies of his signature for sale, the profits apparently for charity.

Daddy Long Legs

Mr Kipling sought sanctuary on no ordinary pier. Pretty, unremarkable Rottingdean was home to possibly the most remarkable railway these islands have ever seen, and it ran right to the end of Kipling's pier. It was known as the 'Daddy Long Legs' because the carriage was held high in the air perched on stilts. Because the track below was underwater at high tide, passengers needed to be lifted up. They would board and alight the train at elevated piers which provided walkways over the water. And this bizarre railway ran on electricity, the creation of local engineer and general bright spark Magnus Volk. In 1880 Volk installed Brighton's first telephone – two actually – so he could call his mate over the road, and also wired his house with electricity. He was an early adopter of this marvel of the age, and his electric railway was one

➤ We do like to be beside the seaside ... In 1894 Magnus Volk's electric railway linked genteel Rottingdean with the delights of Brighton's beaches.

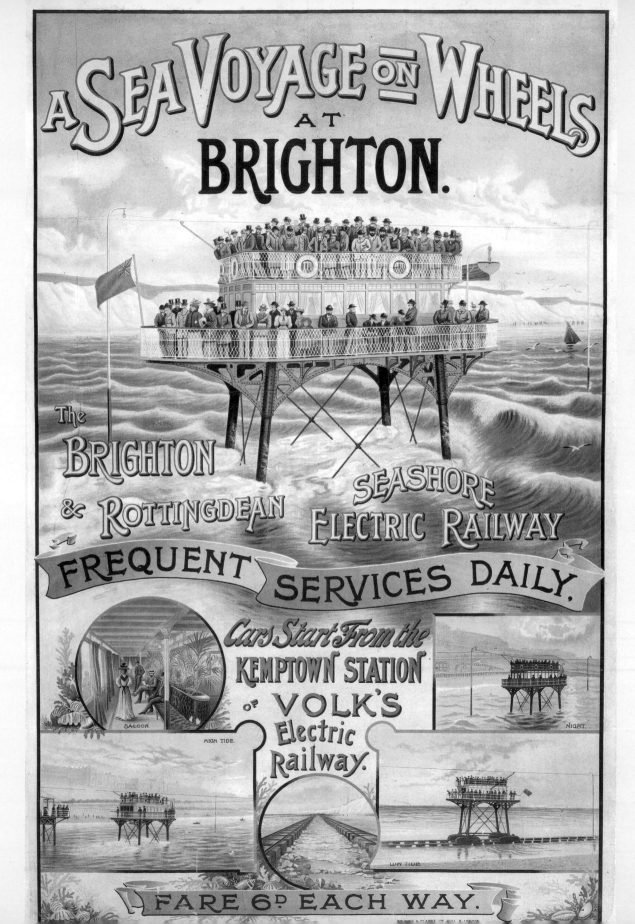

of the world's first. The Daddy Long Legs was a 'high rise' extension of his existing more conventional, albeit electrically powered, line along the seafront in Brighton, taking it out to Rottingdean. The cost of advancing the railway up a steep climb to the top of the cliff or building a viaduct along the undercliff would have been too great. His only, somewhat alternative, option was to run it along the beach, which flooded at high tide, hence the tracks spent part of the time under saltwater. At low tide you can still see the concrete track blocks mortised into the chalk bedrock, a marvellous sight and a great place to explore. Unfortunately Daddy Long Legs has gone: train and track were destroyed by a fierce storm in 1896, just six days after the service opened. Undaunted, Magnus rebuilt his line, and the train ran for four years before closing down permanently. In the end Volk had to take the painful decision to abandon

the Daddy Long Legs because he couldn't afford to move the tracks to make way for new coastal defences. After years of titanic toil against nature his electrifying attempt to conquer the waves was finally reclaimed by the sea. Volk's original narrow gauge railway still runs for just over a mile along Brighton's seafront, linking the Palace Pier with the modern Marina, if you fancy a ride on the great man's tracks.

The storms that swept away the Daddy Long Legs in 1896 must have been quite something because they also finished off the marvellous Chain Pier in Brighton. Before the steam train connected London to Brighton

▼ Brighton's Chain Pier bore a remarkable resemblance to the Brooklyn Bridge in New York, but pre-dated its American cousin by 60 years.

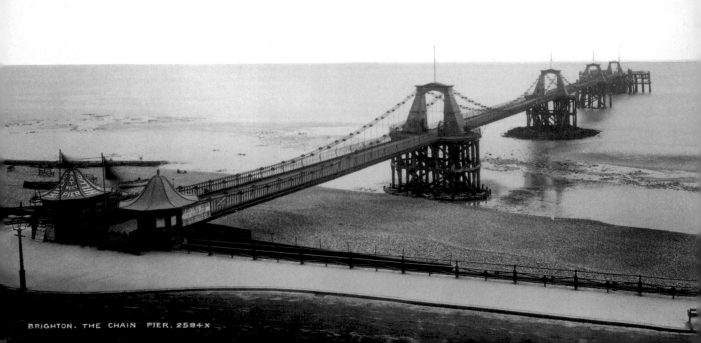

BRIGHTON. THE CHAIN PIER, 2594X

▲ For a while, Shoreham was the home of the first movies – and their stars – before the film industry shifted its focus to the west coast of America.

in 1841 the town was thriving as a gateway to France. In journey time, the route via Brighton was the quickest link between London and Paris. When the Chain Pier opened in 1823 it served as a landing stage for ships to and from Dieppe. A walkway out to waiting boats was suspended from chains strung from towers. Stretching out into the sea for over 1,000 feet from the Marine Parade, it quickly became a popular promenade and even had a camera obscura.

Hollywood on shingle

Bohemian Brighton can claim to have trumped the United States on one of their cultural icons: making movies. Although Magnus Volk was dabbling with electrics in the 1890s it wasn't being used to shoot films yet. The early cameras needed lots of strong natural light. And Brighton had plenty of hours of daylight, an audience looking for thrills, and a cast of luvvies happy to act up. The original stars, though, were ordinary punters filmed on the beach; at first people were content to pay for the novelty of seeing themselves. The original movies were a minute long because that's all the film you could get in the camera. The camera was static, producing a fixed image like a picture frame, with action taking place inside a locked-off shot. But the pioneers of Brighton (and Hove, actually) started to experiment with moving the camera, creating amongst others the close-up, and point-of-view shots, techniques that are now used in every movie and TV show. Those innovations were happening on our south coast at least a decade before any films were shot in Hollywood.

In 1900 one of the great music-hall stars, Marie Loftus, discovered the quiet beaches of Shoreham, down the coast from Brighton. She built a holiday home in what grew to become 'Bungalow Town', and in her wake came a colony of theatrical and film celebrities. Filmmakers followed, erecting a glasshouse studio on Shoreham's beach. The good times rolled but the studio burnt down in 1922. The cameras of The Progress Film Company continued to crank though until the business finally wrapped up in 1929.

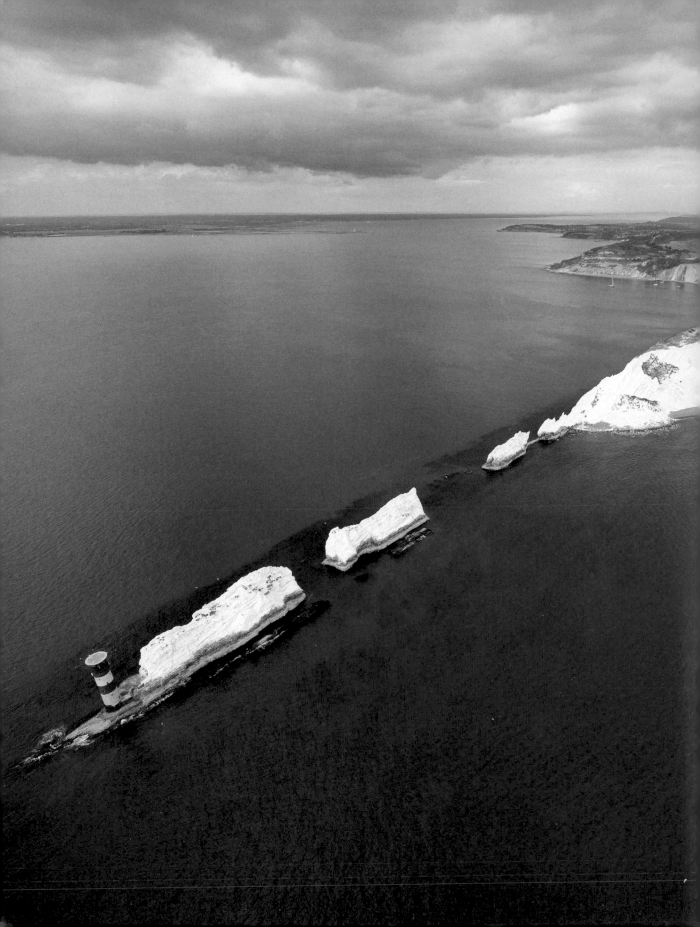

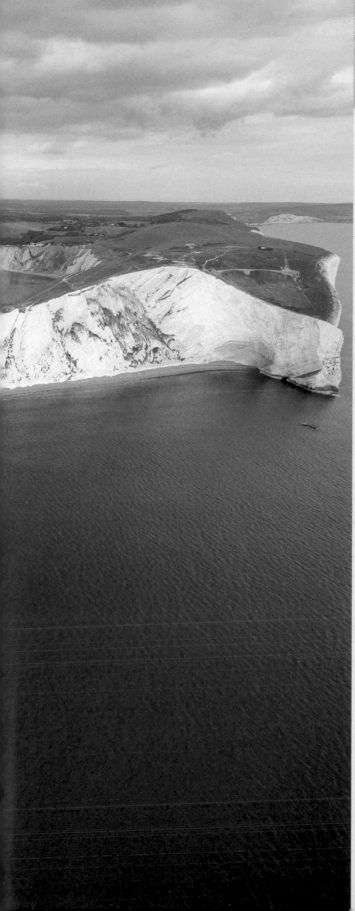

RESTLESS ISLE

It's natural to think of people moving around the world but harder to get your head around the notion that countries themselves are continuously shifting around the oceans. The evidence for the restless journey of landmasses is all around our own shores, and there's nowhere better to see it than the Isle of Wight.

England's biggest island is a geological time capsule that looks like a lost world adrift off the south coast. In a lost world you'd expect to find dinosaurs and the Isle of Wight doesn't disappoint: head to Hanover Point on the southwest side to see footprints of the megabeasts. When these dinosaurs roamed the earth, our bit of it, the British Isles, was about 1,000 miles further south than at present. Land masses are always moving, albeit very slowly, but over millions of years we've covered quite a distance. For most of our journey we were joined to Europe, travelling buddies, getting into some scrapes together. Like the time 65 million years ago when we bashed into Africa, which was on its own mission round the globe.

Evidence of our continental car crash is exposed in the cliffs at Alum Bay, on the eastern side of the Isle of Wight. Bands of sand and rock have been folded up so that they are now almost vertical – the result of a massive shunt that crushed the island, creating a backbone ridge right along it. We got off lightly though: that collision with Africa was so severe it mangled Europe enough to create the Alps. After travelling as part of mainland Britain for millions of years, just a few thousand years ago the Isle of Wight started its own adventure. The rise in sea levels after the last ice age cut it off from the mainland and created the island we see today. It didn't happen overnight but on the geological timescale it was off in the blink of an eye.

◄ Some 7,000 years ago rising sea level separated the Isle of Wight from the mainland. Human lives are too short to appreciate geological time but on a smaller scale our coast is reshaped with every tide.

LULWORTH COVE EXPOSED

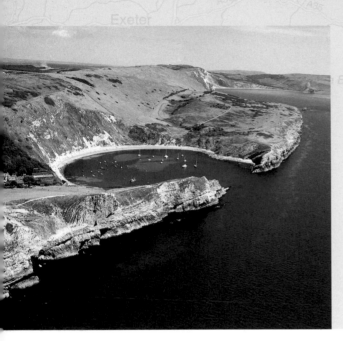

Down the Jurassic coast of Dorset towards Weymouth there's a remarkable natural amphitheatre where the sea is the star. The symmetry and clean lines of Lulworth Cove make it look as though a giant pastry cutter has taken a bite out of the coast. Its scallop-shell form was created by the erosion of sand and clay layers, leaving ribs of harder chalk and limestone exposed.

In the remake of the *Coast* title sequence we wanted to put the 'letters' that spell out the show's title into the cove. A live action shot of Lulworth Cove from a helicopter was processed to create a virtual-3D landscape, to which the computer-generated letters were later added. Look out for the little boat that weaves its way between the letters A and S – we put it in to help with a sense of scale, and also just because it's fun. In the original titles the boat was a much larger tanker, off to the left hand side of the letter C.

Portsmouth and the 'Senior Service'

Portsmouth is the birthplace and home of the Royal Navy. It was Henry VIII who got really serious about establishing the 'Senior Service' in the first half of the sixteenth century. Portsmouth was a good base for a permanent professional fleet because of its large natural harbour and narrow, easily fortified entrance sheltered by the Isle of Wight. The idea of a navy wasn't new: England had a fledgling fleet before 1066, but Edward the Confessor abolished it and William the Conqueror saw little need for defending his newly acquired waters. Trade links between the south coast and Normandy meant the Cinque Ports continued to thrive and could assemble ships in peacetime to ward off pirates and mount limited attacks on the French. But the loss of Normandy to King Philip II of France caused a sudden urgency to restore a navy, and a base was created at Portsmouth in 1212. After all, as the estate agents would say, it offered easy access to Normandy – without being too close to those hostile neighbours.

Its priority as a naval base waxed and waned through the reigns of succeeding monarchs according to the level of threat. As the Scots started to construct a large fleet of warships an arms race ensued in 1509 between the newly crowned Henry VIII and the Scottish king James IV for control of the seas. Anticipating hostilities with France and Scotland, Henry invested heavily in a fleet of great wooden ships using the latest technology of gunports to allow more cannons to be deployed. The flagship of the emergent Navy Royal was the infamous *Mary Rose*, built in 1510. Henry went on to create a standby force of 30 ships during peacetime and by 1540 Portsmouth's docks were complete. Henry's reign was troubled by his inability to produce a son, but it could be said he sired the Navy and ensured Portsmouth's place in British as well as maritime history.

Now there's an added dimension to Portsmouth's lofty naval ambitions: the Spinnaker Tower. It was erected in 2005 as the centrepiece of the harbour's redevelopment. It's an impressive sight: two white steel arcs that represent billowing sails, and at 558 feet it is almost three times as high as that other monument to maritime achievement, Nelson's Column.

Safe as lighthouses

Innovation can be embarrassing when it goes wrong, but for some pioneers on this coast it has proved fatal. The Eddystone reef had snagged countless ships bound for Plymouth over hundreds of years. With the increase of maritime trade in the late seventeenth century commerce demanded a solution. A merchant, Henry Winstanley, had lost a couple of his own ships, wrecked on the rocks. Frustrated by the common belief that it was impossible to build a light on the treacherous Eddystone reef, Winstanley resolved to do it himself.

The audacious venture was financed by a levy of 1 penny a ton on passing ships, and such was the trade in those times there was money enough to pay for Winstanley's bold scheme. In the summer of 1696 he began to build an octagonal tower from granite and wood. Storms in the winter of 1698 damaged the structure but the light was lit on 14 November. Alas, it was discovered it wasn't high enough: spray from fierce seas would obscure the light just when it was most needed. So Winstanley and his men were back out on the reef to raise the structure and the following November his mark-II lighthouse was unveiled to the world. The 120-foot high edifice was finished with ornate engravings and extravagant wrought-iron detailing. Many people questioned its design: would it be able to withstand unrelenting gales and ferocious seas? Winstanley had confidence in his creation: 'I only wish that I may be in the lighthouse in circumstances that will test its strength to the utmost.' On 27 November 1703 it's fair to speculate that he regretted his words. He had gone out to his lighthouse, concerned by the approach of bad weather. That night the biggest storm ever recorded hit the south coast. Britain was devastated: it is estimated 8,000 lives were lost, and Winstanley's was among them. The lighthouse that had signalled ships away from the reef for over four years was all but erased. Just two days after its destruction a ship struck the Eddystone rocks and sank with the loss of all hands. The problem would not go away.

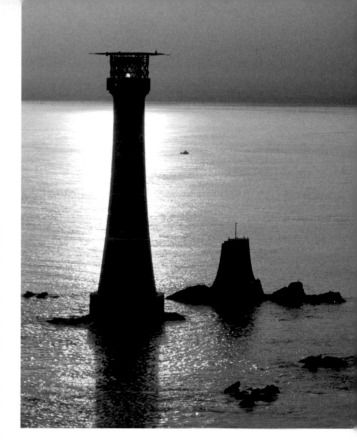

▲ The foundations of Smeaton's lighthouse proved so strong they remain to this day, beside the current, fourth, lighthouse, first lit in 1882 and still in use.

Another lighthouse was built shortly afterwards, this one a conical wooden structure around a brick-and-concrete core. It survived more than fifty years but after it burnt down a Yorkshire engineer, John Smeaton, took up the challenge. His ambitious design made innovative use of interlocking blocks of granite and 'hydraulic lime', a concrete capable of setting under water. His lighthouse entered service in October 1759 and stood for 120 years until it was discovered that the underlying reef had started to crack. As a memorial to its designer the people of Plymouth paid for it to be taken down, block by block, and rebuilt on Plymouth Hoe. Smeaton's lighthouse also has its place in literature – Herman Melville mentioned it in *Moby-Dick*, describing the arrival in Nantucket: 'See what a real corner of the world it occupies; how it stands there, away off shore, more lonely than the Eddystone Lighthouse.' Nantucket is an ocean away from Plymouth's shining light but, as we'll see, Cornwall has another rocky link, just across the Channel.

To the English, Normandy is synonymous with conquest and liberation: two coastlines separated by one channel and united by two momentous invasions – moments when the fate of nations hung in the balance. Out west, Brittany has been connected to the Britons since people first began to colonize our islands.

The Gallic Coast: Calais to Brittany

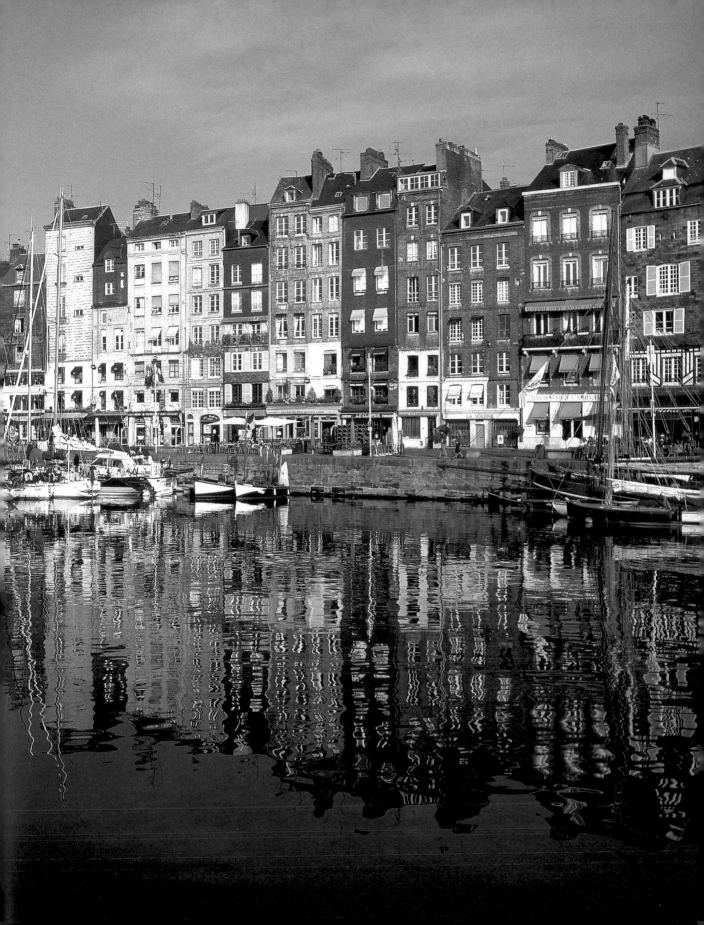

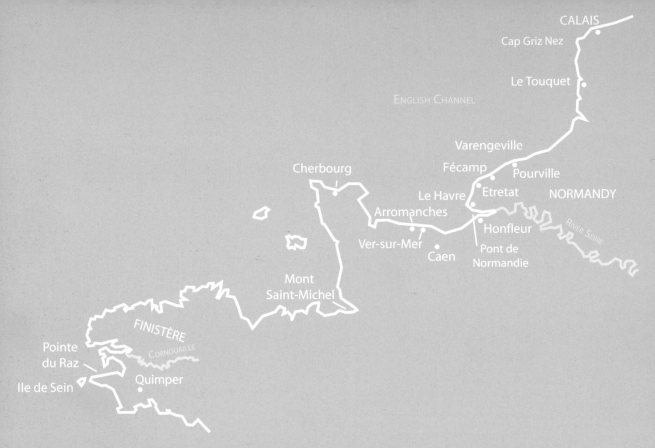

Map labels:
CALAIS
Cap Griz Nez
Le Touquet
ENGLISH CHANNEL
Varengeville
Fécamp
Pourville
Le Havre
Etretat
NORMANDY
Cherbourg
Arromanches
Honfleur
RIVER SEINE
Ver-sur-Mer
Caen
Pont de
Normandie
Mont
Saint-Michel
FINISTÈRE
Pointe
du Raz
CORNOUAILLE
Ile de Sein
Quimper

There are definable days when the direction of a country is decided and the outcome of events determines the destiny of an entire people. The Allied invasion of Normandy and the Norman invasion of England are such hinge moments in history, but what happened before and after to cement the victory is less well known. On our sojourn along the north French coast we'll see why William came home after the Conquest to get the building blocks that would bring Britain to its knees, and discover how a map of the Normandy beaches was assembled before D-Day by daring men and brilliant brains. Invasions aren't easy, even with a massive army behind you.

◄◄ Le Vieux Bassin, Honfleur's picture-perfect port, has repelled invaders and attracted painters.

A mere ditch

In 1804 Napoleon had amassed over 100,000 men to overrun England, and he told them, 'The Channel is a mere ditch. It will be crossed as soon as someone is brave enough to try it'. Bold words but that ditch and our navy kept him at bay.

Napoleon may have overreached himself but the little man was right about the Channel, it is pretty much a ditch and a surprisingly shallow one. We'll see how this small scar was cut by a spectacular natural catastrophe that separated Britain from France. Before then we had been like Siamese twins, joined at the hip by chalk, afterwards we were too close for comfort and the clash of our cultures has reverberated around the globe. We'll witness how a small expedition from Honfleur set Britain on a collision course with France in the New World. But two coasts can't be so close and not share some intimacy. There's 1920s romance to relive in Le Touquet, two little lumps of divine inspiration to climb in honour of St Michael, and, finally, the story of a small island that united two nations in their time of need.

Within a whiff of Britain

Our French connections begin at Cap Gris Nez – literally Cape Grey Nose – where England's nearest continental neighbour is within sniffing distance. This little nose-like promontory on the north face of France is the closest point between two countries that have been the bitterest of enemies and the best of friends and there's evidence of both carved into Cap Gris Nez. Up close the lumpy terrain makes it looks like nature has grown a wart on the nose but viewed from the air another picture emerges: massive earth banks and ditches arranged too regularly to be anything other than the work of man, and what a man.

The earthworks are the remains of a fort built at the command of Henry VIII, the quintessential English king, who was desperate to hang on to the British monarchy's French roots. From 1154 Henry II (great-grandson of William the Conqueror) founded the Plantagenet dynasty who, by virtue of Henry's marriage to Eleanor

▲ The view across Napoleon's 'mere ditch' from Folkestone. Cap Gris Nez is visible in the distance, barely more than 20 miles away.

of Aquitaine, ruled England and about half of what is now France. Although King John lost much of their continental territory in 1204 his Plantagenet descendant Edward III started a long-running battle for the control of France in 1337; the Hundred Years War rumbled on until 1453, ending in defeat for the English, who were left with a tiny toehold on the French mainland, their control confined to the area surrounding Calais.

Tudor guns and roses

The Plantagenets turned their back on the continent and decided to turn on each other instead. Englishman fought Englishman in the War of the Roses and the upshot of all that was the start of the Tudor dynasty. Toward the end of his reign Tudor monarch Henry VIII attempted to reinforce the English enclave around Calais and he ordered six forts to be built. Work on one of them began in 1546 on Cap Gris Nez. Royal engineer

John Rogers adopted an innovative incentive scheme to jolly his workmen along, and the plot was divided into 12 lots, each allocated to a separate construction team by the drawing of straws. The first gang to finish would be sent home to England, and they must have been eager to get back because just 2 months after the spadework began the fort was finished.

It may have been thrown up but it wasn't a shoddy job. The fortifications are about a quarter of a mile wide and the earthworks are still there, albeit overgrown. With a little digging the brickwork of subterranean rooms can still be seen; here the English soldiers stored the essentials for their campaign: gunpowder and beer. Substantial banks of earth were necessary to combat the threat of cannon fire but the fort fell to the French without a shot being fired: the defenders surrendered when the other English strongholds were overrun.

The French blew the foreign soldiers off their Grey Nose but Henry VIII didn't live long enough to see them finish the job and finally boot the English out of France in 1558; Henry's daughter Elizabeth I came to the throne that year and maybe she didn't forget the fort on Cap Gris Nez, because late in her reign a similar design appeared at Berwick-upon-Tweed in order to pacify the Scots – more of that in Chapter 8.

The Grey Nose is punctured by some ugly little concrete studs, bunkers built by the Nazis as part of their desperate defensive line to repel an Allied invasion of the Third Reich. The bunkers sit in the ruins of Henry's fort but they weren't just plonked there. Apparently the Germans took care in placing them, surveying the site as they were conscious of its historical significance. The bunkers are concrete symbols of a time when neighbours across the Channel forgot their differences and fought together for liberty. A bit further down the coast there is a pretty little place where the English and French cemented their relationship in a much more cordial atmosphere.

Paris by the sea

Formally this Pas-de-Calais seaside town is known as Le Touquet Paris-Plage but let's be local and call it Le Touquet, a stylish French dish served with a dollop of British sauce. In the 1920s Noel Coward made it a place to conduct his private passions with select friends from his smart set of sophisticated revellers. Those inter-war years were known in France as *les Années folles*, or 'the crazy years'. Survivors of the First World War were in a mood to party; Paris went wild as did its namesake by the sea. Le Touquet's casino was a legendary hang-out of Hollywood legends Douglas Fairbanks Jr and Marlene Dietrich, and the striking whitewashed building is said to have been an inspiration for Ian Fleming's first James Bond novel, *Casino Royale*. Parisians built elegant second homes among the pines trees, away from the clamour and perfect for repose after a night of gambling.

Le Touquet's success wasn't just down to luck. From the beginning it had wealthy backers, both French and British. In the 1870s as press magnate Hippolyte de Villemessant was busy making his newspaper *Le Figaro* the most popular in France he also decided to take a gamble on developing Le Touquet as a beach resort for posh Parisians, and in 1903 English investors John Whitley and Allen Stoneham bought into the bet. They put their money on sports as a way to attract fellow Brits to the resort: golf and tennis proved to be winners, and the gamble paid off as the casino raked it in. The town recovered from the rigours of the Second World War and by 1953 its airport was the third largest in France, eclipsed only by Paris and Marseilles. You can still hop over by plane, grab a push bike at the airport and be cycling round town 10 minutes later, admiring the villas of the rich and famous.

➤ Le Touquet is the jewel resort of the 'Opal Coast', and this stretch of shore has golden sandy beaches not pebbles. It personifies the *belle epôque*, the period before the First World War when, for the affluent, life was very agreeable.

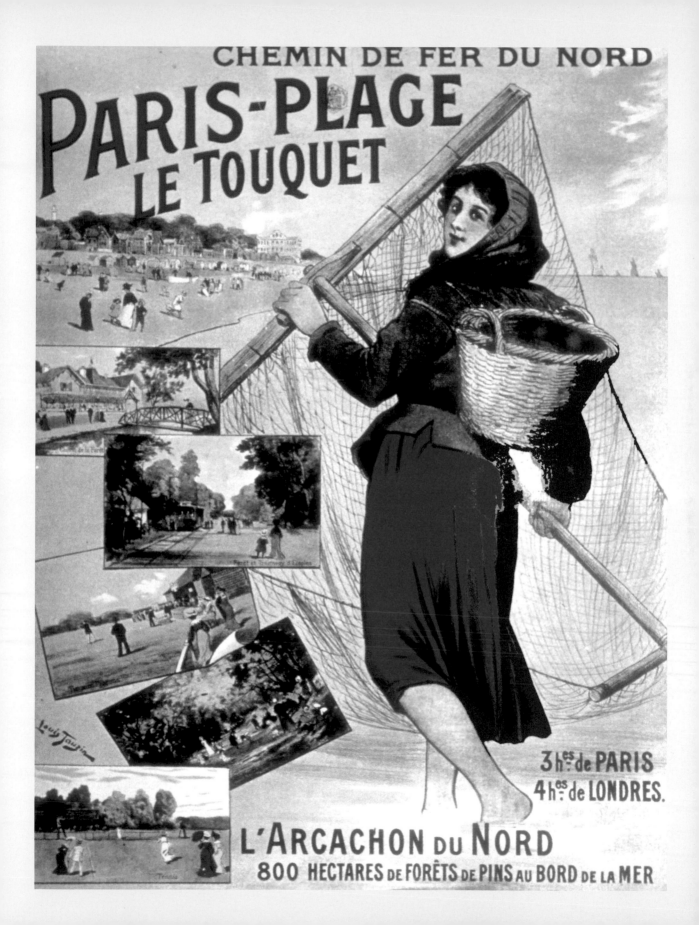

The white stuff

We don't only share a love of being beside the sea with our Gallic neighbours, for as well as paddling in the same sea south coasters also walk on the same soil as their French chums. Wander along the shore near the town of Ault and a surprisingly familiar sight strikes you: welcome to the white cliffs of France. I don't know whether blue birds fly over these beauties but they do stretch for over 150 miles and bear a spooky similarity to Dover's sparkling white cliffs – it's like finding yourself in a parallel universe where the landscape is the same but the culture is quite different. From back in the nineteenth century engineers and scientists have been trying to figure out if the similarities are more than skin deep and the chalk in the Channel is the same on both sides.

In the 1830s French hydrographer Thomé de Gamond decided to take the plunge to establish whether the chalk ran all the way under the sea. In the days before diving equipment this was dangerous, demanding work. To collect samples from the deepest parts of the Channel meant submerging to depths of 100 feet and, as protection from the pressure Thomé put lard in his ears and nostrils. If that weren't bad enough, just before he jumped in he took a mouthful of olive oil to act as a partial seal. Remarkably, he lived to tell the tale – that the chalk did indeed stretch seamlessly under the sea. This was exactly what he wanted to find out because Thomé was hoping to tunnel between Britain and France, and he now knew he could cut through the watertight chalk.

Despite submitting plans in the 1850s Thomé's tunnel was an idea ahead of its time, but generations of engineers kept the dream alive and their work confirmed that the French and British chalk is indistinguishable; so if land links us why does sea separate us? Scientists have only recently figured that out by amassing high-resolution sonar images of the seabed taken over the last twenty years or so, and they've come to a cataclysmic conclusion.

The mighty whoosh

Go back 450,000 years and Britain was permanently connected to Europe by a chalk plain stretching along much of what is now the south coast. And then, quite suddenly, one of the greatest floods the Earth has ever seen breached the chalk and tore through the landscape, cutting a deep scar that's still visible on the seabed of the Channel. The megaflood had been building up for ages: ice covered much of Britain down to London, and the North Sea wasn't a

◄ England and France are not chalk and cheese: we're made of the same stuff, separated by a stretch of water so shallow it wouldn't completely submerge St Paul's Cathedral, even at its deepest point.

A LASTING IMPRESSION

The French know a thing or two about revolutions and the coast of Normandy inspired one that spread around the globe, making a lasting impression on the world of art. Even people who have never been to the 'Alabaster coast', as this stretch is known to the French, will recognize special parts of it from some extremely famous paintings. The chalk cliffs at Etretat captivated Claude Monet, the father of Impressionism, the radical school of painting that emerged in the second half of the nineteenth century. It was a new way of attempting to reproduce nature's fleeting moments of movement and colour. Short, rapid brushes are applied to the canvas and rather than being blended in together they are left as distinct marks so that the mixing of colour happens in the eye of the viewer instead of on the canvas. The artists worked quickly, often outdoors, and the coast was a recurring inspiration because of the ephemeral nature of the seascape. Turning tides, shifting light and changing cloud conditions meant that Monet often worked on half a dozen canvases each day, moving from subject to subject.

Monet was brought up on the Normandy coast and he was always drawn back by its beauty. The pictures he painted at Fécamp, Pourville, Varengeville and Etretat between 1881 and 1886 came to form a major part of his output. Indeed his image of the harbour at Le Havre in 1872 was the one that gave a name to the movement Master Monet did so much to advance. Monet was asked for a title for his picture for an exhibition catalogue; it wasn't meant to be a recognizable representation of Le Havre at sunrise so Monet said to call it 'Impression'. It went in print as *Impression, Soleil Levant*, (or *An Impression, Sunrise*), shown here. The title may have struck a chord with the critics who used it to name the movement but the painting itself wasn't well received: 'Wallpaper in its embryonic state is more finished than that seascape' was one damning verdict. Monet is viewed rather differently nowadays: in 2008 one of his water-lily pictures sold for nearly £41 million. The Normandy land- and seascape continues to draw artists and painters, all trying to capture their own impressions.

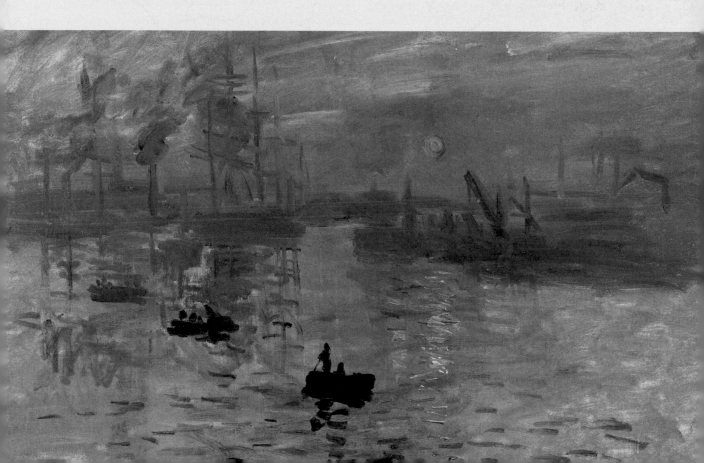

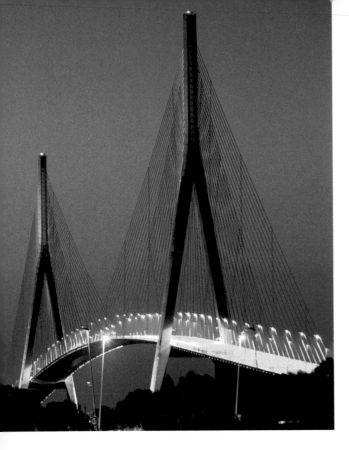

▲ It took seven years to complete the graceful span of the Pont de Normandie, which is suspended over the Seine from 184 cables that fan like fishbones from A-frame towers.

sea but a massive lake, hemmed in by glaciers to the north and the chalk dam at what is now the Strait of Dover. The lake was fed by river water until the chalk could no longer hold it back; our umbilical cord was severed and Britain was born. A subsequent flood about 160,000 years ago made the Channel wider. Temporary bridges of land have connected us to Europe since then because ice ages have sucked up the sea into frozen water but it was the megaflood that first cut us loose with a big slap on the bottom of Britain.

The same chalk means we share the same problems: the stuff is crumbling away at quite a rate, around 18 inches of coast a year in some places on the French side. Erosion takes a greater toll on them than us because the shape of the Channel swills the tide more strongly against the shores of the French; they've lost towns to the relentless scouring of the sea and more will be eaten away. There is little to be done but prepare for the worst: so pressing is the problem that sensors have been put into sections of our neighbour's chalk coast to try and warn of collapses to come. British scientists are cooperating with their French counterparts to try to cope with the forces of nature that have torn us apart.

Our way west is interrupted by another of nature's master works: at Le Havre a huge gash opens up in the coast where the Seine meets the sea, a great river that demands a great bridge and the Pont de Normandie rises to the occasion. The bridge elegantly links the industrial harbour of Le Havre with the picturesque port of Honfleur, a haunt of the Impressionists, and birthplace of Eugène Boudin, who introduced Monet to painting in the open air. Painting runs in the blood of this little fortress town on the left bank of the Seine: walk the 120 miles inland along the river and you would end up in the famous artistic district of Paris.

Honfleur's position guarding the great watery access to the capital against hostile – mainly English – ships made it strategically important as well as a great place for mariners seeking opportunity overseas. Humble Honfleur became the launch pad for one of France's most famous foreign adventures.

A New World at war

In the spring of 1608 soldier and map-maker Samuel de Champlain left Honfleur with three ships hoping to establish a permanent settlement on the other side of the Atlantic in 'New France'. On 3 July 1608 he landed at a promising site and christened it Québec, now one of North America's oldest cities. Its birth may have been relatively easy but there were plenty of growing pains to come. The French relied on trading companies to grow their new colony but the strategy was a dismal failure: poor profits and battles with the locals left New France

▲ Honfleur's fifteeth-century all-wood church has weathered tumultuous times. It was the work of the town's boat builders, and the roof interior reflects its maritime origins, resembling an upturned ship's hull.

in disarray. King Louis XIV had to step in to restore order and finally the fur trade began to flourish.

Despite that success, by the mid-eighteenth century British colonists in North America outnumbered the French by more than ten to one – and would soon be in a fight where every man would count. The Seven Years War was a global conflict to determine how the Old World would colonize the new. Between 1756 and 1763 Britain and her Prussian allies battled a coalition of Austria, Russia and France, with Spain and Portugal throwing their hats into the ring on opposing sides later on. Winston Churchill is said to have considered this the first truly 'world war'. It was fought on two main fronts: Britain conducted an aggressive campaign in North America whereas France relied more on winning territory in Europe, but British naval success scuppered French plans to invade their neighbours across the Channel. Eventually everyone

fought themselves to a standstill and jaw-jaw replaced war-war as peace talks were convened to divvy up the spoils. France gave up its claim on Canada to Britain, reasoning perhaps that soon the colonies would rise up and throw out their European masters anyway. Even though America would soon go its own way Canada remained British and one might muse that the troops who crossed the Atlantic to help liberate France in 1944 spoke English because of the outcome of the Seven Years War nearly 200 years before.

War is over: thank the Lord

Remarkable as it may seem there have been brief periods in our history when the British and French haven't been battering hell out of each other. At the end of the Hundred Years War in 1453 the English finally gave up their claim to the port of Honfleur. As time passed peacefully the town found work for their boat builders' idle hands when in 1468 they started construction of a wooden church. There are several

A towering achievement

The Vikings who began to colonize northern France in the early tenth century needed to reinforce their coastal territory and these newly installed 'Normans' took a trick from the previous tenants. The French were famed for their fortifications including the 'motte-and-bailey'-style construction and the Normans became masters of the art. A motte is a large, conical earth bank built up by digging a big, circular trench and throwing the soil in the middle, then a small stronghold is put on top. The bailey bit is the area next to the motte where the soldiers live surrounded by a wooden stockade with a defensive trench around the outside. Quick, simple and effective these fortifications could be erected in a matter of days, especially as the Normans brought the wood for building their baileys to Britain pre-cut and ready for assembly. William's men left their military mounds of earth dotted around England like giant droppings with little wooden forts built on top, but for a proper castle you need stone.

The conquerors couldn't construct in stone on top of a manufactured motte for years because it took ages for the freshly dug earth to settle into a stable foundation. But the Normans were playing a long game and they wanted to make it plain they were sticking around. The White Tower (below right) was a grand statement of intent to dazzle and dwarf the Anglo-Saxon citizens of London into submission. And, boy, was it successful: now it's the heart of the Tower of London. Britain's signature structure is a reminder of how the Normans taught us the brutal authority of monumental building. The same creamy-white Caen stone used for William's castle at Caen (below left) was quarried to build the White Tower. By the time of its completion in 1100 it dominated the London skyline surrounded by a settlement of mostly single-storey structures. William died before the completion of his White Tower but what a legacy these builders left: there's a little bit of the Normans in almost every stone castle in Britain.

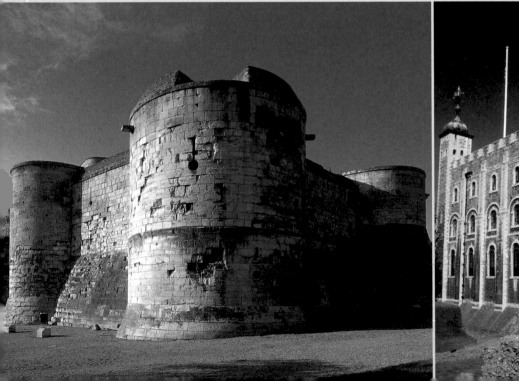

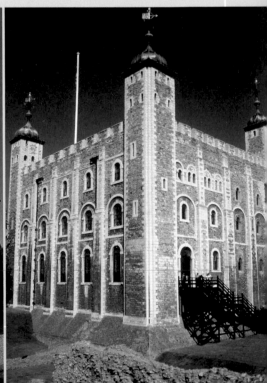

theories as to why it wasn't built in stone – that may have been reserved for all those fortifications – or perhaps timber was a cheap option in a time of post-war austerity. The separate bell tower is a bit of a mystery too; maybe the locals were worried about lightning strikes setting fire to the woodwork of the church, perhaps vibrations from the swinging bells was a concern, or it could be the whole thing was a temporary solution until a stone structure was erected. Or it might have been a fashion statement because it's a jolly fine sight.

The calm after the storm of conflict is a time for reconstruction and following his whirlwind victory in 1066 William the Conqueror had to get cracking to cement his precarious hold on England. Winning one battle doesn't win a kingdom and as William marched inland from the south coast he had to fortify his positions against the hostile natives. Fortunately for the Normans they had learnt a few things about forts from having to fight their way into France in the first place. Norman is a corruption of 'North-men', a linguistic link that's explained by the fact that William's ancestors were Vikings. Since the late 800s, the Vikings had come south to attack the northern shore of France before a deal was struck in AD 912 allowing them to keep the coast land if they repelled further raiders, and that's how Normandy was born.

The longest day

The Normandy coast has seen armies depart and arrive; the sandy shore that stretches for around 50 miles west of Caen was the site chosen for the most ambitious amphibious assault in history: we have reached the D-Day beaches. At 6.30 a.m. on 6 June 1944 Allied forces began an invasion to liberate Europe from the Nazis. Some 7,000 vessels and 12,000 aircraft were mobilized to play their part and on this one day 156,000 troops were landed on the beaches of Normandy.

Despite the staggering size of the operation it was an enormous gamble, and in the years before the assault the Allies had gone to extraordinary efforts to try and stack the odds in their favour.

Wild talents

Defenders naturally have the upper hand in any assault by sea, and the attackers' task is made even harder by soft sand; beaches weren't the most obvious or the easiest terrain to pick for a massive invasion of mainland Europe. The ideal place to get men and machines ashore is a harbour but when the Allies had attempted a smaller-scale raid on the port of Dieppe in 1942 it ended in disaster: 3,000 Canadians and British were killed or captured, and the Germans were ready and had fortified France's northern ports. The alternative of miles of long, flat shore were not an immediate or attractive one and Winston Churchill was all too aware of the potentially terrible price to be paid for trying to launch an invasion on a well-defended beach. In 1915 Allied forces had tried to open a second front during the First World War by assaulting the beaches of Gallipoli in Turkey, where over 100,000 men were killed or wounded before the mission was abandoned. Churchill had been an architect of the Gallipoli campaign; it cost him his job in government and a generation of soldiers learnt to fear fighting on sand.

A further deadly threat to the invasion lurked under the landscape of the Normandy coast. In places soft, sludgy patches of peat are hidden by a thin dusting of sand that isn't always as thick as you think. Peat would bog the Allies down; trucks and tanks stuck in their tracks were just sitting ducks for the German artillery. No reliable map of the danger areas existed so one would have to be made, but how do you survey miles and miles of beach in full view of the enemy without them knowing you are doing it?

This mission impossible was just one of the problems perplexing Louis Mountbatten, the Chief of Combined Operations, who was responsible for launching the Dieppe raid that had ended so badly. When the early planning for D-Day started he went in search of those who might be able to solve the seemingly insurmountable. Mountbatten said, 'I must have the best available non-service men, preferably scientists ... they would have minds open to work on entirely new problems.' The so-called Department of Wild Talents was established and one of the maverick free thinkers recruited was Irish-born scientist and Marxist sympathizer, the brilliant John Desmond Bernal.

Before the war Bernal was pioneering a technique using X-rays to reveal the internal structure of complex molecules, a fearsomely difficult science. The problem he faced was similar to shining a torch into a room full of objects then trying to work out what things were inside and exactly where they were from the shadows they cast on the wall – except that Bernal was doing this on an atomic scale. After the war his work would help to discover the double helix of DNA; during the German occupation of France he was puzzling out where peat bogs were hidden under the beaches of Normandy.

Keeping his work secret from its staff, Bernal scoured the British Library and some surprisingly helpful literature was unearthed. The writings of a local priest who, a hundred years earlier, had found a Roman coin buried in the Normandy coast suggested a date for the peat layer. Roman army records detailed the location of the peat as they used it for fuel, and place names on old Norman maps indicated where marshes might be. A team gathered and analysed a bewildering array of evidence: holiday snaps of the French coast were collected; the RAF dropped bombs and photos of the craters were studied, and as the Germans constructed defences their carts got stuck on the beach so their position and wheel tracks were recorded by aerial reconnaissance.

Rather like doing a jigsaw without reference to a picture on the box, piece by piece a top-secret geological map of the Normandy shore was put together. Tests with tanks and trucks were carried out on Brancaster Beach in Norfolk, which was similar to the sand locations earmarked for invasion. Every conceivable second-hand source was exploited to add to the map but first-hand knowledge was still needed to see for sure if their educated guesses were right. Someone had to take samples from the D-Day beaches under the noses of the German army and if that someone got caught the cat would be out of the bag: the Nazis would know D-Day's location.

Two good men

Two members of the Corps of Royal Engineers, Major-General Logan Scott-Bowden and Sergeant Bruce Ogden-Smith, were picked to swim in pitch darkness on to the Normandy shore and take the all-important sand samples. They trained in Scotland, swimming naked at dawn each morning in icy water, but senior staff were still sceptical: surely they would be spotted and the secret blown? So a trial took place one moonless night in Norfolk, scientist John Bernal playing the part of a German sentry. Major-General Scott-Bowden recalled Bernal's reaction: 'We crawled all round him and marked exactly where we'd been. Then we stood up at the shoreline and came in and saw him and told him where we'd been and he was amazed.' Mission impossible was on.

At the request of Winston Churchill, in the dying days of 1943, the two Royal Engineers were sent to Ver-sur-Mer to test the load-bearing capacity of the beach that British forces would storm 6 months later. Hoping to catch the Germans offguard after they'd consumed a little local wine, the mission was set for New Year's Eve, the pair timing their brief stay on the beach to coincide with the stroke of midnight. Well, that was the plan, but

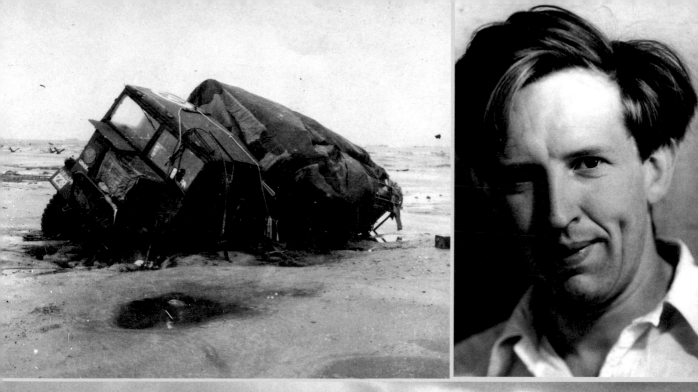

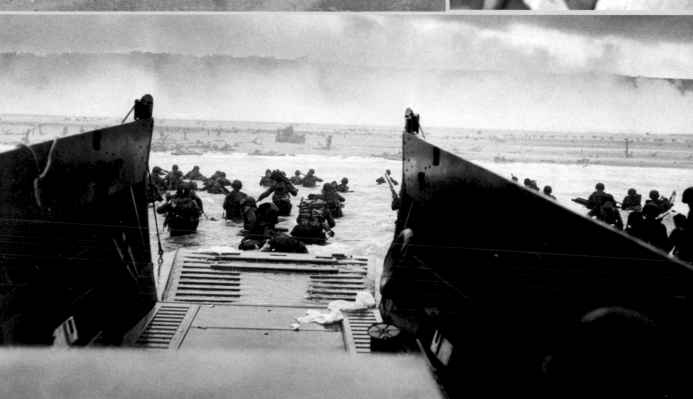

⬆ (Left) Beached on Brancaster during tests in Norfolk to assess a landing on sand. (Right) John Desmond Bernal, nicknamed Sage by his fellow physicists.

⬆ American troops landing on Omaha Beach on D-Day in 1944, one of the few surviving images of the first landings of soldiers in occupied France.

the Major-General told us they forgot to allow for the time difference between Britain and France, so when they were stood on the sand 1944 was already an hour old and celebrations were in full swing; apparently the Germans were 'pretty well on' by then.

The two men wore belts to carry their waterproofed Colt automatic pistols, which were good for 'shooting from the waist'. In addition they had a commando knife, compass, wrist watch and the all-important small drill and tubes for the sand samples. 'The samples were about 18 inches deep. We took the lower 8 inches of an 18-inch sample. Sir Malcolm Campbell reckoned from his experience that with 14 inches depth of sand you had adequate strength even in clay to take the heaviest vehicles.' Sir Malcolm Campbell was the man who had broken the world land-speed record nine times between 1924 and 1935, three times driving on Pendine Sands in South Wales, so he knew about the perils of taking vehicles on beaches. Campbell was one more of the 'Wild Talents' who helped to win the war.

Having secured their samples the sea almost sank the Engineers. The wind had got up and breakers kept pushing them back to shore as they struggled to swim out to the waiting boats. At the third attempt they made it to open water but when Major-General Scott-Bowden heard Sergeant Ogden-Smith yelling behind him, concerned he swam back to the Sergeant: 'I feared he'd got cramp or something ... it turns out he was shouting, "Happy New Year"... I said, "Swim, you bugger! ... or we'll be back on the beach" ... and then I wished him a Happy New Year too.'

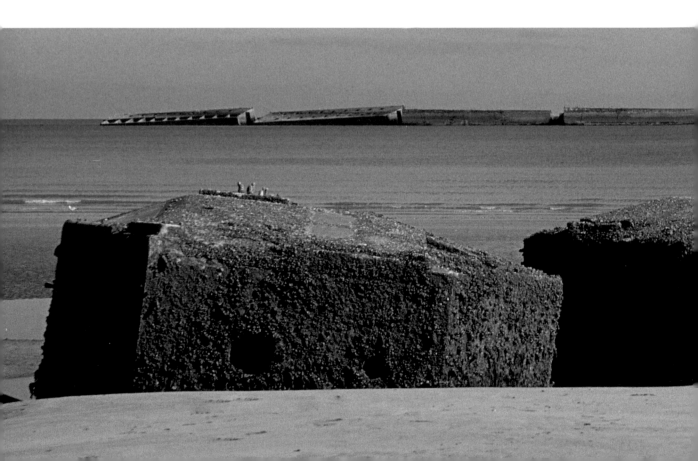

Against all odds they had pulled it off. When scientists inspected their samples a key piece slotted into the geological jigsaw the British were building up. The two men didn't have long to celebrate success: within a month they were sent back, this time to Omaha Beach to collect sand for the Americans. They stationed themselves offshore in a mini-sub from where, using a periscope little thicker than a walking stick, they observed the Germans busy bolstering their defences. Field Marshall Erwin Rommel had recently taken command and Nazi strategy had changed. Under Rommel the Germans planned to stop the invasion on the beaches; rather than letting the enemy inland they would try to kill the Allies while their feet were still wet.

The Nazis' 'Atlantic Wall' of concrete bunkers along the coast from Norway to southern France was to keep the Third Reich secure for a thousand years but it only managed a day or so in Normandy. In contrast, the artificial Mulberry Harbour the British installed to unload tanks and trucks on to the beaches at Arromanches (6 miles from Bayeux, home of the tapestry, 1066, and all that) was intended to last 3 months but large bits of it still stand over sixty years later. The strategically vital Mulberry Harbour was the bold solution to the task of getting heavy machinery ashore when there is no port: bring one with you. Pieces were constructed in Britain then towed across the Channel and assembled – right under the nose of the enemy.

▼ The artificial harbour at Gold Beach, Arromanches, invented and refined by a host of wildly talented people, among them John Desmond Bernal, who worked out the secrets of the beach where it still sits.

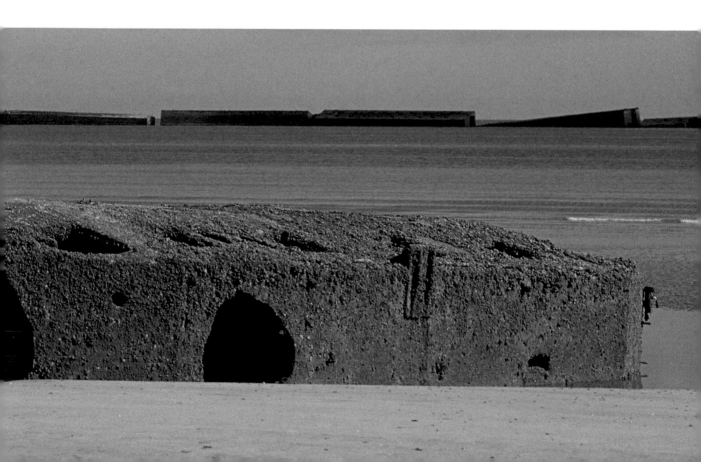

THE AVENGING ANGEL

The east side of the Cherbourg Peninsula was a battleground during D-Day but on the west side of its shore we find the heavenly gem of Mont-St-Michel, a monastic marvel. It's not as peaceful as it appears, though, because it celebrates the battle for the soul of man. St Michael, the most powerful of the archangels, was the leader of the Army of God during the war in heaven against the fallen angels led by Lucifer, and now the faithful believe he rescues their souls, transporting them to heaven for judgement. This warrior angel is honoured by not just one, but a pair of remarkably similar medieval shrines precariously perched atop rocky outcrops on either side of the English Channel.

Mont-St-Michel's monastic links go back to the early eighth century when it's said St Michael appeared to the Bishop of Avranches, supposedly burning a hole into the cleric's head to convince him to construct a small chapel on the mount. In AD 966 the Duke of Normandy entrusted the sanctuary to the care of Benedictine monks, who built the most remarkable abbey in complete defiance of its improbable location. The medieval architects didn't stop there: between the eleventh and sixteenth centuries an entire village was built in the shadow of the abbey's great walls. This divine little peak is a vision of heaven in miniature – one can easily imagine the monks believed they were in the presence of St Michael on its pinnacle.

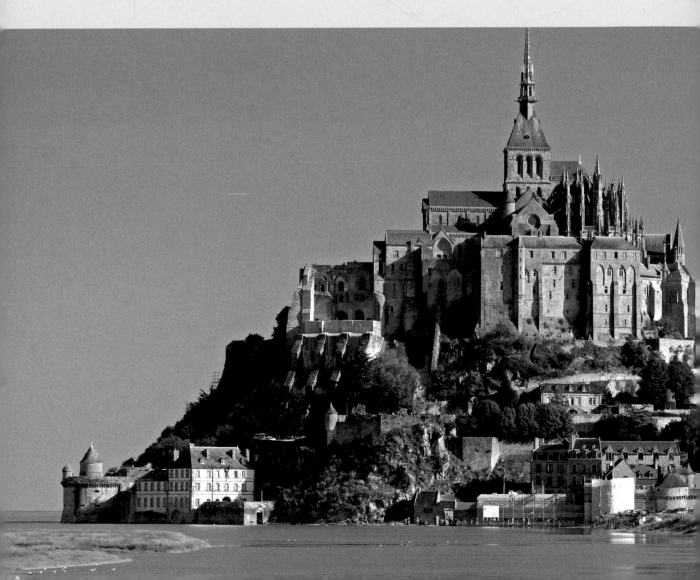

St Michael's Mount is the small conical island that guards the entrance to Land's End on the southwest coast of Cornwall. The Mount was a port and trading post for tin and copper from as early as 350 BC and seafaring merchants were in control until Julius Caesar upset their tidy trade in 56 BC. The island was apparently abandoned to hermits and mystics and it might have stayed that way, but for another apparition of the archangel St Michael, this time supposedly to a fisherman in AD 495, and subsequently it became a sacred site for Christian pilgrims.

After the Norman conquest of England the monks of Mont-St-Michel were given control of their little sister peak across the sea and they were inspired to build a church in honour of their patron saint. Despite their similarities, St Michael's Mount could never match the scale and grandeur of its French predecessor. It was controlled by the Norman monks until King Henry V seized the 'alien priory' of St Michael's Mount for the crown, and by 1424 all links between the two priories were broken. Since the seventeenth century, the castle has been the private home of the St Aubyn family although now it's maintained by the National Trust. Annually around 200,000 people make the trek to St Michael's Mount, while across the Channel Mont-St-Michel attracts millions. Two islands, a single stretch of water and the same thread of history.

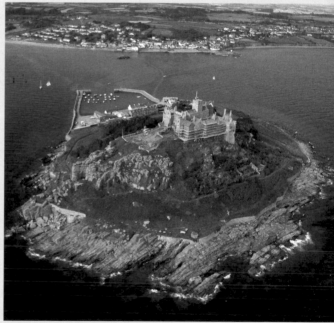

⋏ The monastic medieval world is mirrored on two islands either side of the Channel: St Michael's Mount, cut off by the tide from mainland Marazion.

◄ In more recent times a new breed of pilgrim discovered Mont-St-Michel: tourists. Victorian and Edwardian gentry, artists, writers, nostalgic for the past, began the trend, and we travel in their wake.

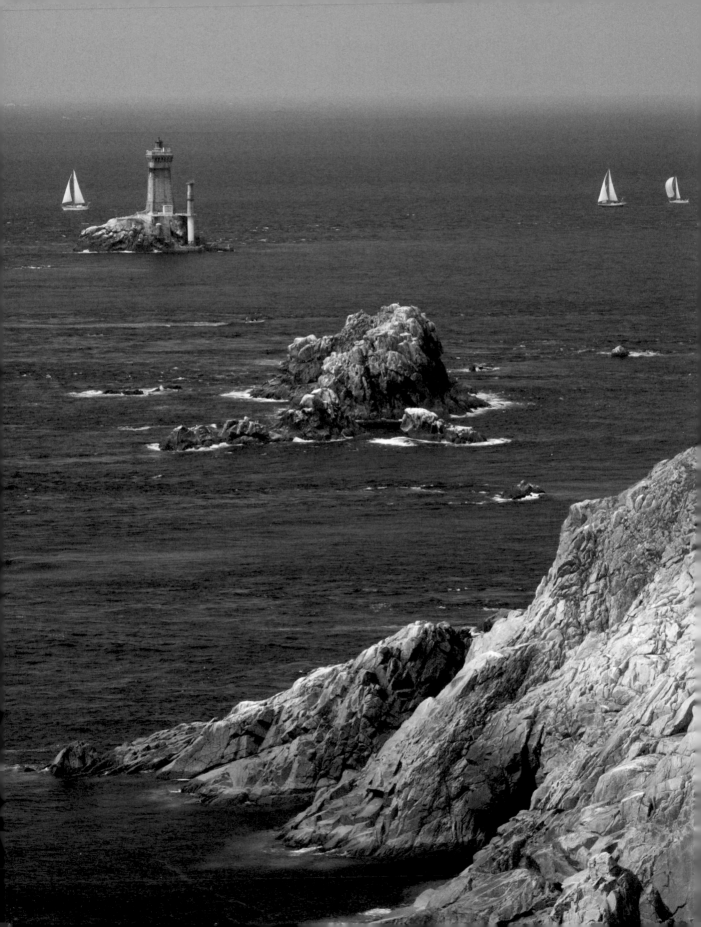

The end of the earth

Moving into Brittany we are heading toward the wild west of France, fictional home to Asterix the Gaul and his army of resistance to the Romans. In reality this region has always been fiercely independent, the Bretons who inhabit this kingdom of the sea have a strong connection to their Cornish cousins across the Channel. They are two communities who share the common bond of living at the edge of their countries; the district at the pointy end of Brittany is called Finistère, which translates as 'end of the earth'. And at the very end of the end is La Pointe du Raz; this rugged rocky spur is the French Land's End, the most western point on mainland France, which attracts over a million visitors a year.

There's a superficial similarity between the Breton and Cornish landscape but look into the history of the people and they start to seem inseparable. When the last ice age froze northern Europe, people trekked to warmer southern climes; then, about 12,000 years ago, as the ice retreated, the people started to advance back, but it seems not everyone walked: some took the short cut and went by sea. A recent DNA study has shown similarities in the genetic make-up of people living along Europe's Atlantic coast; it's thought that around 10,000 years ago seafarers started to move from northern Spain, settling in Brittany, Cornwall and up the western coast of the British Isles.

Age-old connections between the Bretons and the Cornish were reinforced in the confusion caused when Romans retreated back home from northwest Europe in the fifth century. In the vacuum of power Angles, Saxons and Jutes moved into Britain, and people from Cornwall and Wales fled from these Germanic tribes, taking refuge across the Channel. For

◄ The unbounded panorama from the Pointe du Raz, celebrated by French writers Gustave Flaubert and Victor Hugo, attracts millions to head for this 'last rock' of Brittany, lit by the Armen lighthouse.

300 years Celts emigrated into France bringing with them their culture and language; the area they occupied became known as Brittany or literally 'Little Britain'. And the region between Pointe du Raz and the town of Quimper is called Cornouaille – that's French for Cornwall. It's ironic that those original Britons who fled the Germanic tribes had the last laugh, for in 1066 when William invaded England the majority of the men who joined him to conquer the Anglo-Saxons came from Brittany.

If you are really looking for the 'end of the earth', try travelling 5 miles or so beyond La Pointe du Raz to the tiny Ile de Sein, the full stop at the end of our journey. It's not only little, about 1½ miles long, it's also extremely low: the highest point is not quite 20 feet above sea level. There are, of course, no cars here, and not even bicycles. It's good for a bracing walk, and has attracted the odd painter in its time. Setting off by boat from here feels like embarking on a journey off the very edge of the world.

The island has been submerged at exceptionally high tides and twice epidemics have virtually wiped out the population. At the start of the Second World War most of its men were mobilized into the army or moved to the mainland to work, but on 22 June 1940 those who remained huddled around a radio to listen to a stirring plea from General Charles de Gaulle urging French men to join him in England and fight to liberate their land from Hitler. To a man they heeded the call and set sail. Within a few days 128 men from Ile de Sein were in England, accounting for a quarter of the volunteers for the 'Free French' at the time. De Gaulle said, 'Ile de Sein is a quarter of France!' and he never forgot them. In 1946 the island was awarded the 'Order of the Liberation', a high honour reserved for those who made the most heroic efforts for the liberation of France. Three hundred people continue to make their living here, a close-knit community, bound together by sea on all sides.

Hopping back from Brittany to another Celtic coastline we arrive in Cornwall, where some people feel their identity to be distinctly separate from the English, with more historic connections to their Breton cousins across the sea.

The Golden Coast: West Country to Wales

In truth it's hard to know exactly who's who: where do you draw the line? Nations are an attempt to consolidate peoples and cultures but the coast is all about how they mix. When the interior of Britain was thickly forested, early Britons on the edge were linked by sea. Cornwall wasn't difficult to get to back then; the Cornish were trading with Europe not long after the stones went onto Stonehenge. As we journey north to Anglesey we'll see how the English connected with the Welsh, united by the Severn Estuary or, as some say round here, Môr Hafren or the 'Severn Sea'.

Amlwch
Anglesey
Lleyn Peninsula
Portmeirion
Bardsey Island
CARDIGAN BAY
Aberystwyth
RIVER SEVERN
SWANSEA
Gower
CARDIFF
BRISTOL
BRISTOL CHANNEL
Ilfracombe
Lundy
NEWQUAY
Torquay
PLYMOUTH
Land's End
Falmouth
Penzance

Cornwall's cutting edge

The southwest tip of England jabs defiantly out into the Atlantic and at the end of it is a hard nail of granite, polished by powerful waves. Imagine standing on the edge of Cornwall and listening to the hiss, feeling the spray hanging in the air as water collides with rock. The granite beneath your feet conceals a secret whose discovery would help propel Europe from the Stone Age into the metals era. The vital ingredient in bronze production is tin, a rare element in world terms, but not in Cornwall where the granite is tin-rich. Bronze is an alloy of copper and tin, harder and more durable than copper alone, and it can be sharpened to a far superior cutting edge. While the Copper Age marks the start of the metals era, copper, it seems, was not widely exploited, and soon after its discovery efforts were made to introduce tin to produce bronze. This advance was of such significance to human development its name defined the Bronze Age.

By about 2000 BC the Bronze Age was under way in Europe and beyond, before it reached these shores. From Greece and the Middle East early entrepreneurs made perilous but profitable sea journeys in search of this precious metal. Herodotus chronicles that tin was imported from the 'outermost reaches of the world'. Returning traders were secretive about its origins, referring only to the 'Tin Islands', which probably meant the northwest coast of Spain and Cornwall. Weapons, tools, armour and jewellery were fashioned from the new metal and most prehistoric pieces that have been discovered in Western Europe contain Cornish tin.

◄◄ Warmed by the setting sun, the rocky cliffs of Lee Bay in Ilfracombe hide a tranquil beach.

Bronze transformed societies, making people more productive and prosperous. As their wealth grew so, it seems, did their desire for arms. Cornwall and west Devon were the hub of the early arms trade, and, by the late Bronze Age, the well-honed bronze sword made with Cornish tin was the warrior's weapon of choice.

By the end of the eighteenth century, some three thousand years later, armies had grown enormously in size, so much so that one of the biggest problems was feeding the soldiers on long campaigns. In 1795 Napoleon I offered a prize to the inventor of a method of preserving food for his 38,000-strong army. Fifteen years later, the prize went to a confectioner, Nicolas Appert, who discovered the principle of sterilization – although he was unable to explain it – by sealing food in glass bottles and immersing them in boiling water. Glass, however, breaks. Appert's ideas were adapted by Englishman Peter Durand who used iron cans, which were easier to make and harder to break. The iron was coated in tin to prevent rust, and thus in 1810 the 'tin can' was born: within a decade the British Navy was using cans by the thousand. Demand for tin was unprecedented and towards the

▲ The scene at Padstow harbour, now a haven for small fishing craft and fish-loving gourmets, was once far less restful as Cornish miners by the thousand emigrated with their skills to Canada.

middle of the nineteenth century Cornwall, far from being the rural haven it is today, was the industry's world leader, boasting some 2,000 tin mines.

Today the visual legacy of Cornwall's industrial golden age, the engine houses and their brick chimneys, are eerie reminders of the steam power that was needed to pump water from the mine shafts, which often ran out under the seabed. The engines that kept the shafts pumped dry and lifted the ore to the surface were the powerhouse behind a global revolution in the mining industry. Richard Trevithick took high-pressure steam engines to the silver mines of Peru in 1816 and soon copies of Cornish engine houses sprang up around the world – and Cornish miners followed. In every decade from 1861 to 1901 Cornwall lost about 20 per cent of its adult male population through emigration, between a quarter and half a million people in total. For a while Padstow, not Bristol, surprisingly, was a major port of

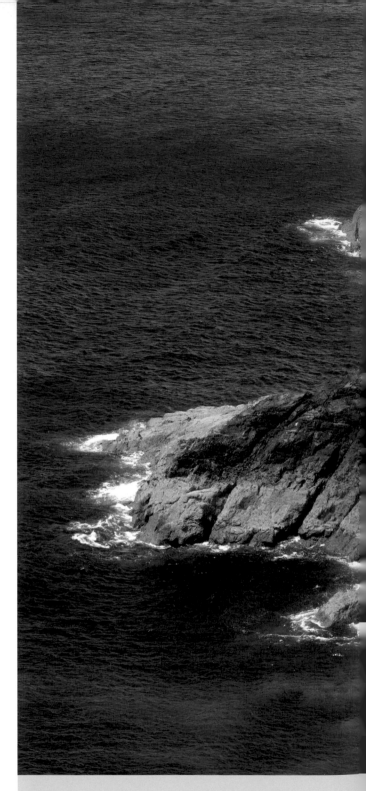

embarkation to Canada, surpassed only by Liverpool and London. The initial exodus led by enterprise was driven by desperation towards the end of the century when the domestic industry went into decline after new reserves were discovered, particularly in Australia.

During the twentieth century the odd attempt was made to revive the Cornish mines but it proved no longer profitable; these days we just don't need as much tin as Bronze Age traders did.

The sea, a highway

Standing on Land's End really does feel like the very edge of our part of the world. Craggy and defiant, Cornwall has withstood the elements throughout the ages and weathered changes in economic fortunes. But for many of us being surrounded by sea feels like a barrier, the end of the line where our roads run out. Perhaps that's because for the most part we've become a nation of land-lubbers, afraid to take to our own little boats. For our ancestors, though, the sea was their highway not just to link them with their near neighbours across the Channel but far, far away, across distant oceans to meet other cultures as well. So as we travel north we'll look over our left shoulder and keep an eye on the water to observe how people have come and gone from this coast for profit and pleasure. Onwards and upwards, or *I fyny fo'r nod* as they say on the north coast of the Severn Sea.

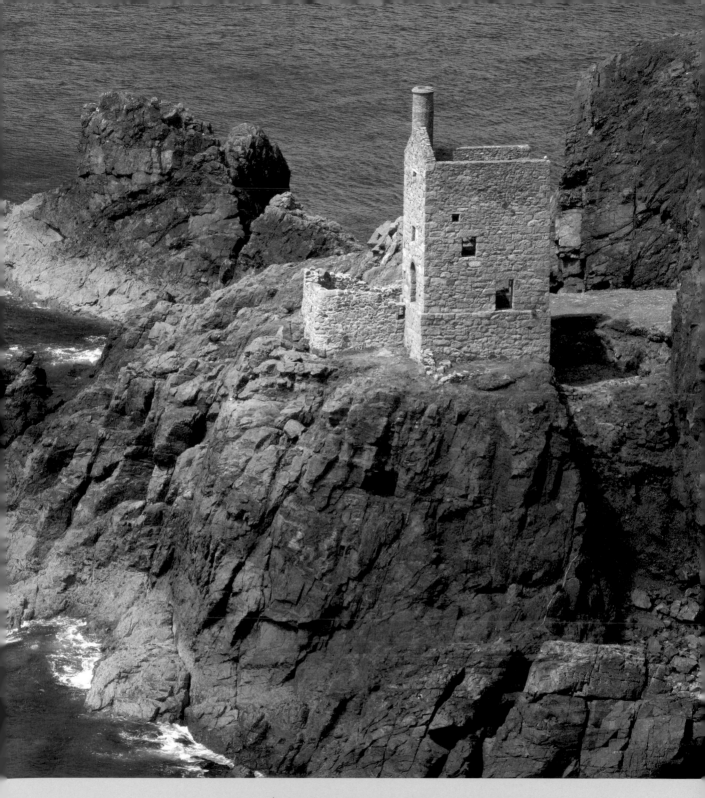

The lonely relics of Cornwall's once thriving tin mines stand as a reminder of our changing industrial emphasis.

Surf, sand and Shell Guides

▲ The chapel-of-ease of St Enodoc is where Sir John Betjeman lies buried. The church itself, accessible only on foot, has half-sunk into the sand that at times threatens to engulf it.

The metal merchants have moved on but Cornwall is still trading on its natural resources. For extreme sports enthusiasts that probably means surf, although the Cornish coast has, of course, for far longer attracted more passive Britons. Mile upon mile of spectacular craggy coves and sandy beaches draw in droves of people and their cars. Back in the days when motoring was still fun, the oil company Shell was busy trying to encourage more leisure drivers and so produced the *Shell County Guides*, a set of travel books aimed at a new generation of car-owners with the freedom to explore. The poet laureate John Betjeman was one of the founding editors of the guides and he wrote one for Cornwall, first published in 1934.

One site you won't find in Betjeman's book is his grave, marked by a simple slate headstone at St Enodoc's near Trebetherick, across the harbour from Padstow. Betjeman loved this diminutive church and considered Cornwall his spiritual home. Many of his poems express his love of the Cornish landscape and in his blank-verse autobiography, *Summoned by Bells*, he captured his boyhood enthusiasm for the shore:

> down towards the sea
> I ran alone, monarch of miles of sand
> Its shining stretches satin smooth and veined.
> I felt beneath bare feet the lugworm casts and
> Walked where only gulls and oystercatchers
> Had stepped before me to the water's edge.

Despite penning that early tourist guide to Cornwall Betjeman wasn't too thrilled with the way the industry developed. He was thankful, he once said, that no one had yet devised a means of building houses on the sea. A few miles out across the water there have been some remarkable developments for nature over the years on the seemingly sleepy island of Lundy.

Just 3½ miles long and about half a mile wide Lundy is a real gem of an island. It's a one-stop shop for wildlife; its waters boast the greatest bio-diversity of any single site on our coast. Lundy was designated England's first statutory Marine Nature Reserve and in 2003 a 'no take zone' was established, restricting fishermen's catches, so now nature runs truly wild underwater. Lobsters appear to love Lundy, and since they've been left alone they've grown bigger: a seven-fold increase in the number of lobsters of catchable size has been reported. They roam around a veritable sea garden, vibrantly adorned with cup corals the colour of sunsets, pink sea fans and sponges. All five species of coral native to the United Kingdom can be found in this one spot, along with over 750 other species of marine life, including dolphins, basking sharks, Atlantic grey seals, orcas and minke whales.

The reason this little underwater paradise exists is because Lundy sits close to the open sea and is bathed in the warm waters of the Gulf Stream, which marine life clearly find preferable to the otherwise chilly Bristol Channel. That doesn't mean, though, the creatures topside have an easy ride: storms regularly batter this rocky outcrop and it takes a hardy breed to survive. Most of the species that thrive on land have had a helping human hand, particularly from one man, the financier Martin Coles Harman. Harman bought Lundy in the mid-1920s and set about making it very much his dominion. It's strange to think such a national treasure could be the plaything of one person but the self-proclaimed king of Lundy was good news for the island's other inhabitants. In 1928, Harman, a keen naturalist, crossed New Forest ponies with a Welsh breed to produce his own Lundy pony and later introduced soay sheep and sika deer.

Although Lundy lies only 11 miles off the mainland it became another world under Harman's control. When the Post Office ended its service on the island Harman started his own (which still operates), complete with puffin stamps. He then got completely carried away and in 1929 minted his own currency, which appropriately enough he called the puffin. Harman's head was depicted on one side of the puffin and half puffin coins, with images of the island's famous birds on the reverse side. The coins were struck in bronze (a nice touch) but saw only limited use before Harman was fined for breach of the Coinage Act, and subsequently the few remaining puffin coins became collector's items. Similarly, Lundy's puffin bird population was almost obliterated – by rats – but with the rodents successfully eradicated from the island the birds are breeding again.

Since 1969 Lundy has been under the ownership of the National Trust and is open to the public. Day-trippers travel to and fro aboard the MS *Oldenburg*, picking up the ferry on the Devon coast at Ilfracombe, a resort town with a difference.

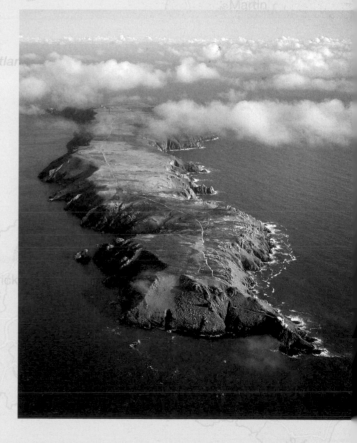

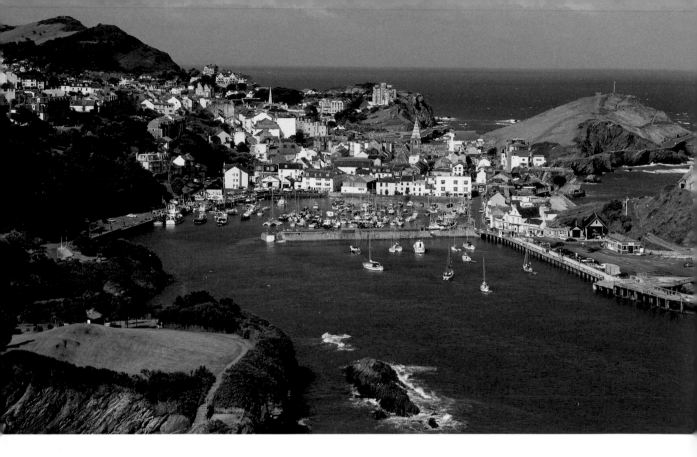

The great divide

Two hundred years ago the seaside holiday we take for granted was still being invented and those early pleasure pioneers faced some formidable challenges. At Ilfracombe their first problem was simply getting to the beach, for the sheltered coves are guarded by high cliffs. In the 1820s the Ilfracombe Sea Bathing Company brought in the experts, Welsh miners, who dug and blasted four tunnels through solid rock; the scars of their efforts still visible in the walls. The passages needed to be wide enough to take a horse and carriage because demure Victorian ladies went to the sea in bathing machines. These wooden huts on wheels were portable changing rooms that deposited the ladies a short distance into the water thus preserving their modesty. Just around a small headland the gentlemen often enjoyed nude bathing; those Victorians were a lot less buttoned up than you might imagine … To prevent any mixing between the sexes a bugler, stationed on the rocks between the two pools, would loudly blow a horn to warn swimmers against straying across the great divide.

▲ Ilfracombe's tourists can still see the four tunnels and pools that transformed the fishing village into a thriving seaside resort, and learn a little Victorian etiquette concerning bathing and boating.

Leaving Ilfracombe, you soon encounter an even more formidable natural barrier that divides land from sea, the Valley of the Rocks and the sea cliffs of Exmoor. Sandwiched perilously between pounding waves below and thin air above is a classic 14-mile climbing route known to purists as the Exmoor Coast Traverse. It was pioneered by Clement Archer who, apparently, had hoped to join the expedition that conquered Everest in 1953. Instead he decided on a sideways challenge, around the edge of Exmoor. The traverse runs from Foreland Point, near Lynmouth, to Combe Martin – nearly three times the distance to the summit of Everest – and takes in 'Great Hangman', which at 1,043 feet is England's highest sea cliff. Archer never managed to complete the challenge and it wasn't until 1978 that another climber, Terry Cheek, and three young police cadets finally conquered the 'Exmoor Traverse'. It took them four days and nights, and no one has since matched their achievement.

Mudhorse fisherman

On the edge of Bridgwater Bay in the Somerset village of Stolford is a family who have gone fishing on the mud for generations. To return with a decent catch the men of the mudflats rely on centuries-old skills and an ancient tool known as the Mudhorse. This is a type of wooden sledge that distributes the weight of a man – and his precious catch – over the soft mud at low tide so that he can move around the slippery flats without sinking. A Mudhorse operates on one manpower; because it has no motor, strong legs are needed to make it glide over the thick treacle of estuary mud to the nets tethered 2 miles from the shore to catch shrimp, sole and skate at high tide. Once the way of life for dozens of fishermen, the uncertain business of Mudhorse fishing is now practised by just one family, the Sellicks.

▲ The simple bisected circle is now an internationally recognized symbol of the efforts of Bristol man Samuel Plimsoll to improve the safe loading of ships.

▲ The Purton Hulks form an eerie testimony to our maritime past: weathered timbers of schooners, barges and Severn trows in their final resting place.

Shipshape and Bristol fashion

Eventually the imposing barrier of the north Devon cliffs give up their grip, and at low tide the shallow water of Bridgwater Bay becomes an expanse of mud. We're nearing the point where the English and Welsh coastlines meet, which in English is called the Severn Estuary; in Welsh it's Môr Hafren, or Severn Sea.

Bristol, and its docks at the mouth of the Severn, has thrived as a hub of international trade for centuries. Twelve million tons of cargo pass through Bristol each year and a son of this great maritime city has left his mark on each one of the ships that dock here and at every other port around the globe. Samuel Plimsoll was the nineteenth-century politician who campaigned tirelessly for safety at sea and succeeded in making it law that all commercial vessels exhibit an international load line, or Plimsoll line as it became known, on the side of the ship to indicate the maximum safe load it could carry. If the water level is above the line when the ship is being loaded it indicates that the load is too heavy and might sink the vessel. The painting of a safety line on a ship was not only sensible but simple, yet it proved bitterly controversial, and it took Plimsoll years to get the measure adopted.

Our story starts with the sinking of the SS *London* in 1866 and the loss of 270 lives. The tragedy caught the public imagination like the *Titanic* of its day. Eye-witness accounts said the ship appeared to be overloaded as it set sail, which wouldn't have been uncommon at the time. Greedy owners deliberately overloaded ships to increase their profits, or claim on the insurance when their overburdened ships sank.

The inquiry into the sinking of the *London* recommended that a simple brush stroke be painted on a ship to mark the maximum safe load it could carry, and this was the cause championed by Plimsoll. Sadly there were too many vested interests and the legislation was repeatedly sabotaged. Some MPs were ship owners or had sympathies with owners; the suspicion was they wanted to maximize profit regardless of the human cost. As the delays dragged on the death toll rose: in 1873–1874 alone 411 ships were known to have sunk around Britain's coasts with hundreds of seamen killed. In 1875 an exasperated Plimsoll finally lost his temper in the House, shaking his fist at Prime Minister Disraeli, and accusing fellow MPs of being 'villains who colluded with murderers outside the House'. Shocked by the upsurge of popular protest, and by cartoons lambasting him in the press, which threatened to bring down his government, Disraeli helped to rush a merchant shipping bill through Parliament, which ultimately led to the Plimsoll line being adopted worldwide. This triumph over greed of ship owners and corruption of politicians made Samuel Plimsoll a national hero: medals were struck in his honour and his face appeared on commemorative plates. It is ironic that we use his name for a type of shoe: apparently because the wearer's feet only get wet if water goes over the line of rubber around the sole.

Incredible hulks

From Bristol we were drawn up river at the suggestion of several viewers who urged us to visit Purton to see the graveyard of the Severn Sea. The Purton Hulks are a magnificent collection of dead ships sprawled for a mile and half along the English side of the estuary. This is not the site of a great maritime disaster: the ships were brought here to prevent erosion by the strong tidal currents. Holes were knocked into their hulls so that the ships silted up and stayed put, as useful in death as they were in life. A local group is actively preserving the remains of these once hard-working hulks as testimony to our great sea-faring past; some may once have roamed far and wide, but others that performed more mundane tasks as ferries connecting England with Wales are not without charm.

THE AUST FERRY

Back in the 1960s the ferry between the villages of Aust and Beachley linked the West Country to South Wales, saving drivers about a 50-mile trip round the Severn Estuary. Now two great ribbons of road glide majestically over the water, but look closely to the side of the first Severn Bridge and you'll still see the remains of the car ramp for the Aust ferry. It's been abandoned since the service stopped in 1966, but once a steady stream of traffic made its way down the ramp at high tide, queuing patiently to be crammed on to a tiny boat, 17 cars at a time. It wasn't the most efficient mode of transport, but there was plenty of time for flirting on board as the English rubbed shoulders with the Welsh.

Waiting for the Aust ferry there was time for one famous passenger to get caught on camera. In May 1966, Bob Dylan had just performed in Bristol on his 'Judas Tour', so called because he'd just gone electric, to the horror of some hard-core folk fans. Dylan had been booed during some gigs and was facing an uncertain reception in Cardiff. It turned out – as I learnt from one of the Welsh sound mixers working on *Coast*, who had a friend there on the night – Bob actually went down a storm.

On his turbulent tour of Britain, the wandering minstrel's quiet moment of contemplation waiting for the Aust ferry is immortalized in the iconic shot used

for the cover of the 2005 Martin Scorsese film *No Direction Home*, which charts Bob's rise to fame. As Dylan was getting wired into a new sound, the times they were a-changin' for the ferry, too. Dominating the background of the photoraph below is the first Severn Bridge just weeks away from completion. Soon Her Majesty the Queen would be meeting the workers who had toiled for 5 years on its construction, with the royal occasion marking a new era of prosperity in prospect for the region – well, for some people at least.

When the bridge opened on 8 September 1966, not everyone was cheering – Enoch Williams, for one, who had operated the ferry since it opened in 1926, was silent. Enoch harboured romantic notions to carry on with his ferry regardless, but it became clear that he couldn't fight the new way of crossing. His boat service stopped the day the ribbon was cut, but all was not lost; Enoch's grandson, Richard Jones, has rescued one of the old ferries and his bitter sweet memories of the birth of the bridge linger on. Richard told us: 'It was a joyous day in some ways because everybody likes a party, but it was also very sad to see my grandfather's lifelong work come to an end. I wouldn't wish to be considered a traitor, but at age 17 the bridge opened up huge new possibilities. So a great feeling of regret, but at the same time that was tempered somewhat by a feeling of new freedom.'

◄ The MV *Balmoral* is a relic of a time when, for some, foreign travel meant a booze cruise between the resorts of South Wales and north Devon.

Going steamin'

A drive over the Severn these days is so often just part of the daily grind; traffic ebbs and flows monotonously over the bridges. For previous generations crossing this same water wasn't a chore but an escape from working life. Welsh coal used to power paddle steamers over the estuary and the miners who rode the boats became adventurers for a day, voyaging between not-too-distant shores. Until the 1970s pubs in Wales were shut on Sundays but different rules applied on the paddle steamers and on the 'foreign' coast of England, so 'steamin'' became slang for boozing. In the Bristol Channel a Sunday service for the pleasure cruisers didn't start until the mid-1920s and when the good residents of Ilfracombe learnt of the plans, letters to the local press expressed concern that the town was set to be invaded by hordes of drunken Welshmen. As it turned out, Sunday sailings were quickly accepted, and residents and holidaymakers in Ilfracombe would visit the pier on a Sunday evening to enjoy the impromptu male-voice choirs that formed on the boats returning to Wales.

High society

As the people of Devon learnt to live in harmony with Sunday-trippers a rather rich man was planning his own extraordinary excursion to the Welsh coast. St Donat's Castle, perched on a promontory overlooking the Bristol Channel, boasts 800 years of history but by the twentieth century countless careless owners had left this medieval pile in need of a little love. Its fortunes were to change spectacularly in 1925 when it attracted an overseas admirer. An early edition of *Country Life* ran an illustrated feature on a 135-room Welsh castle that was down on its luck. The story caught the attention of America's extravagantly wealthy newspaper baron, William Randolph Hearst. Without ever visiting Wales, Hearst purchased St Donat's. It was another three years before he set foot in the place and when he did he turned things upside down, installing 32 bathrooms, a heated swimming pool and three tennis courts. He hired the most expensive architect in the land, Charles Allom, who had refurbished Buckingham Palace for George V. Still Hearst decided the Welsh history of the house wasn't quite grand enough. He bought 18 historic fireplaces from houses around Europe, and incorporated a fourteenth-century ceiling from Bradenstoke Priory in Wiltshire into the roof of a newly constructed party room. Despite concern in Parliament about his 'vandalism' Hearst and his mistress, actress Marion Davies, entertained the Hollywood élite and British high society. The ordinary folk in the Vale of Glamorgan probably enjoyed the stir. But for all the money Hearst lavished on St Donat's, he only spent a few months there. He lost control of his empire during the Depression and sold St Donat's. The world has moved on: the castle is now home to Atlantic College, an international sixth-form college.

The great escape

▲ St Donat's, once the haunt of Hollywood stars, is now home to students who no doubt appreciate the facilities installed by William Randolph Hearst.

Atlantic College may attract students from all over the world, but just a little further down the coast near the vast Merthyr Mawr dune system, one group of visitors came a lot less willingly, and were a little too eager to leave. On Sunday 11 March 1945 a deadly serious game of hide and seek began around the dunes. At the height of the Second World War church bells would only ring to signal invasion but in the final year of the conflict they were sounded in a desperate attempt to warn that there might be Germans at large somewhere on the sand, not trying to invade, but to escape. Soon a massive manhunt was under way; it seemed like every available man and woman had been mobilized, even the local Girl Guides wanted to help.

In 1945, almost a year after the D-Day landings there were about 400,000 prisoners of war being held in camps around Britain, one of which was Island Farm near Bridgend, close to the Merthyr Mawr dunes. The men in hut number 9 at Island Farm weren't content to wait for the end of the war; instead they planned. The prisoners spent time drawing racy images of naked women on the walls to distract the guards from the 60-feet-long tunnel they were digging out under the barbed wire. On a handkerchief they had sketched a map of the Welsh and Irish coasts, while on a shirt tail they made a sketch of the English Channel.

After painstaking preparation 67 German PoWs made a bid to cross the water and head home. Four of them planned to get to an airfield, and they stole a car but it wouldn't start. Remarkably, they managed to convince camp guards coming home from the pub that they were Norwegian engineers, and the guards even gave them a bump start! They got 130 miles to the outskirts of an airport but farm workers found them hiding on the edge of a wood and the game was up. Others made it to Southampton but were recaptured before they could cross the Channel. The waters round our coast, for so long a barricade keeping the Germans out, ultimately formed a stockade holding them in.

The golden coast

If you fancy escaping to the Welsh coast, how about heading for the Gower Peninsula jutting out into the Bristol Channel west of Swansea? It was the first site to be designated an Area of Outstanding Natural Beauty but don't let the showy title put you off, it's 70 square miles of pure joy. The landscape is bold and dramatic, cliffs and caves tempered by long stretches of pristine sand. Over millennia, the ice ages have scrubbed and scraped away at the rock like a series of gigantic spring cleans, which, tens of thousands of years on, still give the place a fresh, sparkling quality. Despite its proximity to Swansea, the Gower is marvellously peaceful and bustling with wildlife. There are rare saltmarsh and dune habitats, and many a fine view from the cliff tops. Clearly our ancestors also favoured the peninsula, for it has over 1,200 archaeological sites of different periods within its limited confines.

You'll find your own favourites on Gower. I love the splendour and sweep of Rhossili Bay, with its 3 miles of beach and the bare, wooden ribs of the *Helvetica*,

▲ Adding a touch of drama to the scene at Rhossili, the ribs of the *Helvetica* protrude from sands. Her fate was not at the hand of wreckers but gales that swept her into the bay's shallow waters.

shipwrecked in 1887, still protruding out of the sands near Rhossili. A defining feature of the bay is Worms Head, a stunning promontory of rock that from the air looks like thin string snaking out to sea. The land bridge connecting it to the mainland is exposed for a few hours depending on the tide, so if you feel fit it's possible to make it all the way out to the end of the Head, and what a place for a picnic! We spotted some people on it when we were doing our aerial filming over the Gower and the shot makes a great image in the title sequence for series IV.

If it's not Gower, it's Pembrokeshire that takes the title of jewel in the Welsh crown, the only one of Britain's 15 National Parks that is almost entirely coastal. It's a great place to relax and I've really enjoyed the times we've spent there before on *Coast*, but on this trip we press on and turn upwards, heading north towards a big bay, one with a mighty big legend.

Legend has it that Cardigan Bay was once home to Cantre'r Gwaelod – the Welsh Atlantis – a mythical kingdom lost to the sea. On a quiet night it is said you can hear bells tolling in the watery deep. Before you dismiss the story as completely fanciful, head for Borth, a few miles up the coast from Aberystwyth, and you'll find huge, ancient tree stumps exposed at low tide. This forest is real enough, for the land used to extend for miles out into what is now Cardigan Bay, and is one more piece of evidence for the massive rises in sea level after the last ice age. Generations of people in these parts observed the sea gradually swallowing up land at Borth, which fed into mythical tales of lost lands under the sea. Dolphins frequently feature in mythology so it's apt that some bottlenose dolphins have made their home above the Welsh Atlantis. Cardigan Bay is one of the few locations in the British Isles with a resident population of these playful mammals.

Mining a mountain

Head north to the end of the Lleyn Peninsula and the island of Anglesey hoves into view. It's the RAF Search and Rescue Service HQ, covering the Irish Sea and Snowdonia National Park. Their coastal base at RAF Valley is shared with a very special flying school, where top RAF recruits learn how to handle fast jets. The airfield was established in 1941 to bolster the defence of Liverpool against the Luftwaffe.

Trainee pilots practising their low flying above Anglesey could be forgiven for not taking their eyes off the controls long enough to take in Amlwch, described in 1748 by a Welsh mapmaker as 'an insignificant harbour that is not worth mapping'. But some 20 years on that harbour became one of the most important ports in Wales owing to Parys Mountain, which overlooks Amlwch. The mountain is rich in copper ore, a fact not lost on Bronze Age miners, but it wasn't until 1768 that a major discovery was made and Amlwch's role changed dramatically. Suddenly, this little port was serving the largest copper mine in the

world and was required to transport thousands of tons of copper ore to the rest of the world. The rocky cargo was hauled around the Welsh coast to the smelters of Swansea, which dominated the metal trade. Copper was greatly in demand as it was used to coat the bottom of boats, and fashioned into buckles, buttons and coins.

By 1880, and one monumental hole later, the mining of copper from Parys Mountain was no longer economically viable and operations were suspended – or perhaps they are simply on hold. The vivid colours of rock revealed by over a century of gouging are an indication that other deposits lie undiscovered, not only copper, but lead, zinc, even a sprinkling of gold and silver. A time may come when demand for the precious metals buried behind the coast of Anglesey will see miners return to the mountain. We started this leg of our journey round the British Isles with the tin mines of Cornwall and now pause for breath at the copper mines of Wales. Tin and copper – now, if we mixed those together we could make bronze! Just before we end, though, there's another little gem of a place that you simply cannot ignore: Portmeirion, featured overleaf.

PORTMEIRION

When *The Prisoner* was first transmitted on ITV in 1967 I was too young to appreciate what was going on. Watching the repeats of the early 70s, my mates and I rediscovered this cult classic, only to realize by the end that the late Patrick McGoohan, the star and co-creator of the series, didn't seem to understand what was going on either. The final episodes couldn't deliver on the malevolent, surreal promise of the beginning: as McGoohan awoke in a strange seaside village, he wasn't happy to find his name had been changed to a number (6), and if he tried to leave a huge white ball chased him along the beach and smothered him. That ball terrified me as much as McGoohan's prison kingdom intrigued me. It was years later that I learnt

it was not a film set but an actual place. The home of *The Prisoner* is Portmeirion, nestling incongruously on the Lleyn Peninsula, and those boyhood memories make it one of my *Coast* favourites.

How did such a beautiful, colourful resort come to be built in North Wales? Well, it is located on land that was owned by the Clough Williams-Ellis family. Bertram Clough Williams-Ellis, the designer and owner of Portmeirion, was a flamboyant individual who wanted to prove that it was possible to build houses without defiling the natural beauty of the environment. Here was an architect, largely self-taught, with the money and talent to realize his dream.

Portmeirion first opened in 1926 but dwellings were added each year until 1939. It is scarcely Welsh in character; its pastel-coloured houses have an Italianate flavour with balconies, columns and fountains. Several of them were salvaged from demolition sites, explaining Clough's description of the place as 'a home for fallen buildings'. He was a master of architectural illusion, using a variety of construction tricks to make the place seem bigger than it actually is, archways to suggest grandeur, slanting buildings to give the illusion of height, even graduating shades of paint to play with perspective. During the second phase of construction, 1954–72, Clough concentrated on the finishing touches; he was 90 when it was finally complete. He earned the praise of American architect Frank Lloyd Wright, who visited Portmeirion in 1956 and shared its creator's Welsh heritage and concern for the environment.

Work on the estate was still ongoing as *The Prisoner* was being filmed, and the architect and actor became friends. That must have been a real meeting of minds: *The Prisoner* famously asserts, 'I'm not a number, I'm a free man,' and Clough certainly made the most of his creative freedom at Portmeirion. We do love to build strange stuff around our shores but rarely does it have the vision and drama of this Mediterranean fantasy made concrete reality on the Welsh coast.

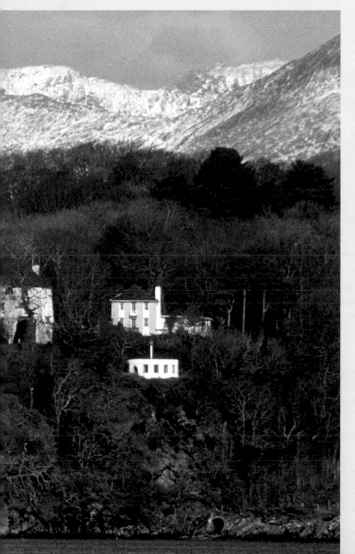

▲ Sir Clough Williams-Ellis was as distinctive as his village, patrolling the estate and directing work wearing trademark plus-fours and yellow socks.

◄ Framed by Snowdonia and the sea, Portmeirion looks dramatically different. Its creator's motto was: 'Cherish the Past, Adorn the Present, Construct for the Future.' Did Sir Clough deliver his dream for you?

Britain and Ireland sit so snugly together it might have been a marriage made in heaven but the match turned sour; instead Ireland sought a long-distance suitor across the Atlantic, forming a romantic attachment to America. On this leg of our journey we'll explore those close connections over an ocean, and turbulent times between Britain and Ireland.

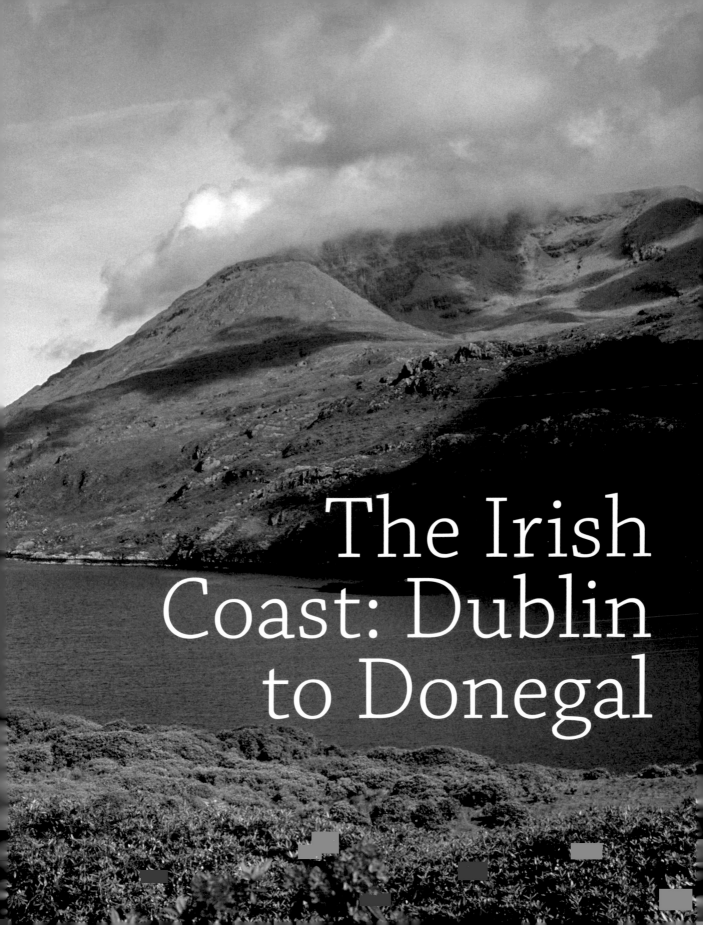

The Irish Coast: Dublin to Donegal

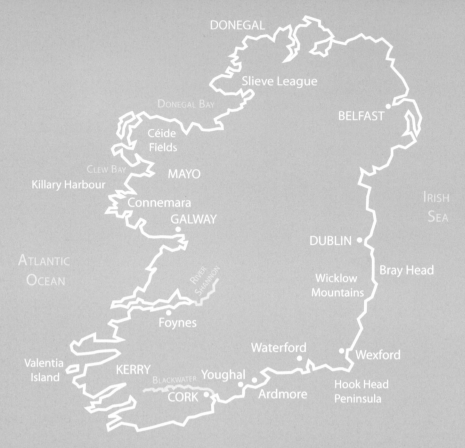

DONEGAL

Slieve League

DONEGAL BAY

BELFAST

Céide Fields

CLEW BAY

MAYO

Killary Harbour

IRISH SEA

Connemara

GALWAY

ATLANTIC OCEAN

DUBLIN •

RIVER SHANNON

Bray Head

Wicklow Mountains

Foynes

Valentia Island

KERRY

Waterford

Wexford

BLACKWATER

Youghal

Hook Head Peninsula

CORK •

Ardmore

We are heading for Donegal on the northwest coast of Ireland, to stand on big, bold, beautiful cliffs and breathe in Atlantic air. Before then, though, we've some glorious landscape to explore and thousands of years of history to experience. This is the story of an island told in reverse because we are working our way backwards in time towards to a surprisingly idyllic beginning, acknowledging along the way the pain of a people in crisis and the ecstasy of individual achievement. We'll embark on a tragic voyage, take the first flight across the Atlantic, follow in the footsteps of invaders, but we start in Ireland's capital city.

◀◀ Killary harbour, known as Ireland's only fjord, forms part of the border between Galway and Mayo.

The black brew

Dublin is one of the world's great coastal cities. It was founded by the Vikings around AD 840 and they didn't just come as raiders, they set up here as traders. The lake where the Vikings moored their boats was called Duhn – or Dubh – Linn, which in Irish literally means 'black pool'. As the English moved in Dubh Linn became anglicized to Dublin. So the city was named after a black pool but it was the 'black stuff' that some 900 years later helped drive the expansion of the docks. I'm sure the Vikings, shrewd traders and robust boozers, would have approved of the export that would put their port on the global map: Guinness.

Arthur Guinness established the St James's Gate Brewery in Dublin in 1759 and, with an eye on the export market, soon after started brewing porter, so called because of its popularity with market porters in London. This fairly new beer developed a distinctive dark colour from the roasted barley used in its brewing process. Dublin's coastal location meant the company was ideally placed to exploit their product's popularity

and within a decade Guinness Extra Strong Porter was being exported to England. The first shipment was only six and a half barrels but it created a thirst for more. By 1914, after changing the name to stout and adopting the famous harp trademark, the trickle had become a flood and the Dublin brewery was producing over 3 million barrels of the black stuff a year.

Leaving the bay

It was fortunate that the beer buoyed up the export trade because Ireland struggled to sell manufactured goods abroad, but agriculture was another important moneyspinner; every day shipments of cattle left Dublin's port for English farms and slaughterhouses. The vitality and value of a port can be measured by more than money, however; it's not just commodities that are carried across the sea, there is also a sense of culture and national identity. Another major export from Dublin was people; tens of thousands of emigrants said their goodbyes to Ireland with a passage out of the city in the eighteenth century. For many, the destination was America: a recent survey

▲ Dublin is synonymous with Guinness. As early as 1914 the 'black stuff' was transported down the Liffey for export to markets as far afield as America, Australia, the Far East and Africa.

of US citizens revealed that 35 million people identify their origins as Irish. As we journey around the coast we'll see why so many felt compelled to leave and discover how an influx of invaders determined the destiny of this island on the edge of the Atlantic.

As the emigrants embarked on their epic ocean voyages, among their last sights of the old country were the massive Bull Walls, which jut far out into the sea to prevent Dublin's shipping channel from silting up. The southern Bull Wall, at over 4 miles long, was the first to be constructed; the northern one was a later addition, completed in 1824 following a survey undertaken by none other than Captain William Bligh of mutiny-on-the-Bounty fame. The shifting sands of Dublin's harbour may be a pain for shipping but they're a great pleasure for locals. It's said that the capital's beaches are its best-kept secret, but not far away there's a beach with a secret of its own.

An earth-moving experience

At the south end of Dublin Bay is Killiney Hill, home to Ireland's rich and famous: Bono, The Edge, Enya and Van Morrison are among those who've lived on this exclusive little lump with great coastal views. These celebrities would surely be recognized if they went for a walk on nearby Killiney Beach, whereas few people have heard of Robert Mallet, a Dublin man, born in 1810. He is known as the father of seismology, a term he coined to describe the study of earthquakes, a discipline he initiated with a ground-breaking experiment on this stretch of sand. After graduating in science and maths from Dublin's Trinity College, Mallet joined the family foundry business but it wasn't enough to occupy his enquiring mind. He set himself the daunting task of trying to explain something that at the time was a complete mystery: why do earthquakes occur and how does their devastating energy travel through the ground? The trouble with tremors is they're very unpredictable, so Mallet decided to create his own earthquake on Killiney Beach.

In the autumn of 1849 he hired a group of workmen to bury 25 pounds of gunpowder at one end of the beach. Precisely half a mile off, Mallet was positioned with home-made apparatus that projected an image of cross-hairs on to a pool of mercury, which he viewed through a separate microscope to record and time the energy released by his 'earthquake-explosion'

▼ Ireland is not a seismic epicentre, but it was on the gentle gradient of Dublin Bay's Killiney Beach that a Victorian civil engineer, Robert Mallet, undertook blasting experiments as part of his research into earthquakes.

Bray Head is a formidable rock barrier, formed where the Wicklow Mountains meet the sea, which prevented progress of the railway down the coast from Dublin. Since it opened in 1855 generations of engineers re-routed the line around this headland but the first to conquer this colossal outcrop was Isambard Kingdom Brunel. Not a man to be put off by a bit of geology, the master builder tunnelled through granite cliffs and crossed deep gorges in order to complete the Dublin–Wicklow line through, not round, Bray Head. We asked railway engineer Michael Barry to comment on Brunel's solution. He called it 'heroic engineering'. The granite is not only extremely hard but also unstable. Even today it would be a really difficult engineering job.

Brunel's elegant bridges spanning the chasms gave passengers an all too real sensation that there was little between them and the sea below. The journey was more like a rollercoaster than a railway and inevitably thrills led to spills. On 23 April 1865 the first-class carriage of the Dublin train left the rails and teetered on the edge of the viaduct 100 feet above sea level. Somehow the driver kept his nerve and pushed on, pulling the carriages back from the brink. Two years later two passengers died and another twenty were injured when three carriages left the rails and fell from one of the bridges. At times it seemed the coast was trying to shrug off Brunel's constraining band of steel, and Bray Head's unstable rock slid on to the tracks so often that the company began selling it to contractors laying Dublin's roads. The elements also took their toll: sea as well as storm damage made the railway so expensive to maintain that some people called it 'Brunel's Folly'. Over the years the line has been stabilized by changes to the route but much of the original remains so you can judge the achievement yourself.

that would register as ripples in the surface of the liquid metal. And it worked: the results were the first step on the journey that revealed how tremors travel as waves through the earth. From these explosive beginnings Robert Mallet attempted to map the distribution and intensity of the world's known earthquakes. By visiting disaster sites and examining records he came within a whisker of a discovery that would take over a century to realize fully – that the crust of the earth is made up of constantly shifting plates and it's their movement that causes earthquakes. The germ of what we now call plate tectonics was formed on Ireland's coast at Killiney Beach.

South of Dublin, beyond Brunel's railway destination at Wicklow, people have largely left the southeast coast alone, free to indulge in a wild embrace with the sea, for the landscape here doesn't lend itself to development, it's soft, crumbly sediment left over from the age when ice sheets covered much of the country. Leaving the invasion of Curracloe Beach to the movie-makers (see page 77), we approach Wexford, where a more peaceful influx takes place every year, just north of the harbour on the wetland known as the Wexford Slobs.

In from the cold

'Slaba' or slob is Irish for 'muddy land' and for the past thirty years or more some 500 acres of protected 'slobland' have become a wildlife reserve. Every year as the big chill grips Greenland, white-fronted geese head 1,800 miles south for the Wexford Slobs, a relatively balmy frost-free marshland, to munch on the vegetation. During winter the grasses store their nutrients deep down in the stem, ready to fuel a spurt of growth come spring, and it's this foodstore the birds are after. The geese dig deep to stock up on energy; they must have poor digestive systems because as they shovel in green stuff at one end, waste regularly exits at the other – every 3 minutes, I'm told. Despite this somewhat antisocial behaviour, scientists studying the birds have discovered the geese pair up and stick together for years: it must be comforting to have a travelling companion on their great migrations south to feed and then north again to breed.

White-fronted geese don't have it all to themselves. Wexford is like an international avian airport with in

excess of 200 species flying into the Slobland after covering huge distances, because this special site is essential for their survival. Some 3,500 Brent geese come from the high Arctic wastes of Canada, whooper swans, snipe and golden plover make the short-haul from Iceland, and wigeon check in from Siberia. This is why the marsh habitat at Wexford is protected: migratory birds are very loyal to particular places for their winter fuel and their numbers have been declining as the wetlands they depend on have been drained for agriculture; what's wasteland to some is precious to others.

The Wexford cots

Whoever wishes to master Wexford's harbour must do battle with a constant natural foe. As the tide ebbs the entire estuary is filled with continuously shifting ridges of sand. Deep-drafted ocean-going vessels cannot cope with the perils of the sandbanks but one very ancient type of boat can: the Wexford cot. Flat-bottomed and traditionally with a pointed bow and stern, this boat is unique to the area. That flat bottom

▲ The Wexford Slobs is an important site for wild birds that arrive in their thousands to eat their way through winter.

means the cot can cope in depths of just 6 inches of water, drifting on and off the sandbanks with ease. These traditional craft have no keel so there's nothing to get stuck in the mud and they are built using the age-old 'clinker' construction, favoured by those fearsome raiders and canny traders the Vikings (whose home we visit in due course), in which the hull is formed of overlapping planks, which makes the boats flexible with a shallow draft.

Around AD 800 it was again those men from the frozen north who took a shine to Wexford's wide, shallow harbour and – along with so many of the estuaries down Ireland's southeast coast – the Norsemen invited themselves in and stayed for a few hundred years. To another infamous invader though, Oliver Cromwell, Wexford was just one more conquest on his campaign to subjugate the Irish Catholics who had sided with the Royalists during the English Civil War. In 1649 Cromwell's New Model Army

SHOOTING PRIVATE RYAN

Even Hollywood productions with cash to splash scout around the world looking for the right location at the right price, which is why the visceral opening sequence to Steven Spielberg's *Saving Private Ryan* was shot on the east coast of Ireland. The first half hour of the film is a stunning re-creation of the American assault on Omaha Beach during the D-Day landings in 1944. In 1997 the beach at Curracloe in County Wexford stood in for the sands of Normandy. Curracloe's geography is a fair match and the Irish government sent representatives to London to lobby the film's producers with the offer of support from the army and the office of public works. Over a thousand Irish troops were drafted in as extras with hotels, guest houses and private property offering to house cast and crew. It took a month after filming to return the beach to normal, so now no sign of the fictional invasion remains.

began a bloody march through Ireland that would last three years before victory was secured, but at appalling cost: some 600,000 Irish were killed or exiled, around one-third of the country's population. Catholic ownership of land fell from 60 per cent to around 8 per cent as Protestant Scots and English were settled on the land. Cromwell went on to rule over the country as 'Lord Protector' until his death. It's little wonder that his brutal adventure across the Irish Sea still resonates as a dreadful, discordant note in the relationship between Ireland and Britain.

Light fantastic

Thirty miles down the coast from Wexford Harbour is the long Hook Head Peninsula, and there is neat suggestion that the saying, 'by hook or by crook', which has made its way into common usage, has its origins here, owing to the decision facing any invaders attempting to take the town of Waterford either by Hook, on the east of the estuary, or by Crook, a village on the west side. Unlikely as that may be, at

the southern tip of the Head the stories of invasion and conquest continue, with another tale of turbulent times between the British and Irish. You might expect a fortress to mark the spot; in fact it's a lighthouse that stands as testimony to foreign invaders on the make. According to the guidebooks, Hook Head is perhaps the oldest operational lighthouse in the world. Historian and author Billy Colfer believes it dates back 800 years, but it has an even older story of conflict to tell. Inside, this substantial structure is built like a castle but that's not for fighting, it's because for five hundred years the fuel for the light was coal, so the stone ceilings and walls are fireproofing features; if you have a big blaze on top of your building you don't want wooden floors. This costly venture was built for business by a newcomer to Ireland, a man intent on protecting merchant ships coming into the port he was developing near by at Ross.

Hook Head lighthouse was the brainchild of William Marshal, an English knight who had powerful connections; his father-in-law was Richard 'Strongbow' de Clare who, around 1170, landed with a Norman army on Irish soil just beyond the

lighthouse at Baginbun and Bannow Bay. Strongbow was descended from the Norman knights who settled in Wales, so in a way this was a Welsh–French invasion of Ireland. Ironically, they weren't really invaders at all; they were invited in by the Irish King of Leinster who wanted them to throw their weight behind him in a local power struggle. It seems these Norman mercenaries liked what they saw and decided to settle; they went on to dominate Irish history for centuries.

Like the Vikings we progress down the coast in search of opportunities to land and just like those master mariners we can't resist a stop at Waterford, where they established their first settlement around AD 850. More recently the city has become synonymous with glass. Waterford craftsfolk have been in the business on and off for over two hundred years, and they know how to make crystal clear. The clarity of their glass is enhanced by adding small amounts of lead oxide to make it sparkle and it also allows the crystal to be worked over a longer temperature range, giving the blowers a little longer to work their magic. However much it sparkles, though, the industry has struggled with the ebb and flow of fashion; we haven't always prized glass as highly as the Vikings did: Waterford Museum's famous Kite Brooch was a cloak fastener that was very much part of Viking haute couture when it was made a thousand years ago – those glass beads were treated like diamonds. Its discovery demonstrates the degree to which Vikings had been assimilated in this part of Ireland.

➤ The Waterford Kite Brooch is Ireland's finest piece of metalwork, dating from the early twelfth century. Its ornate gold filigree and coloured glass suggest Scandinavian and other foreign elements along with the hallmarks of the Irish tradition.

◄ It takes time and patience to go the length of the Hook Head Peninsula but it's worth it to see perhaps the oldest working lighthouse in the world.

Ireland's Pompeii

The true extent of the Norsemen's presence in Waterford has only been revealed fairly recently after archaeologists uncovered a Viking settlement at Woodstown about 5 miles from the city. Such is the historical significance it has been dubbed 'Ireland's Pompeii'. The site is close to the River Suir and it's believed some 120 Viking longships would have used the waterway, which gave them ready access upriver to the rich lands and monasteries of the surrounding valleys. Thousands of artefacts have been discovered here, including a sword and a spear from a warrior's grave, but these people weren't hit-and-run raiders – they came to do business. Among the finds is a collection of weights used by the Vikings to weigh silver when buying and selling goods. To me, the most surprising treasure that's been unearthed is a fragment of an Arabic coin, which suggests the Norsemen's boats were taking them out to the Middle East and we'll discover more about the remarkable extent of Viking trade routes when we venture to Norway in Chapter 7. There's a fine irony here, for the Woodstown site, which tells us so much about the importance of waterways as 'motorways' for our ancestors, was only revealed because of work on a bypass around Waterford; tarmac is what transports us now.

Standing stones

Heading west from Waterford our route is punctuated by a 100-foot-high exclamation mark, one of the best examples of Ireland's famous and mysterious round towers. Ireland has about sixty of these elegant structures; you'll also find three in Scotland and one on the Isle of Man. The tower at Ardmore dates from the twelfth century and, intriguingly, over the years people have managed to forget why they were built.

The most popular explanation is that these towers were bolt-holes for priests. True, you could spy out Vikings or other raiders from the top, and because the door was about a dozen feet up from ground level it's possible to imagine people using a ladder to get in and then pulling the ladder up after them so they were safe from attackers. There are problems with this explanation, though, because many of the towers don't have views that would give early warning and the ladders wouldn't actually fit inside the second level of the structure. Also it's likely the bad guys would have just set fire to the wooden door and, with the tower acting as a terrific chimney, the defenders would have been toasted.It's more likely that this was a bell tower for the church.

The tower is silent now, and the harbour is quieter too, but in its heyday this was a busy fishing village, until boats became too big for the inlet. This story is familiar to neighbouring Youghal; a walled seaport that has been designated an Irish 'Heritage Port', making it a popular tourist destination. Youghal is used to foreign visitors, for one of its notable admirers was Sir Walter Raleigh who was made mayor of the town in 1588 for his part in putting down a rebellion in the area. Despite turbulent times, trade thrived and by the seventeenth century Youghal had blossomed into one of Ireland's main ports. Before ships outgrew its shallow harbour it was far more important than Cork; how times changed.

◄ The sandstone tower at Ardmore stands in the centre of an old monastic site.

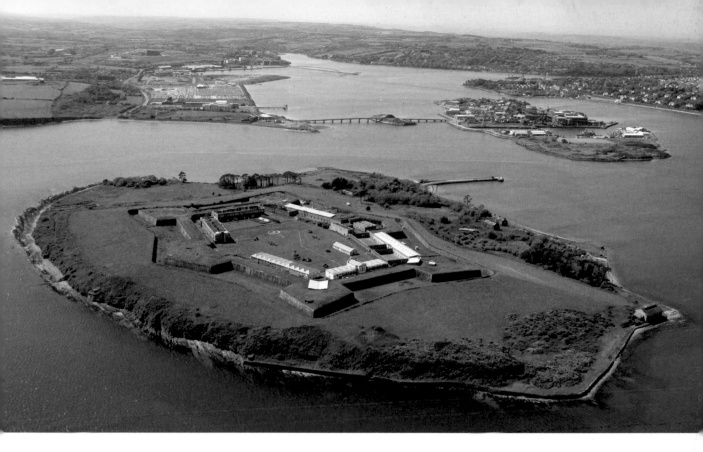

Irish exodus

Although Cork's harbour is one of the world's largest it has a more intimate feel because it's essentially split into two, upper and lower, by Great Island seated in the centre of this vast inlet. There are a number of smaller isles dotted around, some are real gems – like Fota Island with its nature reserve where giraffe, zebra and kangaroo are among the animals that roam free – whereas others are not: Spike Island lives up to its ominous name, a lump of misery in this bay of beauty. Spike Island has the look of a prison camp and its fortress was indeed used to hold male convicts in transit to Van Diemen's Land (now Tasmania) in the nineteenth century, and it also housed IRA prisoners during the war of independence before the establishment of the Irish Free State in 1922.

More happily, the harbour is home to the Royal Cork Yacht Club, founded in 1720, which makes it the oldest in the world. The club's headquarters has moved several times over the centuries before anchoring itself in Cross Haven, on the west side of Cork Harbour. It

was established when the notion of sailing for pure pleasure was still novel, a pastime popularized by Charles II on his return to the throne in 1660 from exile in the Netherlands. Away from the austerity of Cromwell's England Charles had picked up the new-fangled fashion for yachting. The Royal Cork Yacht Club stays true to its roots, emphasizing the simple joy of sailing; it might be old but it isn't stuffy, for every two years tens of thousands of people gather here to take part in the regatta known the world over as Cork Week.

The impressive meeting of land and sea makes Cork Harbour a natural amphitheatre and on this beautiful stage the most bitter tragedy in Irish history was played out as great ships conveyed desperate souls far away from the Emerald Isle. At the south tip of Great Island is the historic harbour town of Cobh, which was the major embarkation point for the flight from the Potato Famine. Between 1848 and 1950 a staggering 2.5 million people, hungry for a better life, left Ireland from this small seaport.

Human misery is rarely captured in the clinical numbers that itemize a disaster but such is the scale of the Famine that the figures do tell a story that otherwise beggars belief. The 1841 census put the population of Ireland at over 8 million (about half that of England and Wales); by 1926 the number of people in Ireland had collapsed to a historic low of little over 4 million. Imagine half the population of a country dying or leaving in a period of about eighty years. It's perhaps only when we put it into context – think of your road with every other house empty – that we can begin to understand the devastating effect of this famine on Ireland and how it coloured its relationship with Britain and the New World.

In the first half of the nineteenth century the Industrial Revolution and the expansion of the Irish linen industry saw the population rise to that peak of 8 million. Good farming land was scarce and the people relied on the potato because it was an intensive crop, meaning a high yield from a small area. In 1845 a fungal disease called *Phytophthora infestans*, or potato blight, wiped out a third of the crop in Ireland. This agricultural disaster was compounded by a worse failure in 1846 and further losses in subsequent years. The Irish people were starving to death and there was a general feeling that Britain did little to alleviate this humanitarian catastrophe. The economy was crippled for generations and it burnt a sense of British injustice into the national psyche, an inflamed feeling that was also carried across the Atlantic by the millions fleeing the famine who embarked at Cobh Harbour. From its peak in the middle of the nineteenth century the Irish exodus abated but the port remained a lucrative stop for the great transatlantic liners, and one of those calling was about to become the most famous ship in history: in 1912 *Titanic* stopped by.

➤ In a global beauty contest for gorgeous harbours, Cork would certainly be a natural contender for the crown.

RMS Titanic comes to town

Titanic was built at the Harland & Wolff shipyard in Belfast. The city had developed into the industrial powerhouse of Ireland in the nineteenth century and came to rival Glasgow as the major shipbuilding centre in the British Isles. Before the Great War, White Star Line and Cunard shipping companies were competing for Atlantic passenger trade, ordering ever bigger and faster liners. In 1906 Cunard launched their luxury liner the *Lusitania* from John Brown shipyard on the Clyde; *Titanic* was the White Star Line's response. She was over 900 feet long and, at 175 feet above the slipway, the tallest structure in Belfast. At her launch in May 1911 *Titanic* was the biggest man-made object ever to move across the face of the earth. After fitting, she was ready for her maiden voyage. She set sail from Southampton on 10 April 1912, making a short hop to Cherbourg to pick up more passengers, before steaming into the Atlantic toward New York, and her last port of call was

Cork. On 11 April a crowd gathered outside the White Star Line's ticket office in Cobh to see the celebriity liner. On board was a young local man, photographer and theology student Frank Browne. His uncle and guardian had paid for Frank to travel on the *Titanic*, first class from Southampton to Cork, but no further.

Seven people disembarked, a bitterly disappointed Frank among them. On board he had met a wealthy American couple who had offered to pay his passage to New York. He had telegraphed his Jesuit superior, requesting leave. The reply was terse and unequivocal: 'get off that ship', signed 'Principal'. Some 123 people did join the doomed ship at Cobh. Watching the *Titanic* leave Frank Browne recorded her farewell with his camera, images that made the front page of newspapers worldwide, their haunting power doing much to illuminate the legend of that tragic liner.

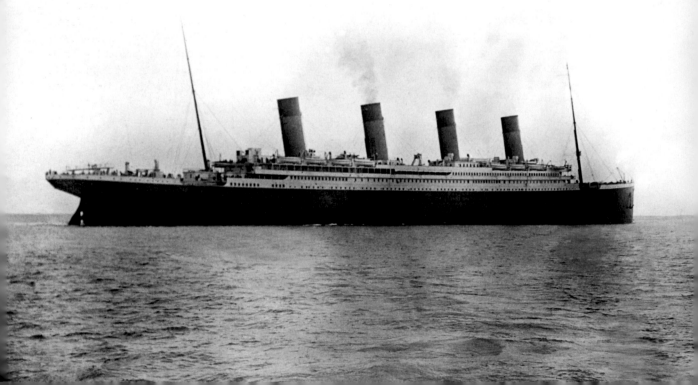

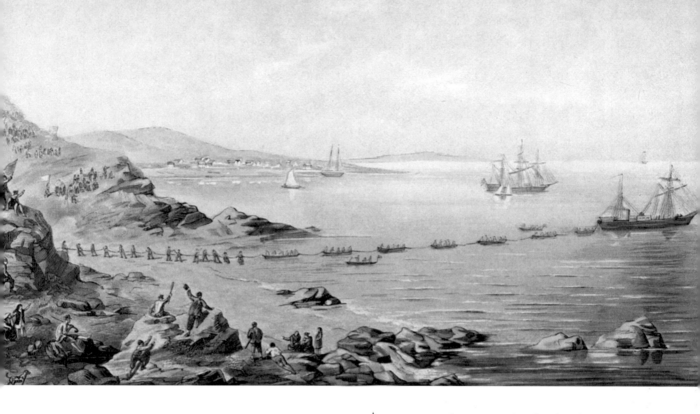

Wired and wireless

The big boats that crossed the Atlantic weren't the only way the Irish and the Americans made connections from coast to coast. In the summer of 1858 a headline in *The Times* signalled a remarkable development in communication between the USA and the British Isles: 'The Atlantic is dried up, and we become in reality as well as in wish one country.' Meanwhile there were 100 gun salutes in Boston and New York and church bells rang out, all because the first telegraph message was sent between the Old World and the New. It was a monumental achievement: 2,500-miles of telegraph cable had been laid under the Atlantic Ocean, from Heart's Content on the east coast of Newfoundland to Valentia Island in the southwest corner of County Kerry. The feat was not without frustration. At the first attempt, in 1857, the wire broke after 350 miles; another year later two ships met in the middle of the ocean then headed off in opposite directions, paying out cable as they went, and twice the cable snapped forcing them back to the beginning until finally in 1858 – success!

▲ Connecting the coasts of Ireland and America by cable was dubbed the Eighth Wonder of the World.

Celebrations, though, were short-lived, because the messages were weak and getting weaker. Engineers argued over the best solution, but the wrong man had his hands on the apparatus and tried to rectify the problem by blasting the cable with thousands of volts, causing the wire to burn out. A Board of Trade inquiry followed and blame was batted back and forth, without result. Ultimately the only option was to lay a new cable, but it would have to wait until America stopped tearing itself apart in the Civil War of 1861–5.

The same year the first cable failed, the salvation of the project was being pushed by huge hydraulic rams into the Thames; on its launch the SS *Great Eastern* was easily the largest ship ever built at a whopping 693 feet in length. The stress of building this monster took a fearsome toll on its creator Isambard Kingdom Brunel; before her maiden voyage he suffered a stroke and died. Although she was conceived as an ocean-going passenger liner Brunel correctly predicted his ship could also be the solution to laying

WIRELESS MEN

In 1901 Guglielmo Marconi (below left) dispatched the first radio message across the Atlantic from his transmitter at Poldhu in Cornwall. In order to create a commercial service in 1907 he chose Clifden on the Connemara coast to minimize the distance, and beefed up the signal considerably by using a

horizontal directional aerial, for which Poldhu proved unsuitable. Derrygimla, the peat bog that almost finished off Alcock and Brown, provided fuel for the Marconi station. Electrical generators charged up a massive capacitor made from 288 metal sheets, each 60 foot x 20 foot wide and set about 6 inches apart. This apparatus occupied most of the transmitter building and could provide a 15,000-volt spark, which gave enough oomph to be picked up in Nova Scotia.

Marconi also began installing his wireless system on ships to transmit messages in Morse code and training men to operate his gear. John George 'Jack' Phillips (right) was one who attended the Marconi Company's Wireless Telegraphy Training College, ending up at the Clifden station in 1908. In March 1912 he landed a prime posting – Jack was on his way to Belfast to join RMS *Titanic*. He did not survive.

the transatlantic cable. The *Great Eastern* could easily carry the 2,500 miles of wire on her own, unlike the previous attempts, which had required two ships, each with half the length of wire, meeting in mid-ocean. Even with a redesigned stronger cable and Brunel's leviathan paying it out across the Atlantic, the attempt in 1865 was also a failure when the wire snapped, and it was another year before America was connected again to Ireland. For Cyrus W. Field, the American merchant who had championed the cable from the start, ten years of struggle were over. When Field was asked for his reaction he said, 'I left the room, I went to my cabin, I locked the door; I could no longer restrain my tears – crying like a child.'

Magnificent men

One could hardly describe the Americans and Irish as near neighbours but reaching out to bridge that great divide is a theme that's repeatedly echoed as you journey up Ireland's west coast. The Shannon is one of the country's great rivers and, as one would expect, its estuary is a busy shipping lane. More surprising is

that this same stretch of water was also an important 'runway' for early transatlantic flights. Flying boats pioneered commercial passenger traffic over the oceans, and it was from the small town of Foynes on the south bank of the Shannon that these majestic liners of the air launched themselves towards North America.

Flying over the ocean posed formidable challenges to 1930s aviators. Early aircraft engines were unreliable, navigation over featureless water was difficult, and then there were unpredictable storms to battle against. Also, back then, long concrete runways were a rarity at coastal airports around the Atlantic, so for maximum flexibility it seemed prudent to use a combination of plane and boat that could take off from the sea and also land on water in case of emergency. In 1937 Boeing won the competition to build a transatlantic plane for Pan American Airways: the result was the legendary B-314 flying boat, which remained the largest commercial plane to fly until it was eclipsed by jumbo jets some thirty years later. Each amphibious giant cost more than half a million dollars, which bought a range of 3,500 miles and the capacity to carry as many as 74 passengers in double-decker comfort.

On 26 March 1939 the Pan American B-314 *Yankee Clipper* made its first trial flight across the Atlantic from Baltimore, Maryland, to Foynes, and three months on, Pan Am inaugurated the world's first transatlantic service, each passenger paying a whopping $375 for a one-way trip across the ocean. This quiet little town on the Shannon estuary found itself the focal point for air traffic over the North Atlantic until services were severely disrupted by the Second World War and rapid advances in aviation soon made the magnificent flying boats obsolete. In 1945 a DC-4 flew from New York on to the runway of the new airport at Rineanna, the Irish name for Shannon International, and the brief era of the luxury seaplane was over.

▼ The sky – and the sea – seemed the limit for the magificent seaplanes that crossed the Atlantic but sadly those glory days were short lived.

Heading north, another landmark in the history of flight soon comes into view – and what a sight the little town of Clifden must have been for Captain John Alcock and Lieutenant Arthur Whitten Brown. On 15 June 1919, after 1,900 miles and over 15 hours, the two British flyers were about to land in a bog beyond Clifden to complete the first non-stop transatlantic flight. When they left St John's in Newfoundland they had been heading for Galway but, having climbed on the wings to clear ice from the engines, and flown blind through fog, the hills of Connemara convinced them they'd reached Ireland. As they circled, looking for a landing spot, they flew over the Marconi Wireless station near Clifden, where the first commercial transatlantic radio message service had started in 1907. When the operators came out waving, the pair didn't realize the message they were

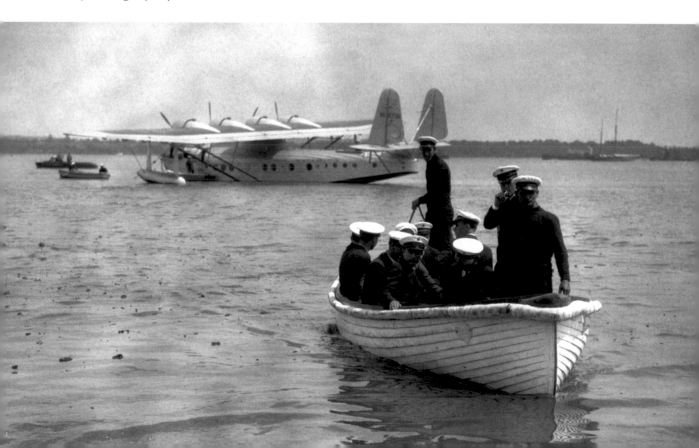

trying to transmit was that their plane was heading straight toward dangerous swamp on Derrygimla Moor. Fortunately, their seatbelts held the heroes in safely and they survived the wet landing, received a £10,000 prize from the *Daily Mail* for their record-breaking flight, and soon after were knighted by George V.

You don't need a plane to get a great aerial view of Clew Bay in County Mayo. Instead, climb the 2,500-foot 'holy mountain', Croagh Patrick, which is an important site of pilgrimage for Catholics. Reaching the peak is an act of penance so some make the ascent barefoot, even on their knees. From the top of the mountain you can try to count the number of islands in Clew Bay; the locals may tell you there are 365 but at high tide the figure is more likely a third of that number, although more appear as the water level drops. These islands

are sunken drumlins, whale-shaped hills formed by glacial action, and evidence that great ice sheets once covered the north of Ireland. Back then, Ireland, Britain and Europe were one big land mass with no separating seas and people moved freely, populating the region as the big freeze began a rapid retreat.

Around 10,000 years ago, as the ice melted and sea level rose, Ireland started its own isolated adventure as an island. Initially settlers clung to the coast, for its rich supply of food suited hunter–gatherers living by their wits, but there came a time when there was a change of people and a change of plan. Fortunately for us, the Irish peat has preserved their handiwork.

▼ The view of Clew Bay from Croagh Patrick takes your breath away, a fitting reward after the climb.

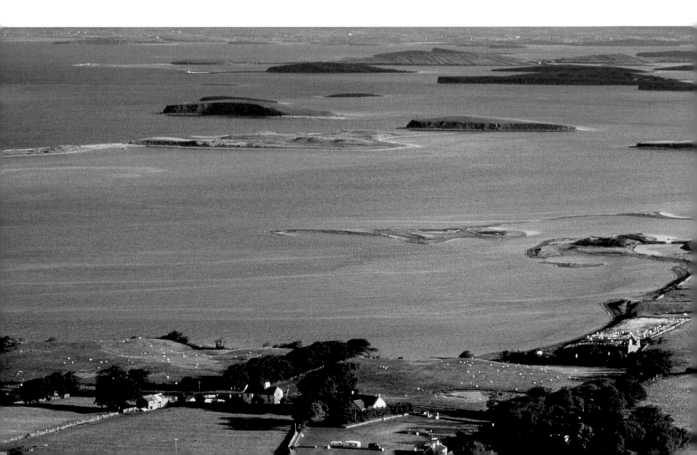

Ireland's first farmers

Head west along County Mayo's North Coast Road to where spectacularly serrated cliffs drop vertically into the sea. The horizontal strata of limestone and shale exposed in this cliff face gives it the appearance of a huge layer cake, and the icing on top of this cake contains a very sweet secret. The cliff landscape is smeared with a thick topping of peat bog, and back in the 1930s when a local schoolteacher, Patrick Caulfield, was cutting peat for fuel he was struck by how often he hit stones buried deep under the turf. What perplexed him was the stones were in regular piles – someone must have purposely arranged them and they could only have done so before the peat bog formed on top, which meant those stones were placed there a very long time ago. The mystery remained for forty years until Patrick's son Seamus, a trained archaeologist, discovered the secret of the regular piles of rocks.

The stones turned out to be walls that once marked out the fields of ancient farms, tombs and the foundations of houses, homes so old they were abandoned before the pyramids were built. Buried under several square miles of the Céide Fields bog are hundreds of Stone Age farms that were once home to as many as a thousand people. Parallel field walls over a mile long run inland from the coast, and are subdivided into plots that could sustain an extended family of herders and farmers. This neolithic site is over 5,000 years old and shows the transition from a society of hunter–gatherers to herders and cultivators capable of organized, widescale management of the land. Farming had spread from the Middle East and was probably brought to Ireland by people from Britain and Europe arriving in boats with their cattle. They came, they saw, they settled, displacing or assimilating the original hunter–gatherers.

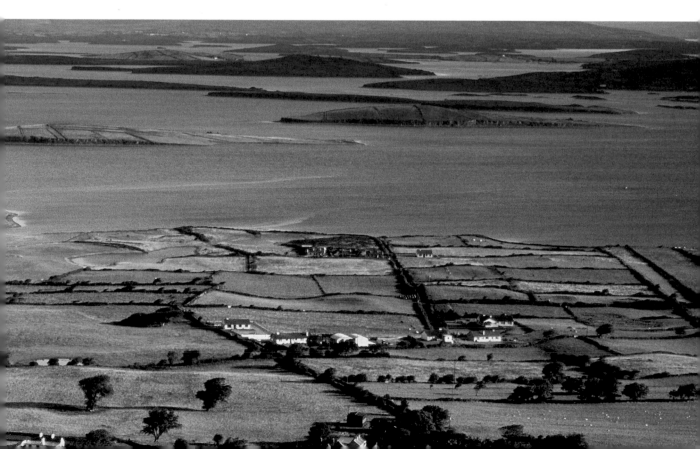

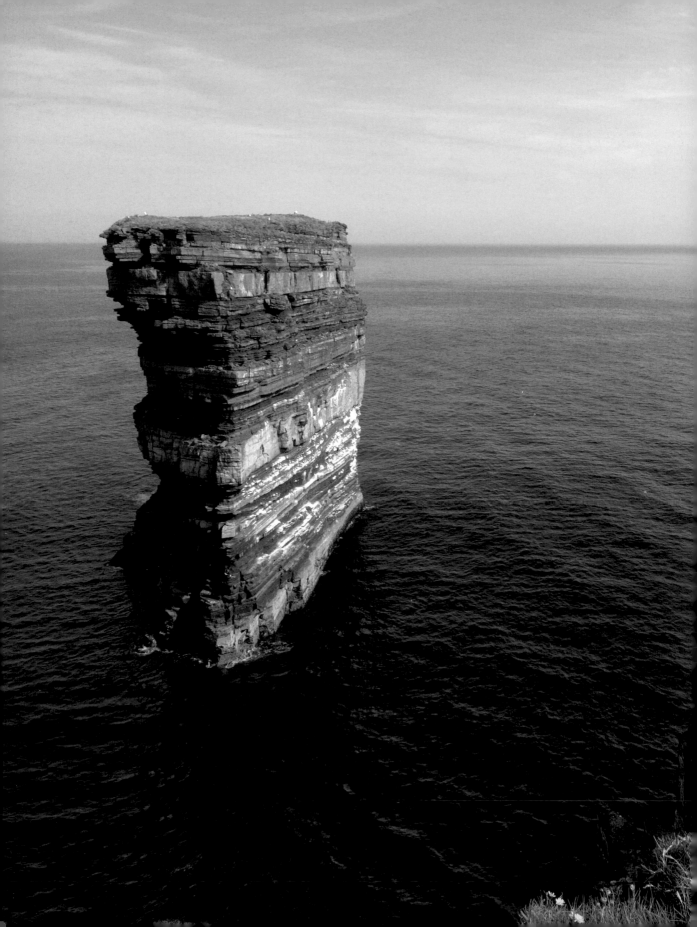

It's ironic that the progressive lifestyles of the early farmers at the Céide Fields may have led to the demise of their settlement because as they cleared the primeval oak and pine forests they exposed the soil to more rainfall, which could have created the conditions for the wetland to grow, eventually forcing them from their homes. Whether the blame lies with their landscape engineering or a change in climate, the bog that buried the site also preserved it, affording us a unique insight into the complex and ingenious lifestyles of our ancestors. One of the most interesting things to note is what hasn't been found at the Céide Fields: there is no sign of defensive walls so it would appear these people didn't fear attack; in fact the evidence that's been unearthed suggests Ireland's first farmers were a peaceful bunch, living harmonious rather idyllic lives, at least until the bog came and it was time to move on.

Travelling around to the south coast of Donegal Bay we end our Irish odyssey on the spectacular Slieve League sea cliffs, but don't look down unless you've got a head for heights: it's a giddying 2,000-feet sheer drop to the Atlantic. Instead, look south across the fine surf of Donegal Bay for a glimpse of the Céide cliffs and a reminder of the site where the birth of farming in Ireland is preserved under the turf. On our journey we've seen how over the millennia those early settlers have mingled with waves of invaders and traders, and we've witnessed the struggle of their offspring to survive when the crops failed. From this vantage point on the highest sea cliffs in Europe we can look west; as did desperate souls in their thousands, two hundred generations after their ancestors became farmers, forced by famine to abandon their fields for a new world across the water. In a simple turn of your head the history of a nation is told by the view from its coast.

◄ Doonbristy is the 160-foot sea stack sliced so neatly off the layer cake of Downpatrick Head in County Mayo, but for some of our earliest ancestors the top of these heights was home. What a view.

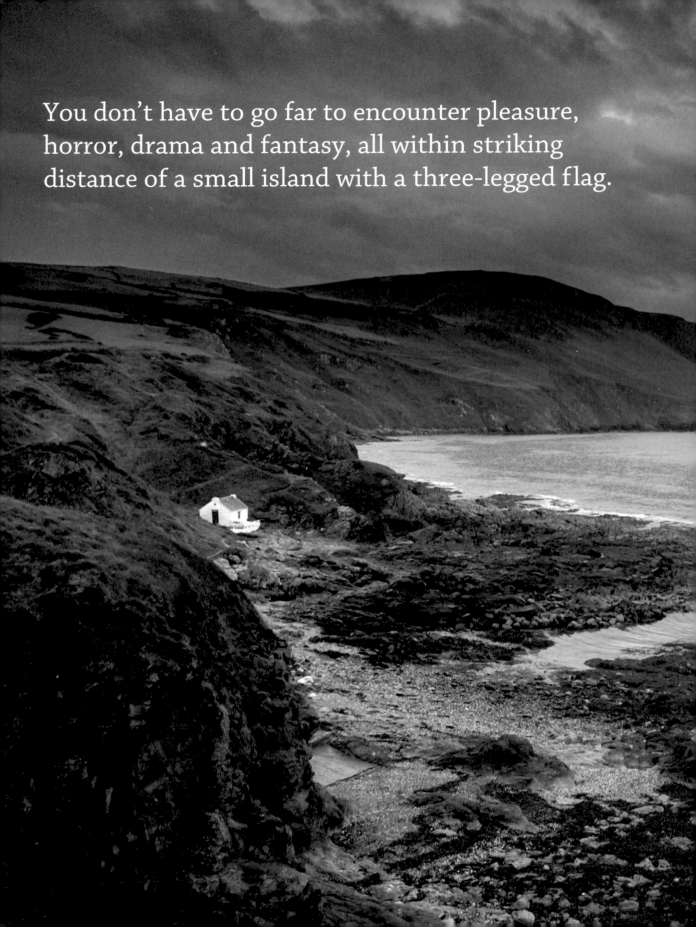

You don't have to go far to encounter pleasure, horror, drama and fantasy, all within striking distance of a small island with a three-legged flag.

The Irish Sea Coast: Where Nations Meet

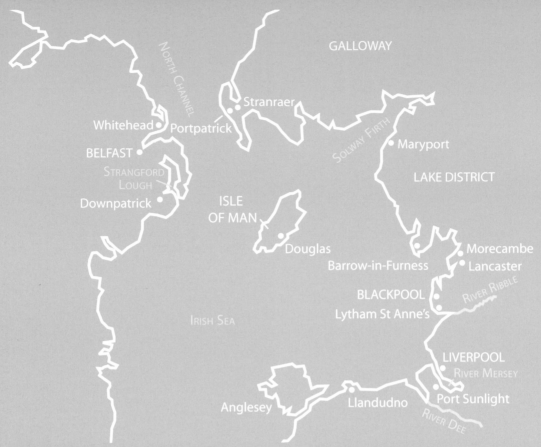

GALLOWAY

NORTH CHANNEL

Stranraer

Whitehead Portpatrick

SOLWAY FIRTH

BELFAST
Maryport

STRANGFORD LOUGH
LAKE DISTRICT

Downpatrick
ISLE OF MAN

Douglas
Morecambe

Barrow-in-Furness Lancaster

BLACKPOOL RIVER RIBBLE

IRISH SEA Lytham St Anne's

LIVERPOOL
RIVER MERSEY

Anglesey Llandudno Port Sunlight

RIVER DEE

Coast receives a stream of enquiries from people wanting to make their own circumnavigation of Britain. Often their plan is to do sections at a time and complete the entire trip over many years. My advice is to allow longer than you think and while I'm sure you think it takes a long time, believe me, it takes a lot longer. Our roads are mostly built to get us to the coast rather than travel along it, and it's faster to fly to the west coast of America than to reach some isolated parts of our own shores. So, how about a short cut, a *smörgåsbord* of coastal treats from all the countries of the United Kingdom in one whirl around the Irish Sea?

◄◄ A nineteenth-century fishermen's cottage with a view of a dramatic stormfront at Niarbyl Bay, on the Isle of Man.

Independent at heart

The Isle of Man is the geographical heart of the British Isles and the coastlines of its mainland neighbours virtually enclose it within the Irish Sea. Lying roughly equidistant from England, Scotland, Northern Ireland and Wales the island has managed to maintain its independence from them all. It's not part of the UK or the European Union but it's a dependency of the British crown. The Government is made up of 24 elected representatives of the House of Keys, which performs a similar function to the House of Commons, and a 9-member Legislative Council, whose role is akin to the House of Lords. Together these bodies form the High Court of Tynwald, which has the authority to pass laws subject to royal assent; laws passed in Westminster only affect the Isle of Man if they are adopted by Tynwald. So, that's the legal stuff, but it's important because Tynwald, founded in AD 979, is perhaps the oldest parliamentary system in the world – a clue to the mind-set of the people on this small island, just 32 miles long and up to 15 miles wide, surrounded by more powerful neighbours who have never managed to subdue the independent Manx spirit.

Expressions of national pride and identity come in many forms, and it is fitting that the islanders adopted something circular, so where better to start our wheel around the core of the UK than with an actual one? The Laxey Water Wheel was built in 1854 to pump water from the shafts of the Laxey zinc and lead mines on the east of the island. The structure was named 'Lady Isabella' after the wife of the island's Lieutenant Governor, one assumes because of its elegant beauty rather than its size. The islanders claim that it's the largest surviving metal water wheel of its kind in the world. There's a sense of the grand statement here; it isn't only the scale of the wheel that impresses, it's handsomely mounted too, suggesting it was designed to do more than merely power pumps. 'Isabella' was constructed by Manx engineer John Casement who used the natural fall of the streams to power the wheel. *Coast* archaeologist Mark Horton was part of a team that excavated around the site in 1985 to reveal its buried industrial heritage. Mark tells me that the Great Wheel only ever achieved a fraction of its projected power. But it was spectacularly successful in its other objective and – like the London Eye some 150 years later – was an immediate hit with the people and remains

one of the island's most popular attractions ever. All that imposing theatrical construction was as much about instilling investor confidence as shifting water; the workings could have been boxed in and hidden away, but instead it stands in all its over-engineered glory, exuding the confidence of the new industrial age and entrepreneurial pride of the island's people, their famous three-legged symbol adorning the brickwork.

In fact you'll find those legs everywhere: on the flag, on the money, looking like the crooked spokes of a wheel. The triskelion (from the Greek for 'three-legged') emblem chosen to represent the island is one of the oldest symbols known to be used by humans. When we visited the Isle of Man, 'Butch' Buttery – fisherman, chef and Manxman through and through – told us the three legs are an ancient Norse symbol. It appears on the island's coat of arms with the inscription '*Quocunque jeceris stabit*': it means 'whichever way you throw me, I will stand'. In Norse mythology the triskelion represented the

▲ The gaping mouth of the basking shark makes the fish look pretty dangerous but in fact it is simply filtering plankton, small fish and invertebrates.

Haven for smugglers and sharks

As our coastal waters warm in summer, basking sharks move up the British coastline, following the Gulf Stream, from Cornwall as far north as the Western Isles of Scotland, and the Isle of Man is a global hotspot for sighting them. The best months to see them are June and July. You can watch out for them from the shore but if you're in a boat and lucky enough to get up close to them you'll be stunned by their size: a full-grown adult can be as big as a bus and weigh twice as much as an elephant. Watch for their characteristic lazy zigzag movement through the water as the sharks follow a line of plankton, hoovering in as much as they can. It takes an awful lot of those tiny creatures to satisfy these enormous fish. And they'll go to remarkable lengths to get a feed: sharks that visit the Isle of Man have been tagged and found to travel over 6,000 miles across the Atlantic, en route to the coast of Newfoundland, and diving at times more than half a mile deep, following the concentrations of plankton.

Las Vegas of the North

movement of the sun through the heavens – a fitting choice of emblem for an island located at the hub of a circle of surrounding countries.

The resourcefulness and independence of the Manx people have enabled them to set their tax rates lower than in the UK, which is vital for the health of an economy that has few natural resources beyond fish. Lower rates of duty than the mainland made the island a smugglers' paradise in the past, goods being unloaded here free of tax then shipped in secret across the Irish Sea into Britain. This system was so effective even ocean-going ships began to sell direct to the Manx people, their wholesale contraband including wine, brandy, coffee and tea. Strong beer brewed on the island and intended for sale to ships bound for the New World also found its way to the mainland, much to the annoyance of customs officials who complained of loss of revenue. And if all this skulduggery doesn't make the island sound dangerous and romantic enough it's also surrounded by sharks.

Like the sharks circling the Isle of Man we are making our tour of the coastlines around the Irish Sea, taking in every country of the United Kingdom before returning to the Isle of Man for a story about the start of an institution vital to the entire British coast. On our journey to the mainland we'll be following the 60-mile route of a wire running just over 3 feet under the seabed. This wire is almost a foot wide and heavily armoured because it carries electricity. Although the Isle of Man generates some power the Subsea Interconnector is their link to the National Grid. Apparently, when tides are exceptionally low, you might catch sight of the cable on the beach just north of Blackpool – what a great place to wash up. I'll admit it, I'm biased, having spent family holidays there and a good many day trips, Blackpool

is the seaside to me. Like generations before us we always travelled by train, eyes glued on the horizon as we approached: first one to see the Tower, shout!

Blackpool has certainly not been immune to the struggle for survival faced by many resorts in the last few decades, but the gaudy old dame of the Fylde coast has fared better than most. Blackpool claims it's the most popular resort not just in Britain but Europe. Perhaps a key to its success is keeping landmarks like the Tower, which give the town a strong identity and character; you might not like it but at least you know what it is. Back in 1885 Blackpool opened an electric tramway along the promenade – the first of its kind in the country – and it was an early adopter of electric lighting. The affectionate epithet 'Las Vegas of the North' has more than a ring of truth, especially at the Pleasure Beach. Inspiration for the Beach came from a visit to Coney Island in New York by William George Bean back in the 1890s. He returned to Blackpool to build an American-style amusement park, his fundamental principle being to make adults feel like children again. But maybe the town's greatest innovation and certainly my favourite is the transformation of the entire seafront

▲ Blackpool has continually imported winning ideas from around the world to attract visitors. How fitting that its motto is 'Progress'.

into a shining spectacle of light. Over 100 years ago, Blackpool created a novel way of extending its season by two months and putting itself memorably on the tourist map: the Illuminations stretch for almost 6 miles and shine for 66 nights every year attracting over 3.5 million visitors as summer memories fade in the autumn chill. Now that's what I call a guiding light.

Sinking sands

Brash Blackpool's northern neighbour Morecambe has traditionally relied on more refined attractions than thrilling rides and glittering lights. The renovation of its Art Deco-inspired Midland Hotel is an attempt to re-create the town's former glory. Although The Midland was built during the Great Depression of the 1930s, its modernist architecture and continental staff helped to attract the urbane, international holidaymaker. The hotel looks out toward the town's major attraction,

Morecambe Bay's 120 square miles of glorious shifting sands, one of the great natural wonders of the North, and the largest expanse of intertidal mudflats and sand in the country. The beauty of the Bay belies its danger; it is said that spring and flood tides can flow in as fast as a horse can run, and quicksands can trap the unwary who then drown as the tide rises.

Despite the risks, for centuries people have walked across Morecambe Bay. Before the railway, it was the main route to and from the Furness Peninsula: royally appointed guides had operated in the Bay since the sixteenth century and before them the job was performed by monks from the Cartmel Priory. The difficulty of traversing the Bay added to the isolation of the land north of Morecambe; the old coach service linking Lancaster to Kendal also used the perilous short cut over the sand and several coaches either sunk or were overtaken by the incoming tide. A memorial in Cartmel churchyard to 140 victims of the sands recalls how nature can be treacherous.

Big in Barrow

Round the great sweep of Morecambe Bay there's something else big. The Royal Navy's first submarine was built in Barrow-in-Furness in 1901 and this Cumbrian seaport is now designated a submarine centre of excellence. Back in the 60s the shipyard made the Polaris class, Britain's first submarines to carry nuclear missiles, followed in the 80s by Trident. Recently, Barrow has been working on the SSN Astute Class Attack Submarines, powered by nuclear energy and equipped with torpedoes and cruise missiles. Their reactors create enough energy to supply a city the size of Southampton. Houses near the yard are dwarfed by the subs' enormous shells, which are made using modular construction methods, with the living quarters, cabins and control deck slotted into the hull of the boats as complete units.

Cocklers at Morecambe Bay race against time and the tide. The loss of 21 Chinese cockle-pickers in 2004 is a stark reminder of the danger of this work.

The Duddon Estuary

At the end of a very long day making the first series of *Coast* I was travelling with Nick Crane and the crew. We had one more stop before supper and my thoughts were firmly focused on a steak pie, not the landscape of Lancashire. We parked up and started yet another tramp with heavy gear through bushy scrub. Suddenly we emerged to a sight so jaw-droppingly beautiful we all fell silent, work forgotten, film equipment abandoned. We walked over virgin yellow sand, gazing in the distance at the blue mountains stretched across the horizon. We had reached the Lake District and the romantic splendour of Wordsworth Country, and Nick was inspired to recite from the poet's 32nd sonnet:

but in radiant progress toward the Deep,
Where mightiest rivers into powerless sleep
sink, and forget their nature – now expands
Majestic Duddon, over smooth flat sands
Gliding in silence with unfettered sweep!

Wordsworth wrote 34 sonnets trying to express how he felt about the Duddon Estuary, and hearing Nick speak on that late summer evening perfectly captured the mood – and made me wish I'd paid more attention to poetry at school. Wordsworth traced the river in words, from source to sea, from birth to death; for him the Duddon Estuary was the 'only place to approach the Lakes'.

Looming over the estuary is the 2,000 foot peak of Black Combe, where the Lake District National Park meets the sea. That peak has been a mariner's landmark as long as there have been people around to need one. The Lakes are not famous for their coastal scenery but from the top of Black Combe in clear weather I can guarantee you a spectacular vista, to the south the long finger of the Duddon Estuary, beyond it the shining sweep of Morecambe Bay and – if you're lucky – a wee peek at the Isle of Man.

THE WICKER MAN

On this part of the Scottish coast there are many tales of tussles between Christians and Pagans; some may be legend, others pure fiction. Galloway is famous as a location for a legendary cult film, *The Wicker Man* (1973). A wicker man is an effigy used by the ancient Gauls in human sacrifice. The film tells the story of a fervently Christian policeman, played by Edward Woodward, who is burnt to death in *The Wicker Man* by Christopher Lee and his followers. The action was supposedly set in the Outer Hebrides, but shooting in the islands must have been a ferry ride too far for a low-budget British horror. Instead the film makers came to Galloway, testimony to the unspoilt and dramatic nature of this coast. The area has become so inextricably linked with this classic film that its name has been used for an annual music and arts event – the Wickerman Festival is Galloway's Glastonbury.

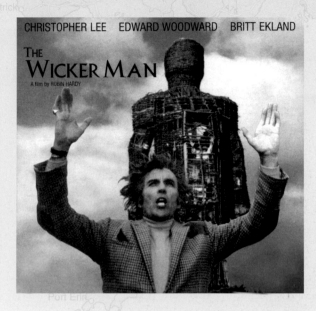

CHRISTOPHER LEE EDWARD WOODWARD BRITT EKLAND

THE WICKER MAN

A film by ROBIN HARDY

Scotland in our sights

Up the Cumbrian coast toward Wordsworth's 'hoary peaks', we approach the Solway Firth. It's a massive natural barrier of water that now forms part of the border between England and Scotland, but before those nations existed this was the edge of the Roman Empire. Two thousand years ago the Romans established a major defensive settlement at Maryport. This Roman fort was part of one of the ancient world's most ambitious defence frontiers and acted as a command and supply base for smaller forts that reinforced the defensive line of the coast, stretching 25 miles up the Solway Firth to where it connected with Hadrian's Wall. The settlement that developed at Maryport was believed to have been occupied by the Romans for 300 years. A geophysical survey has revealed the layout of houses, a workshop and granaries to meet the needs of up to a thousand soldiers and their families. The town was abandoned in AD 410, when the army was recalled to defend Rome against the Barbarians.

Christians and pagans

So that's what the Romans did for this part of Scotland but let's not forget the Vikings. A thousand years ago Norsemen ruled the nearby Isle of Man and their influence still reverberates around the surrounding shores. Crosscanonby Church, north of Maryport, has a Viking gravecover and a cross-shaft in its graveyard, which points not so much to invasion as settlement. A living legacy of the Vikings is an ancient form of fishing that is still practised on the mudflats of the Solway Estuary. The haaf-net fishermen walk out on to the mud and wait for the tide to come in right up to their chests. As the water level rises they lean against their haaf, or heave nets, which resemble portable tennis nets on a rigid rectangular frame. The nets are held at right angles to the flow with the hope that incoming salmon or sea trout will be trapped in the mesh. A wooden club or mell is used to kill the catch, then the fisherman uses a wooden needle to thread a rope through its gills and ties it to his waist.

The Gobbins Cliff Path

Until the 1880s Whitehead, in County Antrim, was an isolated village with little to recommend it but great sea views. Then along came the railway, putting it within easy reach of the centre of Belfast and the eye of the developers. Before long Whitehead offered the refined pleasures of a typical Victorian resort but with a remarkable twist. In 1902 Berkeley Deane Wise, the railway magnate who brought the train to Whitehead, realized there was money to be made on this rocky coastline. He opened a crazy cliff path around the nearby Gobbins rocks. Like the great piers that the Victorians loved so much, the Gobbins Cliff Path allowed tourists literally to walk over water. It was a heart-stopping traverse around more than 2 miles of sheer cliff face, just a few feet above wild seas.

In order to construct this ambitious path, steps were cut into the rock, and bridges built in the Belfast shipyards were transported to Whitehead on sea barges and hoisted into place. There was a suspension bridge and a wonderful tubular construction that ran out from the mainland to an isolated pillar of rock in the sea. The railway company advertised the Gobbins path as 'a walk with ravines, caves and natural aquariums that has no parallel in Europe' and the public agreed. It was an instant hit with the well-to-do and the working classes alike and an even bigger draw than the Giant's Causeway. But sadly their fascination faded; the path was shut down during the Second World War because the railway didn't have the staff to maintain it. Although it opened again in 1951 it fell into disrepair and it was closed again in 1961. But perhaps not for good: there are plans to restore it, and I hope the publicity the Gobbins Cliff Path gains from *Coast* might play some part in renewing interest in it, not just for its sheer impudence at making something from nothing but for the exhilaration of walking over the water of the North Channel.

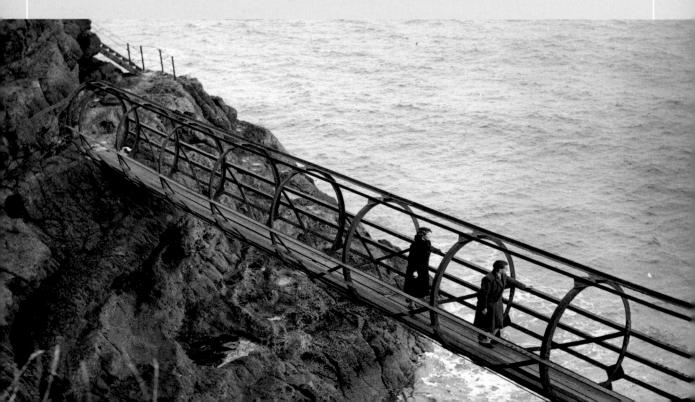

Something similar to haaf fishing might well have been a familiar sight for the holy man who founded a church on the Scottish side of the shore at the mouth of the Solway, hoping to convert Picts to Christianity. Early Christian scholars record that Galloway-born Ninian, later St Ninian, came to Whithorn around AD 397 and founded the first Christian church north of Hadrian's Wall. Five miles from Whithorn Priory is a small cave right on the coast, to which pilgrims bent their footsteps because tradition has it that St Ninian used to go there to mull over his thoughts. Such a remote, windswept stretch of coastline might seem an unlikely spot to try to establish Christianity in Scotland, but 1,600 years ago this bit of Galloway was buzzing – a crossroads for traders on the route between Britain, Ireland and out to Europe.

The people of Galloway may have been pagans but they were very open to new ideas. The tip of Galloway affords a view of Northern Ireland just 22 miles across a narrow strip of sea known as the North Channel. Portpatrick is almost as far west as you can go in southern Scotland but its pretty little harbour ceded to Stranraer as the main ferry port for the trip across to Ireland as the size of ships increased. In turn Stranraer is losing services to a ferry port just north of Cairnryan, which now links the Galloway traveller with Larne.

Gateway to Northern Ireland

The ferry traffic into Larne makes it a bustling gateway to Northern Ireland. If you head north on the A2 you're at the start of what's prosaically known as the Antrim Coast Road. This stretch was designed by the engineer and architect Charles Lanyon in the 1830s. Thanks to his skills it has a good claim to be one of Europe's most scenic coastal highways; no other road in the United Kingdom hugs the coast quite like this as

it winds round rocky headlands for 23 glorious miles to Cushendun. But we're heading south, continuing our circuit around the Irish Sea, following the A2 down to Whitehead, not in search of road but a path, a promenade over the sea like no other I've encountered, the Gobbins Cliff Path. Our *Coast* favourite (opposite) shows you just how remarkable that walkway was.

The wild inlet

Heading south on our circuit, we reach the UK's biggest sea inlet. Strangford Lough is about a third the size of the Isle of Man, with 150 miles of its own twisting shoreline, but it's water, not land. A narrow pinch in the coast connects the Lough to the sea and fierce currents surging through the bottleneck bring 450 million cubic yards of water into the Lough with every tide. That mighty flood of energy made it the ideal spot for the installation of a tidal turbine. When it began operation in 2008 the Strangford turbine was the world's biggest of its type, generating enough electricity to power a thousand homes. If tidal energy can be reconciled with its potential impact on wildlife and the technical challenges overcome, the various schemes under consideration round our coast could generate 10 per cent or more of our electricity needs – a prospect that promises a bonanza for the companies that can bring tidal power to the people. Surely if Isambard Kingdom Brunel were alive today he'd be hatching a few hydro schemes, although this particular coastline probably wasn't his favourite because it was a few miles further south that his pride and joy ran aground.

The SS *Great Britain*, the world's first propeller-driven steam-powered iron ship, rests dry-docked in Bristol where she was built, but in September 1846 Brunel's magnificent vessel was beached in Dundrum Bay. The skipper claimed a newly built lighthouse wasn't on his chart and, mistaking that light for one on the Isle of

Man, he steered Brunel's almost 3,000-ton baby right on to the beach where she stuck fast. Brunel visited his stricken ship to find a way of protecting her before the winter gales. He gave instructions for a lattice framework to be built around the vessel to dissipate the energy of the pounding seas. This ingenious construction bought precious time for Brunel and James Bremner, a ship salvage expert, to make *Great Britain* seaworthy again. At the end of August 1847, on the highest tide of the year, she was set free, although by this time Brunel's Great Western Steamship Company was bankrupted.

Grand designs

As SS *Great Britain* was refloated the Chester and Holyhead Railway was being built to carry people and mail between the British and Irish capitals. The new line ran close to the North Wales coast and with it came investment: Llandudno was about to be born. In 1848 Lord Mostyn was poring over plans for a purpose-built resort and in the next thirty years many of Llandudno's grand buildings were laid out by the Mostyn family. By the early 1890s an extension to the pier was completed. It's still the longest pier in Wales.

Head east of Llandudno and your progress is soon impeded by a large rectangular gouge in the coast. This is the Dee Estuary, a curious wetland that isn't very wet but is very special. It's where Wales meets England and also where a wealth of migrating birds meet the British coast. Surprisingly, this vast area of flat marsh remains dry for most of the year, but with the spring and autumn high tides the marsh vanishes completely. In a flash saltmarsh becomes sea, a good time to watch the wildlife of the Wirral scramble for safety.

➤ In Llandudno's heyday it was the 'Queen of the Welsh watering places'. Steamships deposited day trippers from Merseyside at the end of its long pier.

Paxton's park

If the flash floods of the Dee Estuary sound a little too racy, how about a walk in the park? On the other side of the Wirral Peninsula is Birkenhead, home to the world's first municipal park, which opened in 1847. It was designed by Sir Joseph Paxton who wanted to create an idealized landscape of meadows and naturalistic woodland belts and sinuous lakes, shaped to resemble rivers. The park was visited by Frederick Law Olmsted, one of America's great landscape designers, and it subsequently influenced his work on Central Park in New York City.

The funding of municipal parks wasn't purely an altruistic gesture from the city fathers. Industrialization meant people were crowding into the new towns and there were fears about riots and disorder. Public spaces were provided to act as 'urban lungs' to offset the cramped, noisy and often polluting conditions in which many people found themselves, and the municipal park, with benches and a bandstand, was considered to be a controlled, civilizing means of encouraging working people to meet and 'take the air' (rather than take to drink) on their days off. All those bodies squeezed together in grimy industrial towns gave two grocers from Bolton the idea for a new venture at the end of the nineteenth century: they decided to manufacture soap. This decision taken by the Lever brothers laid the foundations for a business enterprise on the banks of the Mersey that became a global empire.

▼ Birkenhead Park has been restored and Paxton's inspirational design is now largely as it was when the Victorians enjoyed its civilizing calm.

A REVOLUTION IN THE WAY WE WASH

The evocatively named Port Sunlight was founded over one hundred years ago by William and James Lever. The brothers developed a new manufacturing process for a solid bar of laundry soap made from palm oil that was gentler on the skin than soaps made from animal fat (especially whale oil) and washed more effectively. The success of their product meant they needed to find a new location for the business, which had outgrown its original premises in Warrington on the banks of the Mersey. What the Lever brothers needed was a site that would allow for future expansion, was close to the river for importing the palm oil, and had a railway line for transporting the finished product. The unpromising land they purchased enabled them not simply to build a new factory but to transform the marshy ground into a garden village to house their factory workers. The philanthropic Lever family members were intent on sharing their prosperity, and invested much of their profits into community projects for Port Sunlight, seeing the value of providing for the well-being of their workforce. They took pleasure in planning the garden village, employing architects to ensure its unique style. In addition, they built their own harbour to import millions of barrels of palm oil rather than pay the port of Liverpool for the privilege. Port Sunlight was to become the largest private port in the world.

The *Coast* team made a simplified version of Sunlight Soap, enlisting the help of chemists from the Open University. We mixed just two ingredients: caustic soda and palm oil, the soda to make the oil-based soap soluble and the palm oil to help dissolve grease and grime. From about 1 pint of palm oil we managed to obtain six small tablets of soap. So, on the scale of things, it's not surprising that the Levers saw the need for their own harbour to import the oil in bulk.

The Mersey was the Levers' gateway to the world and their new port the focal point of the business, which by the 1930s had become a global enterprise. In West Africa it seemed money really did grow on trees: palm kernels were harvested by hand and trampled by foot to release the oil that was then shipped to

At a Glance
anyone can **see** the difference between the twin-bar of clear, pure
Sunlight Soap
and other laundry soaps, but you'll **know** the difference when you
use it, because it cleanses with
Less Labour, Greater Comfort.

the Merseyside factory. Sunlight Soap's exotic, pure ingredients were part of the brand, and the advertising, with its promise of brightening the lives of hard-pressed housewives, was one of the first instances of a marketing campaign aimed squarely at women. Cut, wrapped and branded, Sunlight Soap was an immaculate success, and one of the first examples of a cleaning product to be marketed as a consumer commodity. Sadly, the port was closed and became a landfill site because much of the manufacturing is done elsewhere, but the soap business is still there. Port Sunlight is now a research centre for Unilever, the industrial giant that started with the enlightened vision of selling sunlight.

'The world in one city'

We've almost come full circle on our tour around the coasts surrounding the Isle of Man but the gravitational pull of Liverpool is just too strong to resist a brief visit. As the Dee Estuary silted up the great city on Merseyside thrived, driven in the eighteenth century by the terrible trade in slaves from Africa to supply the English colonies in North America and the West Indies. In the nineteenth century, London lost its monopoly on trade with Asia, and Liverpool was able to enter the arena, trading with India and China, and quickly becoming a port of international stature. With the ships came new people and fresh ideas: from Chinese immigrants to rock'n'roll the city's culture was continually enriched with every arrival.

By the twentieth century Liverpool's prosperity relied on an increasingly brutish balance of power between dock workers and the port owners. Processing cargo was gruelling, labour-intensive work conducted under the careful supervision of the stevedores. An expert stevedore could fit together the irregular-shaped loads in the hull of ship so the surface of the pile was

▲ Stevedores once dominated the docks. These were the strong, skilled men charged with securing and unloading valuable cargoes, on which the ship owners' fortunes could be made or lost.

as smooth as a newly laid carpet. Such skills gave the dockers a measure of control over imports and exports that their unions were not afraid to exploit, but the shipping companies had an ace up their sleeve: the container, a simple metal box that changed the world. Containers as we know them today were first used in Newark, New Jersey, in 1956. Once standardized container ships entered shipping lanes around the globe, transporting goods by sea became faster, cheaper and easier, and the lives of dockers worldwide changed for good. The old quays are deserted now, the odd listed building lies derelict, others have been transformed into 'heritage homes' or retail outlets. The new docks built to embrace container-ship technology are thriving though; trade through the Port of Liverpool is busier than at any time in its past but it employs a fraction of the workforce. The old culture of the docks has gone with the wind – the landscape isn't the only thing to be remodelled by powerful forces of change on our coasts.

SEFTON SANDS

Beyond the concrete and brick at the mouth of the Mersey the coast morphs into an ocean of sand. Sefton has the largest expanse of dunes in England, and the Westerlies, whipping across the Irish Sea, sculpt this sand city grain by grain. Occasionally tides and winds expose what I think are the most remarkable things we've discovered on our shores. Footprints in the sand aren't exactly uncommon, except at Sefton the prints are made by people who walked here 5,000 ago.

Volunteer ranger Gordon Roberts (shown below) made the discovery about twenty years ago, walking his dog at Formby Point. The footprints were formed in mud and baked hard by the sun, then covered with layers of sand, which preserved them for five millennia. They may be exposed for a few days, ephemeral messages from our ancient ancestors, before the shifting sand shields them again. Your height is about seven times the length of your foot, so it's a simple calculation to work out how tall these early inhabitants were. Physically they were just like us but their livestyle was radically different. From the footprints scientists can analyse their gait, and it appears that the women and children were gatherers, collecting shrimps, razorshells and the like, while the male footprints arc directly associated with deer tracks, suggesting they hunted. The shore was the supermarket for early Britons; from earliest times it has nourished our lives.

Sefton Sands teem with life, everything eats everything else, and at the bottom of the food chain are sand hoppers. These tiny crustaceans feed on rotting seaweed and when you see how important hoppers are to the rest of life here it's clear why beaches aren't cleared of this natural 'rubbish': a clean beach is a dead beach. In the marram grass that binds the dunes together roam bigger beasts – lizards, beetles, natterjack toads – no wonder the sand hoppers stay low during the day but at night they have to come out to eat. Unfortunately, they're not alone; the toads hoover up the hoppers by the hundred. All part of the circle of life acted out every second around our shores.

Train one, save many

This coast played a pivotal role in the formation of the Royal National Lifeboat Institution (RNLI). Its crews, unlike other emergency services, are volunteers and their sea rescues funded by donation. That unique relationship with the public began with events on 9 December 1886 in the waters off Lytham St Anne's, south of Blackpool. A German ship, the *Mexico*, was in trouble, and three lifeboats were launched from neighbouring stations. One of the lifeboats made it to the ship, rescuing all men on board, but the other two, unaware that the *Mexico*'s crew were safe, battled on through atrocious conditions. It proved to be the worst single disaster in the history of the RNLI: 27 volunteers perished. The disaster moved the British public to raise over £30,000 to help the bereaved families and prompted the first street collections for the RNLI.

It is fitting that a lifeboat tragedy returns us to where we began our miniature tour of the UK because a few miles across the Irish Sea on the Isle of Man is where the RNLI was born. A nineteenth-century Manx resident, Sir William Hillary, was appalled by the number of ships wrecked around the island and he proposed a rescue fleet manned by trained crews. In 1824 his lifeboat institution was founded and some three decades later it became the RNLI. It was Sir William's idea to build a tower on a dangerous reef to provide shelter for crews whose vessels were wrecked on the rocks. From his home on the Isle of Man, Sir William dreamt of a rescue service that would cover the entire coast of the British Isles. I find it astonishing and uplifting that, despite the troubled relationship between Britain and Ireland, the RNLI does indeed operate not only around the British coast but the whole of Ireland as well. It seems our common bond as island people living in turbulent seas has the power to transcend political storms.

◄ The Tower of Refuge in Douglas Bay is a fitting memorial to one man who could not swim yet went to such lengths to save the lives of those at sea.

On our journey between the two major cities of Scotland we will go both the long and the short way around. Travelling out to the Hebrides we'll discover how a myriad of glorious islands and inlets make this coastline longer than you could possibly imagine, but we also try what might be the most beautiful short cut in Britain.

The Scottish Coast: Islands and Inlets

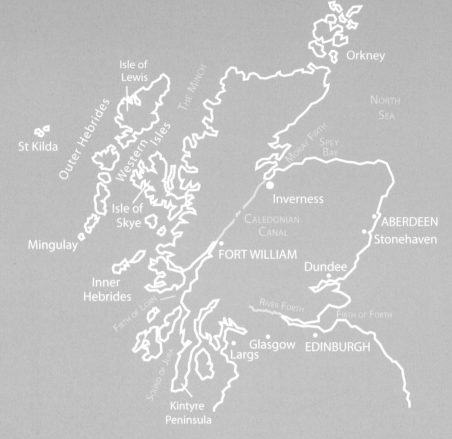

On the map: Orkney, Isle of Lewis, Outer Hebrides, THE MINCH, NORTH SEA, St Kilda, Western Isles, MORAY FIRTH, SPEY BAY, Isle of Skye, Inverness, ABERDEEN, Stonehaven, CALEDONIAN CANAL, Mingulay, Inner Hebrides, FORT WILLIAM, Dundee, FIRTH OF LORN, RIVER FORTH, FIRTH OF FORTH, SOUND OF JURA, Glasgow, EDINBURGH, Largs, Kintyre Peninsula

With so stunning a shoreline it might seem odd to take a man-made short cut, but our route includes not only what might be the most beautiful canal in Britain, but also the most dramatic. Along a coast of extremes we'll winkle out tiny creatures that make their homes in the bones of giant ones, and visit the tiny island that once 'roofed the world'. On the west coast we wave off the era of the Atlantic liners and work our passage on the famous little Clyde-built steamships that opened up the Western Isles to the wider world. It's a joyful journey that never disappoints and starts in a great city I was happy to call home in the 1980s.

◄◄ The first major bridge to be constructed in steel, the Forth Bridge is legendary for its cantilevered design as well as the time it takes to paint it.

No mean city

The distinctive grid plan of the Merchant City district was laid down in the eighteenth century by Scotland's first millionaires, the 'tobacco lords' of Glasgow. The Treaty of Union between England and Scotland in 1707 gave the Scottish entrepreneurs access to Virginia, England's former colony in America, and made their fortunes trading tobacco. Glasgow's position on the Clyde, open to the trade winds from the west, gave it an advantage over other British and European ports. Many of the Glasgow merchant ships were built in North America, where supplies of timber were plentiful, specifically for the Atlantic crossing but when the War of Independence started in 1775 ship-building came home to the Clyde, whose channel had been deepened in 1768 – a shrewd decision. In the nineteenth century iron replaced wooden hulls, but the real revolution occurred when steel replaced iron because the greater strength and flexibility of steel heralded the era of supersize ships. Construction in 1879 on the Clyde of the SS *Rotomahana*, the first ocean-going vessel fabricated with a steel hull,

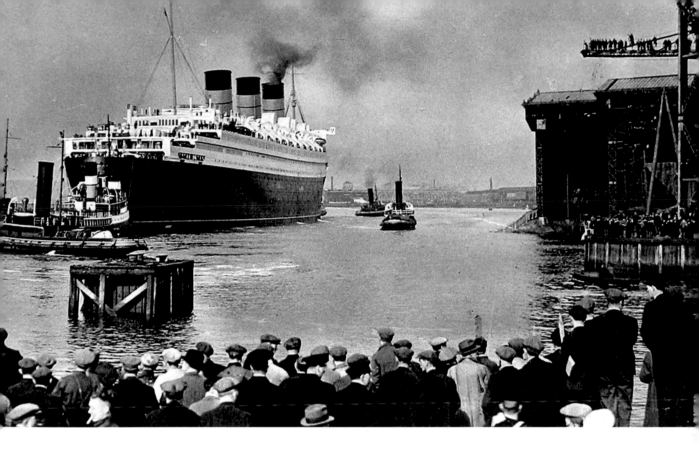

prompted a cascade of orders, output from shipyards around Glasgow trebled and by 1914 one-fifth of all the world's ships were Clyde-built.

The *Queen Mary* was one of a series of Clyde-built liners designed to slash the crossing time to America. She claimed the prestigious Blue Riband award in 1936 for the fastest transatlantic passage but her opulent interior and winning lines hide a darker tale of decline. She started life anonymously as 'Hull 534', her keel laid down in January 1931 at the John Brown yard in Clydebank, but work stopped in December 1931 when the superliner and her builders fell victim to the Great Depression. Her abandoned hull dominating the Clydebank skyline for over two years must have been a constant reminder to the men of their lost livelihood. Eventually government loans and a merger between her owners Cunard and their great rival the White Star line saved the ship: she was launched by Queen Mary in September 1934 and honoured with her name. So the *Queen Mary* escaped from the Clyde but the shipyards had only postponed their demise. After the Second World War, fearing another collapse in demand, owners were slow to invest in new production

▲ Recognizable to disaster-movie fans as the model for the liner in *The Poseidon Adventure*, the *Queen Mary* was the biggest passenger liner of her day.

methods and when the yards proved too small for the ever-larger ships demanded by global commerce, the shipbuilders fell like a line of dominoes.

The glamour of the grand liners and their Atlantic adventures is dazzling but lost in their shadow is another story of tough little ships that never left Scotland. The original steamships weren't built to race to America but for pottering around the Clyde. In 1812 the river welcomed the PS *Comet*, the workhorse of Europe's first commercially successful paddle-steamer service. Steam technology evolved and by mid-century the much-loved little 'Clyde Puffers' started to chug along the Forth & Clyde Canal from Glasgow out to the Firth of Forth on the east coast. Sea-going versions of the Puffers soon linked Glasgow to the Hebrides, the boats carrying wood, coal and corn west and north out to the islands and returning with fish and dairy products; their journeys became part of the folklore of the Western Isles. I share the Scots' love of these

▲ The Largs Pencil is a monument to the battle that culminated in the Vikings leaving the west coast of Scotland for good.

Lochs, Largs, locks

At the mouth of the Clyde are stunning views down Gare Loch and the smaller Holy Loch before the channel opens up and we're almost in open sea. Passing Largs, a town on the North Ayrshire side of the Firth, you can't fail to spot a tall column of stone standing isolated on the shore, its pointed top giving it the appearance of a giant's pencil. It commemorates the Battle of Largs, which ended centuries of Viking control of the Hebrides in October 1263. When the Norwegian king Håkon Håkonsson learnt the Scots were planning to oust them he amassed a mighty battle fleet, the biggest to leave Norway, and positioned his ships off the coast at Largs. Unfortunately for Håkon the weather favoured the Scots and a storm blew up, driving some of the longships onshore. After the loss of some ships an indecisive land battle followed and most of the Vikings, demoralized, headed home but Håkon hung on in Orkney, hoping to renew his hold after the winter. His luck didn't improve: he fell ill and died, and his successor sold the Hebrides to the Scots by signing the Treaty of Perth in 1266. Today the people of Largs relive their ancestors' triumph with an annual Viking Festival, joined by modern re-enactors demonstrating costume, weaponry and lively skirmishes, culminating with the burning of a longship at the Pencil.

steamers and their crews: imagine being master of your own destiny, setting off in a small craft into a vast universe of sea with a galaxy of islands – to boldly go wherever trade and your little engine can propel you!

The near mythical status of the paddle steamers was cemented by the pen of author Neil Munro, who wrote light-hearted stories about a Clyde Puffer, the *Vital Spark*, and her crew. Three different adaptations were televised as series for the BBC and the tales inspired the 1954 Ealing comedy *The Maggie*. Para Handy is the crafty skipper of the *Vital Spark* and the plots revolve around his turbulent but affectionate relationship with the crew. In one episode the boat's engineer McPhail quits but, unable to get a job, he invents one on The Majestic Line, which supposedly sails to Rome – a cheeky nod to the more glamorous master mariners of the Clyde and their ocean-going liners. Showy state-rooms are not for us though: we follow in the wake of the Clyde Puffers on a trip to the Highlands and beyond.

Heading from the Clyde toward the Inner Hebrides the route is blocked by the Kintyre Peninsula. At the tip of this long finger of land the turbulent waters off the Mull of Kintyre have the potential to wreck any vessel. To open up trade between Glasgow and the Hebrides a short cut was needed to bypass the Mull of Kintyre, and it's a sign of the money that merchants hoped to make that the Crinan Canal was completed in 1801. It took 100 miles off the journey to the islands and by 1854 some 30,000 passengers as well as 27,000 sheep and 2,000 cattle were enjoying the canal's great views.

➤ The guide books call the 9-mile Crinan Canal Britain's most beautiful short cut. It's perfectly navigable, if you fancy trying out its 15 locks.

OTTER SPOTTING

Beautiful sights are scarcely uncommon on Scotland's western shores so it's easy to miss some gems. With a little patience and local knowledge though, it's possible to spot otters. Overall their numbers have declined in Britain but there are about 8,000 distributed around Scotland and the inlets of the west coast are one of best places to find them. This comes as something of a surprise because these otters are river animals that have learnt to survive in the sea. It helps that the waters are warmed by the Gulf Stream, and the lochs provide shelter and fresh water pools. These shy creatures brave the sea because they need seafood – lots of it. They need to consume close to a fifth of their body weight in fish every day to replace the energy they expend fishing off these coasts. Their average life expectancy is only about four years, an indication that the harsh environment takes its toll, but at least these rare treasures are now well protected by law.

The slate islands

The Crinan Canal discharges its westbound passengers into the Sound of Jura, which has a liberal sprinkling of skerries, the local name for the myriad islands mostly too small for habitation. Making the journey up the coast it's a good bet – given that they share their name with the island's single pub – that the odd Clyde Puffer might have stopped off at Easdale, in the Firth of Lorn, some 15 miles south of Oban. This is a remarkable place, not just because it's the smallest permanently inhabited island of the Inner Hebrides; it also used to be a major industrial site. It now has about 60 residents but from the mid-1500s to the end of the 1900s slate was carved out of the landscape and at the peak of its industry there were as many as seven working quarries, and a population of 500, squeezed on to an island less than half a mile long and a third of a mile wide.

Easdale and its neighbours, Seil, Luing and Belnahua, have been called the 'islands that roofed the world'. The importance of the industry was such that the product was named Easdale Slate and it was exported to Glasgow, Ireland and out to the wider world until a storm in 1881 flooded many of the Easdale quarries and commercial extraction ended a few years after. Some of the old workings have formed beautiful deep pools of clear water, helping to make this abandoned industrial island a tourist magnet (the birds like it, too), with the added bonus of no roads or vehicles: here the wheelbarrow is the recognized mode of transport. Easdale is only 650 feet from Seil, which can be reached by car from the mainland by crossing the Clachan Bridge, or 'Bridge over the Atlantic', according to the signposts. Think small: the ferry that shuttles between Easdale and Seil carries just ten passengers at a time but plans for a causeway link in 2005 were overwhelmingly opposed by residents: clearly they like things just the way they are.

Super mammals

Whether their vessel is a huge bulk carrier or a tiny Clyde Puffer the crews that wend their way around the Western Isles are not alone, for these waters are a

highway for the biggest of beasts: humpback, sperm, killer and minke whales all pass through here. The Gulf Stream is one of the world's strongest ocean currents, moving warm water from the Gulf of Mexico into the north Atlantic and eventually up the west coast of Scotland. That water is rich in nutrients, which results in a massive plankton bloom every year, a bounty that attracts predators of all sizes, right up to the whales.

Big they may be but watching for whales can be a frustrating time. A good tip for spotting them is to look out for the groups of birds feeding on the surface that may indicate a shoal of fish below, which may also attract inquisitive minke whales looking for the herrings, sprats or sand eels that concentrate in shallower coastal waters from May to September. Minke whales spend the summer months feeding in the rich waters off Scotland's west coast but no one really knows whether they stay around the Scottish coast all summer or continue on their migration.

The lives of the leviathans that roam the oceans are a mystery in so many ways but a more taxing question is what happens to them when they die? Scientists who try to establish the fate of whales have a problem, since stumbling across a dead one on the seabed is about as likely as landing the jackpot on the national lottery. Instead researchers wait for a whale carcass to be washed up on the shore. One experiment they'd like to do is sink a whole whale in deep water offshore and return later to see what's happened to the body. However, it can be tricky to get hold of a whole animal, so researchers carry out tests with whale bones in their attempts to learn more about the importance to the ocean-floor ecosystem of 'whale fall', the death of one of these great marine mammals. When a carcass sinks to the ocean floor it makes a hearty meal for a host of sea dwellers that strip its flesh and organs, and the skeleton doesn't go to waste either: some very odd things move into the bones. Sea urchins, spider crabs and squat lobsters are among the residents who like

▲ The flat-bottomed Clyde Puffers proved ideal for deliveries to the islands because they could beach at low water, unload, and float off again at high tide.

to … well, squat inside a whale skeleton, treating it as a temporary reef, but my favourite bone-dweller is the recently discovered *Osedax mucofloris,* whose name translates as 'bone-eating snot flower'. UK researcher Adrian Glover told us that his team might have misnamed the organism; in fact it's a highly specialized worm, less than an inch long, adapted to living on whale bones. The worm roots itself into the bone and extracts oils with the aid of symbiotic bacteria while its flower-like plumes take oxygen from the water.

What perplexes scientists is how the tiny bone-eating 'snot flowers' that live on the rare but concentrated nutrient supply from whale fall could turn up in temperate waters, when previously they were known only to exist in the depths of the Pacific. Let's hope the scientists can get their hands on a whole whale carcass to progress their research. I think it's fabulous that just off our coasts there are delicate and bizarre marine ecosystems alive and well on dead whales.

One of the most popular questions we get from *Coast* viewers is: how long is the British coastline? It's such a simple question you'd think we would have a simple answer but you'd be wrong. Figuring out the precise length of our shore has led to a whole new branch of mathematics that affects our lives in all kinds of surprising ways, even our mobile phones. It's a story with an odd beginning and a perplexing conclusion.

Between the First and Second world wars mathematician and pacifist Lewis Fry Richardson applied his considerable analytical skills to developing theories of why countries go to war. Richardson hypothesized that the propensity for war depended on the length of the common border between two nations, and when he looked up the length of a country's border he was surprised to find widely different values quoted. Surely a border should have one agreed length but it didn't. Richardson worked out that the length of a boundary depends on the size of ruler you use to measure it, and the shorter your ruler the longer the border is. No one paid much attention to his remarkable result until in 1967 mathematician Benoît Mandelbrot published an academic paper asking, 'How Long is the Coast of Britain?'

The coast is very wiggly and the smaller the ruler you use to measure it the more precisely you get into the nooks and crannies and hence the longer it gets. Mandelbrot knew from Richardson's work that in theory you could go on like this for ever, so by using ever smaller rulers the coast keeps getting longer: his conclusion was that the coast is infinite! Mandelbrot thought that, rather than comparing coastlines by length, he would work out a number for how wiggly they are, a measure he called the 'fractal dimension'. It's a fraction between 1 and 2 depending how wiggly the coast is, so the shore of East Anglia, which is very smooth, has a fractal dimension of about 1.05, whereas the west of Scotland with its myriad islands

◄ The ins and outs of the coast between Cape Wrath and Sandwood Bay in the Highlands are a sight to savour, but it took the mind of a genius to work out that they actually go on for ever.

▲ The work of Benoît Mandelbrot, creator of the fractal geometry of nature, proved a milestone in mathematical thinking and captured the minds of artists and scientists working with 'wiggliness'.

and inlets is super wiggly and its fractal dimension is 1.3 – the second highest in the world. First prize goes to Norway at about 1.5, while the curve of the South African shore is almost like an arc of a circle and comes in at around 1.02.

Mandelbrot's fractal geometry describes all manner of natural shapes that are made up of repeating patterns, like a fern, florets of broccoli or the tiny branches of airways in your lungs. Fractals, he proposes, are nature's way of using wiggliness to pack the most into a limited space. Engineers can use fractal maths to pack the longest mobile phone aerial into the smallest space, giving a tiny phone with good reception. This is all fabulous, but what is the practical answer for how long is the British coastline? The Ordnance Survey quotes a figure of 11,073 miles for mainland Britain at high tide and that measurement has been calculated with a hypothetical 'ruler' that is just 4 inches long.

Tiree extremes

The most westerly of the Inner Hebrides is no stranger to the whales that weave their way around the endless wiggly coast, from Tiree way out west, to the Isle of Skye in the north. Tiree perches precariously on the very rim of Britain; there is nothing between it and North America except water and wind. Extreme-sports enthusiasts come here to be pulled by the wind, skimming over the water and often right up into the air, although if kite surfing is too exhilarating for you there are more earthly pleasures to enjoy. The island's outstanding natural beauty attracts painters and photographers, hoping to capture its windswept vistas and special light, and perhaps a sighting of the

magnificent sea eagles that have successfully been reintroduced into the wilds of the Western Isles.

Tiree's white sand beaches are bathed in a surprising amount of sunshine. This flat little island has the highest monthly sunshine total recorded in Scotland at 329 hours in May 1975, which is good although it doesn't top the record monthly total for the UK, which is 383.9 hours of sun recorded in July 1911 at Eastbourne in Sussex. According to the Met Office, May is generally the best month for sun on Tiree, a good time for a wander out to the famous Ringing Stone. This huge boulder of granodiorite, quite unlike the geology of Tiree, was carried in the last ice age from the island of Rum to the north. Apparently when it's struck with a pebble it sounds like a bell but don't bash too hard: legend has it if the ringing stone shatters Tiree will sink beneath the waves.

▼ Weather dominates life on Tiree in a way quite unlike the mainland. The Gulf Stream keeps it cool in summer and frost-free in winter, perfect for appreciating the 46 miles of stunning coastline.

The guga hunters

Communities in the Outer Hebrides were bound together by a strong oral tradition; their history wasn't written down, it was spoken and remembered among them – so when a group of islanders dispersed, thousands of years of memories faded away. What we do know of their lives reveals a reliance on every natural resource available. Fishing was a staple along with rearing cattle and sheep, but more surprising is how important seabirds were to their livelihood. In response to their extreme environment, the little archipelago of St Kilda, the remotest part of the British Isles, had a centuries-old organized system of seabird fowling: the men would descend the cliffs on ropes to catch them and women would prepare them for the pot or salt them for later use. The islands' tenants paid their rent in seabird feathers; puffins (known as sea chicken), fulmars, gannets (or gugas, the name for the young birds), guillemots and their eggs were a major part of the St Kildan diet; seabird carcasses were dug into the ground for fertilizer and their skin used for shoes.

As the twentieth century approached, the market for feathers and other island exports dwindled. St Kilda's population began to give up the struggle and emigrate to an easier life. Those who stayed became an early tourist attraction as steamships brought city folk responding to the adverts that urged, 'Come and See Britain's Modern Primitives', and at first the canny St Kildans traded on their reputation. The lifestyle was not sustainable and in 1930 the remaining 36 residents requested evacuation to the mainland, ending an extraordinary story of survival. But some gained: St Kilda is the most important seabird breeding colony in northwest Europe. The islands and surrounding marine environment now have dual World Heritage status for their unique natural and cultural significance.

THE ABANDONED ISLES

Life on a small Scottish island can be a marginal existence in all senses, with animals and people struggling to share the limited resources their rocky homes have to offer. By 1918 sea eagles had been hunted to extinction on the little Hebridean island of Canna and it was a similarly depressing story all around the Scottish shore. The end of the nineteenth century was a period of rapid change and the delicate balance of age-old communities was disrupted by the collapse in demand for their traditional exports.

The sea eagles were not the only victims in the bid to survive: some of the islands also lost their human population. Mingulay on the southern tip of the Outer Hebrides was described by Neil Oliver as being 'like Skull Island, it's the sort of place you expect to find King Kong living'. Neil's marvellously evocative description is one of my favourite moments in *Coast*, and perfectly captures the extraordinary and eerie majesty of Mingulay's jagged gneiss cliffs with vertical chasms cutting down to the sea. They bear the brunt of some of the worst storms in all Scotland.

Mingulay has many archaeological sites, confirming a long history of settlement, and on the relatively more sheltered east side of the island there's a lush green valley, safe anchorage and a village. That village, though, is in ruins because, after two thousand years of struggle against the harsh conditions, it was abandoned within a single generation: the last man left in 1912, and now the sand dunes are moving in.

◄ Mingulay takes its name from the Norse, meaning 'big island'. It is the largest of the Bishop's Isles, but a small world for humans to inhabit. Now it is home to grazing sheep and colonies of seabirds.

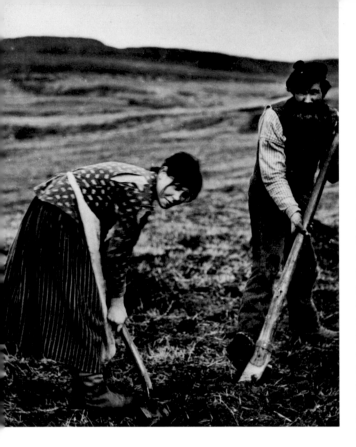

▲ For many Hebridean islanders, existence right into the twentieth century was governed by what they were able to harvest, trap or rear.

Smog on Skye

Few things seem worse than being forced to leave your island home because the resources can no longer support you. But hardship took another form for the kelp-cutters of the Western Isles who were bullied into staying and carrying out gruelling and dirty work for subsistence wages. It's a story of the greed of landowners and the desperation of tenant crofters that is repeated across the Outer and Inner Hebrides, but the misery of this shameful enterprise is perhaps most poignant in the way it was played out amidst the stunning scenery on the Isle of Skye. Viewed today, the way the majestic mountains seem to touch the sea takes your breath away, making it difficult to believe that two hundred years ago the smog of pollution blighted the island. Back then workers were busy extracting chemicals from kelp because an alkaline ingredient in this seaweed was vital to the glass industry.

In order to shape molten glass soda ash is required, which, until the late 1700s, Britain's glass industry imported mainly from Spain. When the Napoleonic Wars started at the end of the century the imports stopped. Fortunately for glassmakers, soda ash can also be extracted by burning kelp seaweed, and Scottish landowners were not slow to realize that their kelp-rich shores could become gold mines – all that was needed was a workforce to undertake the dirty, back-breaking job. To process the kelp to meet the sudden, lucrative demand for soda ash, landowners moved tenants from their crofts to the coast during an infamous period in Scottish history known as the Highland Clearances. Some families were brutally evicted by force, their homes burned, while others found the increase in rents intolerable and were driven by hunger and financial desperation to take up work on the coast, either kelp-cutting or fishing. Tens of thousands of crofters and their families were displaced from the land they had lived on and worked for generations, to be replaced by large-scale sheep farming, which proved more profitable than people. Even today many remote glens remain silent and empty after the Clearances.

Dotted along the shore of Skye are the remains of kelp-cutters' homes, a visible reminder of their impoverished lives during the boom years of the industry. By day entire families were out in all weathers, harvesting and burning seaweed, and crammed in together at night. From the comfort of our twentieth-first century homes it's hard to imagine the rigours of this lifestyle, although the personal experience of a storm ripping my tent to shreds on Skye is enough to know that the weather would scarcely have helped. Historian Donald William Stewart described life for the workers:

'It was a grim task, arduous work, knee deep in freezing cold salt water for most of the summer months, sawing seaweed up. Then you'd have to drag it or haul it or carry it, back-breaking work, up to the top

THE LEWIS CHESSMEN

Much of the old west coast way of life has gone for good but some 800-year-old chess pieces lost on the Isle of Lewis miraculously reappeared. The Lewis chessmen were made when the Vikings ruled the Hebrides and it's thought the elaborate figures, carved in walrus ivory and whale tooth, were made in Norway. Trondheim is the most likely place for their manufacture, for it is known to have had workshops producing walrus ivory goods and a chess piece found in St Olav's parish church in Trondheim closely resembles the Lewis queens. How they came to be lost and found remains a mystery. It is possible they belonged to a merchant trader travelling from Norway to Ireland but exactly who found them is still uncertain. They reappeared to the eyes of the world on 11 April 1831 when they were exhibited in Scotland at the Society of Antiquaries. Ninety-three chess pieces still exist: precious when lost, priceless recovered.

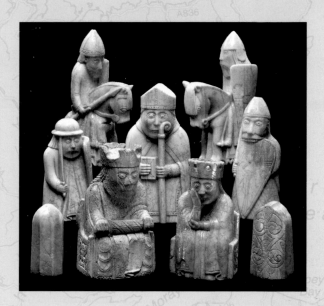

of the shore, where you'd clean it and dry it, then you put the seaweed over pits and you burnt it, covering the islands in thick smoke visible for miles out to sea. Some 20,000 people across the Western Islands working every summer in this grim filthy dirty work, just as much a product of the Industrial Revolution as the black smoke belching out of the chimneys in Glasgow and Birmingham and Manchester.'

Boom and bust

The attraction of kelp as an easy money-spinner proved irresistible for landowners. On Skye, Lord Macdonald of the Isles was richer by up to 20,000 pounds a year, the equivalent of over a 1 million pounds by today's standards, while his workers received a pittance for their labour. So why did they stay? The traditional route out of poverty was a passage across the Atlantic and a new life in the New World. A Scottish clergyman was quoted as observing in June 1803 that 'The Spirit of emigration is very great in the western coast' and the ruling classes realized that workers were too valuable to lose. After lobbying by landlords Parliament brought

in the Passenger Vessels Act in that same year. Under the pretext of improving conditions for passengers this legislation effectively tripled the cost of a transatlantic ticket, stemming the flow of emigration, so the poverty-stricken workers faced a stark choice: either cut kelp or starve. In fact, that decision was taken care of with the ending of the Napoleonic Wars in 1815: cheap soda ash from Europe again flooded into Britain; the glass industry turned its back on Scottish seaweed and so the landowners no longer needed the kelp-cutters. The Passenger Act was repealed in 1827 and although some kelp-cutting continued into the twentieth century many of the redundant workers were left to fend for themselves.

The effects of boom and bust are disproportionally greater on islands than the mainland: it is always difficult to maintain the fragile balance that determines whether small, remote communities are viable. No matter how difficult their lifestyle, the independence that isolation brings is important to the mind-set of islanders, which is why when a bridge was constructed connecting Skye to the mainland in 1995 it proved controversial and unpopular. The link over the Kyle of Lochalsh is

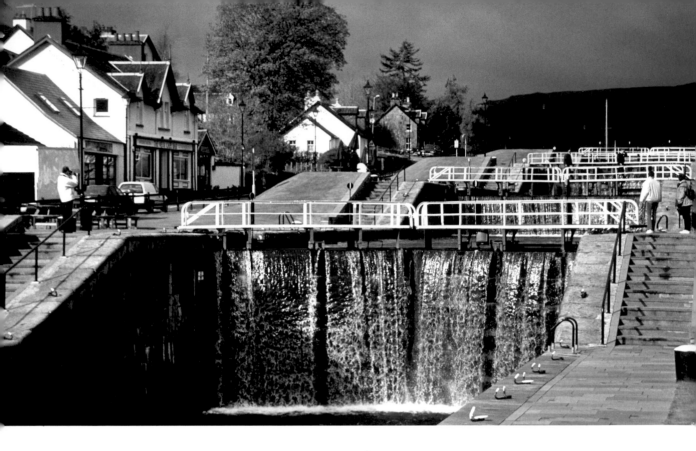

just a thin ribbon of road but since 1995 it established a permanent connection to the wider world, regardless of ferry timetables and weather. Now ferries are for the tourists who still prefer to go over the sea to Skye, a far cry from when the Clyde Puffers brought goods to and from Glasgow. To the crews of those little steamships, though, navigating over the vast area of sea that surrounds the Inner and Outer Hebrides, the constantly changing coastlines must have seemed endless.

The Caledonian connection

The length of the coast is a serious consideration if you're walking round it but boats of course have an advantage: they don't have to snake in and out of every indentation. What worries sailors on their circumnavigation of the Scottish coast are rough water and rocks. En route from the west to the east crews feared the passage through the Pentland Firth. This narrow channel between Orkney and the north coast of the mainland, is notorious for some of the world's

▲ The Caledonian Canal has 29 sets of locks along its length. The most impressive engineering feat is Neptune's Staircase, north of Fort William, a ladder of eight locks that raises vessels 70 feet above sea level over a distance of less than a third of a mile.

fastest tides, which, among other hazards, creates a patch of rough water known as the Swelkie (from Old Norse meaning 'the Swallower'), so not surprisingly sailors would prefer to avoid it. What they needed was a big short cut, a direct connection between west and east, to bypass the perilous north coast altogether, and that's exactly what the Caledonian Canal does. It's a bold and beautiful waterway that runs from the west coast at Corpach near Fort William for 60-odd miles through the Highlands to Inverness in the east. For much of its existence, though, it has been largely a waste of the tremendous effort and money invested in it.

Work on the Canal began in 1803 during the massive upheaval caused by the Highland Clearances. Faced with so many disposed tenants and to stem the tide of emigration, building the Canal was part of a grand

attempt to help stabilize the population by providing decent jobs and improving trade. Thomas Telford and William Jessop planned and executed its mammoth construction: a third of the Canal's length had to be dug out to connect natural waterways including Loch Ness; there were also 29 sets of locks and 4 aqueducts. The estimated time to complete the Canal was 7 years but the project ran for 19 years and was nearly three times over budget when it was finally opened in 1822; worse still, it leaked and wasn't deep enough to accommodate the larger ships that had by this time become more common. Despite the fact it was taking less in tolls than it was costing to maintain, public money had to be raised between 1843 and 1847 to deepen and improve it. While the Caledonian Canal did serve as an express route for steamships before the railway era, it never achieved its aim of acting as a thoroughfare for trade.

Engineers could ultimately tame the landscape but world events were beyond their control. The year the Canal was started Britain was fighting the French, which made this northern route seem attractive, but by the time it was completed the Napoleonic Wars were over and, as steam took over from sail, mechanized ships were less concerned by turbulent waters around the north coast. Over 180 years on, after substantial renovation in the 1990s, Britain's first state-funded transport project has finally come into its own as a leisure destination. Previous generations must have felt considerable anguish at the overruns and overspending; perhaps it would have been some comfort for them to know how much it is appreciated in the twenty-first century.

Two great glens

Strike out across the coast of northeast Scotland and you encounter Spey Bay, where the mouth of the mighty River Spey meets the Moray Firth. It's a place where some of Scotland's true greats converge: salmon fishing, golf and whisky. Fishing is the oldest preoccupation: salmon have been fished from the river mouth probably since prehistoric times (ospreys, as well as fishermen, know to take advantage of the Spey's rich pickings). Golf, or 'gowf' as it was known, has been enjoyed on the rolling sandy links since medieval times, but whisky is the new love: it has been distilled – legally that is – around the Spey since the late eighteenth century. Strathspey, the undisputed heartland of whisky production, contains the largest number of distilleries of any of Scotland's whisky-producing regions and the two best-selling single malts in the world, Glenfiddich and Glenlivet, are Speysides. Now there's a heartwarming tale for this bracing coast

Great balls of fire

Heading down Scotland's eastern flank on the final leg of our journey to the Firth of Forth, we're stopping off for another warming story. Some 15 miles south of Aberdeen you'll find Stonehaven, its neat harbour and austere old town full of authentic charm. What makes it remarkable are the blazing balls of fire that fill the streets on New Year's Eve, possibly inspired by pre-Christian rituals, which celebrated the purging power of flames. The exact origin of this unique Hogmanay festival is lost in the Scottish mists but the 'Fireballs' have blazed brightly for over a hundred years. The balls are up to 2 feet in diameter and made of anything that will burn with the assistance of a splash of paraffin. They are kept at a safe distance from the 'swingers' by means of a length of wire or chain. As the town clock strikes midnight both men and women parade along the main street, swinging the blazing fireballs around their heads to the delight of a crowd of tourists and the locals whose numbers are swelled by family and friends returning from far afield for the spectacle. The flames are extinguished as the swingers hurl them into the harbour but the drinking continues well into the first morning of the new year.

The silv'ry Tay

If you fancy a little swimming on the east coast think twice before you take on the River Tay. It's Scotland's longest river and the mightiest in Britain, spewing as much water into the sea as the Thames and Severn combined. It's always been a formidable obstacle to progress along this coast, and presented cattle drovers with a long detour inland looking for a safe crossing. Several bridges were built but they had a habit of being washed away. Perth is miles inland but it used to be the nearest crossing point to the coast until its bridge was destroyed by a storm in 1621; the Perth residents went another 150 years before another one was built.

Downstream at Dundee the Tay is considerably wider. It took the confidence of the Victorian age, when anything seemed possible and train companies were expanding up the east coast, before Dundonians got their bridge. It took 6 years, 10 million bricks, 87,000 cubic feet of timber and 15,000 casks of cement to build. The Tay Bridge was 2 miles long, a world record at the time, and civil engineer Thomas Bouch was knighted by Queen Victoria for his design. However, on the night of 28 December 1879 during a violent storm the bridge collapsed as a train was crossing the Tay; none of the 75 people on board survived. Within a year of the collapse Bouch died a broken man after he was blamed by the Board of Trade inquiry. This terrible episode highlights a dark side of the Victorian dream and exposes the myth of their 'infallible' engineers.

▼ Shoddy construction, poor maintenance and bad ironwork have all been blamed for the Tay Bridge disaster. If the cause is still in doubt, the outcome is not and will be remembered for a very long time.

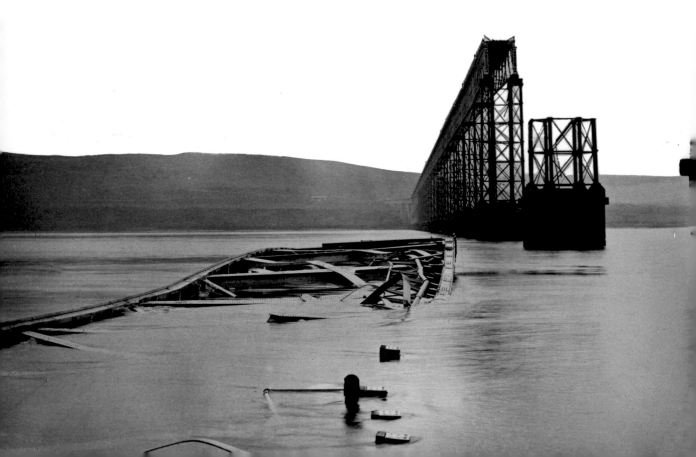

Suspension over the Forth

Further down the coast is a tangible tribute to the victims of the disaster, more filling than any stone memorial, a magnificent steel edifice that has become the symbol of Scotland's engineering excellence. The glorious Forth Rail Bridge sits imperious, mighty and massively over constructed because its design is a direct reaction to the Tay Bridge tragedy. Sir Benjamin Baker had inspected the ruins of the Tay Bridge and gave evidence to the inquiry, so he took no chances with his design for the Forth crossing. Steel replaced the wrought iron of the failed Tay Bridge and its slim lines were abandoned in favour of bold cantilever lattice work for the Forth Rail Bridge. The trains that glide over the water are dwarfed by the structure that supports them, which is at least twice as strong as it needs to be. Its monumental design achieved more than spanning a river; it rebuilt confidence in the Victorians' ability to conquer nature: a bold statement of intent that has stood firm since 1890.

⋏ Unlike the Tay Bridge, the Forth Rail Bridge was an engineering marvel, but were it not for the mistakes in the design of the bridge by Thomas Bouch it may never have achieved such monumental heights.

The Clyde Puffers that have been our companions on much of this Scottish journey would have passed under the Forth Bridge and its construction must have intrigued the crews of those hard-working little boats. They gained their name from the puffing of their innovative early steam engines as they plied their trade between Edinburgh and Glasgow via the Forth & Clyde Canal. This inland waterway was in fact the testbed for the world's first practical steamboat in 1801, using technology patented by William Symington, one of Scotland's great inventors, which would ultimately revolutionize shipping worldwide. The legacy of engineering innovations is what brought me to Glasgow in 1983 to research into a new inspection method for oil rigs, and that first encounter with the city that was once the global capital of shipbuilding was my springboard to explore the Scottish shore. Whatever your motivation for the trip, I promise it doesn't disappoint.

The Viking Coast: Norway and the Faroes

When the Vikings launched a reign of terror on our unsuspecting coast their shores were shrouded in secrecy: few dared venture to the frozen home of the Northmen. Now we're here to explore the land of fjords and master mariners.

Norway has a wonderfully contorted coast, stretching deep into the Arctic Circle and carved by the same ice sheets that sculpted Scotland. It may be a chilly country but we'll see how the Norwegians plan to keep us warm in winter via a steel umbilical cord laid on the seabed.

As well as episodes of terrible violence against our isles these Nordic neighbours have a long history of lending us a hand. A thousand years ago we were gobbling up some very stinky fish, an early form of fast food the Vikings produced, for which the cold, dry air of the Lofoten Islands was no doubt suitable. It was on these islands that we discovered a secret that helped us win the Second World War.

On the way back to Britain we'll sail down sea channels to seek out the story of the Viking boat builders and drive over the Atlantic on one of the world's wildest roads. Our saga starts north of Britain and west of Norway on a little group of islands we've both occupied but neither of us owns. The first settlers on the Faroe Islands may have been Irish monks; Norsemen didn't arrive until the ninth century. For a couple of hundred years the islands were free but then they

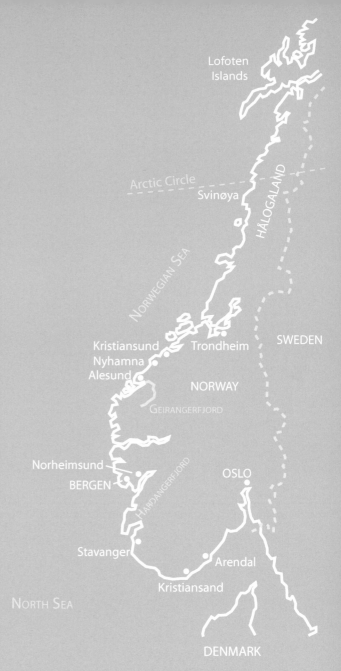

came under foreign control, first Norway, then Denmark. If you've never set foot on the Faroes then a treat awaits. It's a land of stunning beauty where romance blossomed for British troops while war raged in the surrounding seas. We begin just before that story starts, going back in time to our darkest days.

◄◄ Preikestolen cliff above Lysefjorden, 'like Scotland on steroids', according to Neil Oliver.

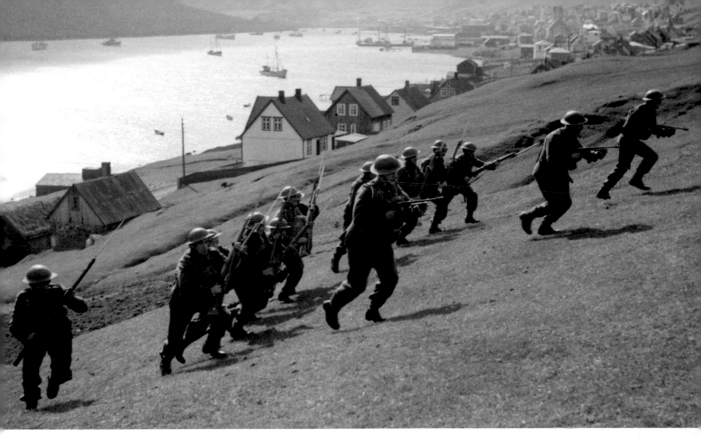

Operation Valentine

Early in 1940 a deadly game of chess for the control of Western Europe was in progress as two great powers picked off territory, positioning their pieces in preparation for battle. In April the Nazis moved into Denmark and Norway; Britain feared that they also planned to occupy the Faroes. Their isolated position high in the Atlantic could have made the islands a formidable U-boat base that might have proved decisive in the battle to strangle Britain's supply routes across the ocean to America.

Winston Churchill decided to pre-empt a possible Nazi strike. On 11 April 1940 he announced that the Danish territory of the Faroes was now under British control – Churchill's statement of intent was typically robust: 'We shall shield the Faroe Islands from all the severities of war, and establish ourselves there conveniently by sea and air until the moment comes when they will be handed back to Denmark liberated from the foul thraldom into which they have been plunged by German aggression.' In the days and

▲ British servicemen training on the grassed slopes of the Faroe Island fells must have thought they had been stationed on a peaceful haven in the midst of a battle to safeguard the Atlantic supply route.

months that followed, British troops began to travel out to the tiny outcrops that make up the Faroes, lands lost in time and the space of the vast Atlantic.

Although the islands lie roughly half way between Iceland and Norway the UK is their nearest neighbour, but we're hardly close: the Faroes are around 200 miles from mainland Britain. Now you can take the express route and fly there, thanks to the British servicemen who built the airstrip in the Second World War. They had to arrive by boat and what a sight awaited them after hours of grey swelling seas. This volcanic archipelago has soaring cliffs; green fells and rocky protrusions rise from swathes of fertile valleys and peaceful fjords and sounds. When Neil Oliver followed in the wake of those British soldiers his first reaction was: 'This is *Lord of the Rings* – it's Middle Earth!', a quote that encapsulates the drama of a landscape from another world.

The Faroes comprise 18 separate islands with nearly 700 miles of coastline and are home to fewer than 50,000 people who are never more than 3 miles from the sea. The rock they inhabit was spewed out of underwater volcanoes; in the ages before people the elements shaped the lava into improbable peaks and sheer sea cliffs, creating a gigantic landscape on a strangely tiny scale. It takes a certain sort of character to cope with the conditions out here but many of the British soldiers who started to arrive in 1940 were from Scottish regiments and they probably had some sympathy with the rigours of island life.

In addition to the airport the British built roads, accommodation and gun emplacements in preparation for an enemy that never came. Although operations in the Atlantic were monitored from the Faroes, the 8,000 servicemen stationed here didn't see much direct action; instead there was time for romance. The troops were an occupying force albeit a friendly one, so while there were tensions there was also a meeting of minds and hearts. Some 170 marriages were made in this archipelago of peace amidst a world at war, an oddly fitting outcome because the British codename for the occupation of the islands was Operation Valentine.

The men of the Faroes played their own part in the war effort; one-fifth of all the fish eaten in Britain was landed by the islands' fishing fleet, often at great risk. In 1942 the trawler *Nyggjaberg* was sunk by a U-boat near Iceland and 21 Faroese seamen were killed. In all over 130 fishermen were lost during the war and British servicemen found themselves in the unexpected role of surrogate fathers to the children of the trawlermen who perished. Local historian Mina Reinert told us: 'The people remember the

◄ Lighthouses are usually isolated but the Kallur lighthouse, overshadowed only by the 1,761-foot Borgarin Peak, is also a long way up from the sea.

kindness of the soldiers: they were very good to the children; they brought them chocolates and made them toys.' The love of British chocolate survives; to this day you'll still find it for sale on the islands.

The whale hunters

On islands with few resources and limited connections to the wider world, self-sufficiency is vital. Surrounded by one of the cleanest oceans on Earth the food that has traditionally sustained the islanders is whale meat, and the Faroese don't just eat these precious animals: in the old days nothing went to waste – the blubber was also a source for much-needed fuel oil. Hunts involve the whole community and during the war British troops joined in. The pilot whale was considered a gift from God, providing food for a long time. When a shoal of whales is spotted offshore the fishermen go out in their boats and herd the animals into a bay where the water is too shallow for them to escape; men, women and children then wade into the water to kill the small whales. The catch is cut up and distributed around the community; everyone has a share, even those too infirm to take part. This type of hunting only died out in the Scottish islands about a hundred years ago; it's not pretty sight but when you're struggling to survive in unforgiving seas there's no place for the squeamish. Times have changed and now alternatives are available, but many want

▼ For Faroese youngsters, the presence of British servicemen was not a force to be reckoned with but a source of friendship and fatherliness.

to preserve the tradition of harvesting the bounty of their seas so whaling continues as part of the historic culture of the Faroes, despite the objections of the wider world.

The whale-hunting days of the British servicemen were short lived. By 1944 it was clear the Germans would never use the Faroes to threaten the Atlantic convoys. The theatre of war was shifting south to the beaches of Normandy and so did many of the troops who were stationed on the islands. Occupation ended in 1945 and although the Faroese now have a large measure of autonomy they remain a province of Denmark, which is a clue to their Viking heritage. It's a Nordic link that's visible in the blond hair of the people and grassy green roofs of their houses.

Grass roots

A Faroese home is known to the locals as a *sethús* or 'seat house' after the traditional Viking farmhouses that had seats placed along the long walls. These ancient Norse dwellings inspired the classic Faroe

⋀ The turf that tops traditional Faroese homes follows the seasons of the year and even paints itself: light green in spring, darker in summer, brown in autumn and white in winter.

houses, tarred brown or black with white painted windows blending into the terrain under a large grass roof. Tastes have changed over the years with taller multi-coloured homes becoming common but some preserve the traditional turf top. Grass roofs are a symbolic link to the Viking age but there's more to them than just nostalgia, turf is a living material that requires little maintenance and provides good insulation.

The house style was not the only thing to be carried across the sea from Norway; so was the wood to build them. There are few trees on the Faroes so wood was cut to plan and packed on to boats ready to build the houses from a kit of parts; so that Scandinavian skill with flatpack construction goes back over a thousand years. The Faroese settlers set out from Norway around AD 800 and we retrace their passage, back to their homeland, to explore the longest coastline in Europe: we're heading into the lair of the Vikings.

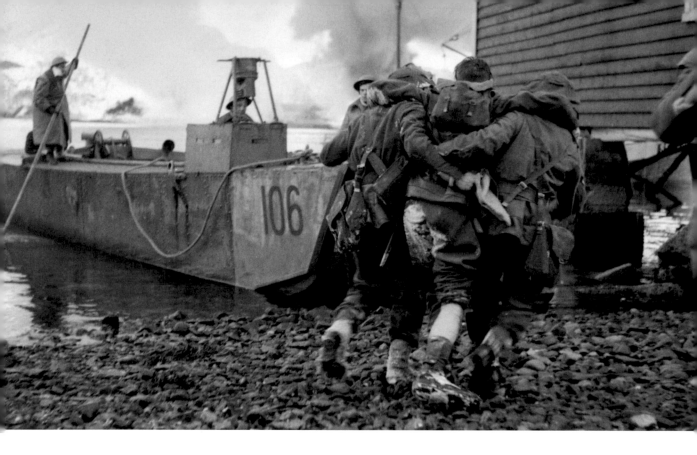

Operation Claymore

Approaching a foreign coast by boat for the first time you may be forgiven for feeling a knot of anticipation in your stomach, but we're here to find out how Britain and Norway have a shared history, reaching out in friendship and in war across the North Sea. Imagine how British commandos and their Royal Navy comrades felt as they steamed in secret toward Nazi-occupied Norway, their destination a cluster of islands off the coast about 100 miles north of the Arctic Circle. In the early hours of 4 March 1941, the Germans occupying the Lofoten Islands were unaware that British and Norwegian forces were about to make a daring raid: Operation Claymore was under way.

By 1941 the Nazis were masters of western Europe, supremely confident of their iron grip on the region but this raid was the beginning of the fight back. Part of Churchill's strategy was to harass German occupying forces up and down the North Sea and Atlantic coasts of mainland Europe. After final training on the Faroe Islands a flotilla of ships under a naval

▲ The raid on the Lofoten Islands resulted in the destruction of ships and munitions factories. There were casualties but no loss of land or naval forces, and the operation was a great boost to morale.

escort of destroyers headed for the Norwegian coast. The Allies entered the harbour at Svolvaer under the cover of darkness: German soldiers, officials and collaborators were rounded up, fish-oil factories being used to make glycerine for munitions were destroyed and the drama of the operation was captured on film for the newsreels. As the euphoria of success wore off the world viewed the raid on the Lofoten Islands as a vital morale booster, albeit with little real strategic value, but a handful of people knew that a chance discovery during this raid would help change the course of the Second World War.

While ships blazed in the harbour a group of brave British soldiers climbed aboard the *Krebs*, an armed German trawler. Before it sank they managed to recover a priceless prize. The most valuable item on the enemy trawler was their Enigma cypher machine, a device used to send coded messages. The German

THE ENIGMA MACHINE

The rotors of an Enigma machine (pictured below right) are a set of odd-looking wheels a few inches in diameter with cogs around the perimeter and letters stamped into the metal rim. They were the heart of what was essentially a fiendishly complex 'typewriter' to turn military communications into code. Type a letter on the Enigma and it makes the geared wheels rotate, producing a message you could only read with another machine with the rotors set the same way. Another vital element in the system was a 'code key', a list of characters that acted somewhat like a PIN number for an Enigma machine. The Germans usually obeyed the golden rules of encryption to the letter – code keys were changed every day and the old ones destroyed – except the German officers on *Krebs* had kept their list of old code keys. It was an oversight that helped break the seemingly impenetrable Enigma Code.

crew of the *Krebs* had managed to throw their Enigma machine overboard but in the terror and chaos they had forgotten something. During a hasty search of the ship before it went down the British troops came across a wooden box with some documents, which, following the standing order to collect any important-looking machines or papers, they retrieved. Their diligence paid enormous dividends: the box contained lists of code 'keys' and rotors for a naval Enigma machine, which just happened to be among the most precious secrets of the German military.

The rotors and list of code keys seized during the raid on the Lofoten Islands were sent back to Bletchley Park, the British code-breaking centre in Buckinghamshire. The boffins at Bletchley had seen rotors before, but the list of keys was truly priceless: it meant the British were able to decode enemy messages that had been sent during February 1941, and that led to further captures of code information, allowing the Allies to read German naval messages between March and June of 1941. That seemingly small raid on the Lofotens, taking the Nazis by surprise, helped to shorten the war and saved countless lives.

Boat versus car

The north of Norway has always been linked to the south by the sea – far quicker than working your way around the fjords that can cut over a hundred miles inland – but it's only relatively recently that regular sailings have run. In the nineteenth century the Industrial Revolution was making the south progressively more prosperous while the wild north was falling behind. To try to offset this disadvantage, in 1893 the Hurtigruten boat service was initiated to carry mail and other cargo into the far north. Soon the Hurtigruten, which roughly translates as 'Express Route', grew to be a fleet of ships, making it possible to travel the entire length of the country on a scheduled service. The ships carried the mail right up until 1983 when air and road finally took over; nowadays it's more of a tourist service, but still a spectacular way to see the shoreline.

To cope with their long, thin country and challenging coastline the Norwegians have been constantly inventive, even building roads across the sea. In the

year the Hurtigruten was relieved of its postal duties, construction started on the Atlanterhavsveien – the Atlantic Road. When it opened in 1989 it became a serious contender for the world's best road trip. On average it took over a year to complete each mile: no wonder it was voted 'Norwegian Construction of the Century'. Eight bridges cross between tiny islands and provide 5 miles of pure motoring pleasure.

The pipe of power

Our connections coast to coast with Norway continue at Nyhamna in Aukra in mid-Norway but the links are futuristic not historical: this is the site where a pipeline starts that runs hundreds of miles along the seabed, like a steel umbilical cord stretching all the way to Yorkshire. The pipeline, a mere yard or so wide, can supply up to one-fifth of Britain's gas requirements.

The Ormen Lange gas field lies some 70 miles off the Norwegian coast and nearly 2 miles below the waves. *Ormen Lange* (or 'Long Snake') was the name of a Viking longship powered by 60 oarsmen,

▲ The Atlanterhavsveien, more rollercoaster than road, is a major tourist attraction in its own right, so don't expect to have the ride all to yourself.

whose voyages were chronicled in the Norse sagas; the natural gas from the field will head south down the route the Vikings took to England's east coast coming ashore at Easington in Yorkshire. Constructed of 40-foot lengths welded together and laid over two summers of relatively calm seas, at 746 miles long it's the world's longest subsea pipeline.

All this engineering effort doesn't come cheap but rest assured we'll be paying handsomely for up forty years – that's how long the gas is projected to last. The Norwegians hardly use any gas themselves; instead they exploit hydro-electric power to meet nearly all their needs, including running the plant that will export energy to us. In contrast we've gobbled up virtually all our North Sea gas supply; in the 1990s with the privatization of power generation the new companies made a 'dash for gas' and we've been burning it to generate electricity as well as heat our homes so now we're gas junkies who have to go abroad for our fix.

Viking fish salesman

The Lofoten Islands feel like a mystical land, one where there's a palpable sense that the spirits of ancient Norsemen cling like mist to the mountains. This little group of islands sits deep within the Arctic Circle, but the surrounding sea isn't as cold as you'd imagine. The waters are washed by the Gulf Stream and the relative warmth attracts huge shoals of cod. And fish always attract fishermen: in the boom time thousands of men would be drawn to the Lofotens every winter and they needed somewhere to stay.

On the island of Svinøya you can still see the 'rorbu', the small red cabins that were built to accommodate an army of fishermen, sleeping two, even three to a bunk. They packed their catch of cod just as closely, hanging them up in pairs on huge A-frames built in the open air so the fish would dry slowly in the sun and wind during the spring, a trick they took from their Viking ancestors. This air-dried cod is called 'stockfish', the fast food of the first millennium. It sustained the Vikings on their long sea voyages because drying the cod in the salty Lofoten air preserves it for ages.

We asked Neil Oliver to give the stockfish a try. He failed at the first hurdle, not getting near his mouth because he couldn't stand the smell. He commented: 'I've eaten some things in my time, but I draw the line – this is beyond rank. I tell you, if this was what the Vikings ate, as well as being terrifyingly violent, they must have had breath that would stun a monkey!' Tastes have certainly changed because back in the tenth century Europe was gobbling up this stuff and the Norsemen had a prized product on their hands. You don't think of the Vikings as fish salesmen but as Christianity became established the church began to discourage eating meat on Fridays, so fish was on the menu. As stocks of fresh fish fell dried cod was in demand, a hunger that helped to make the Vikings wealthy.

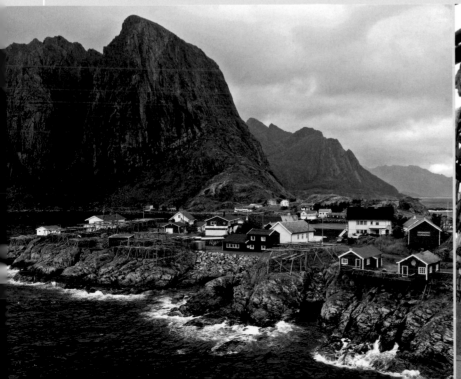
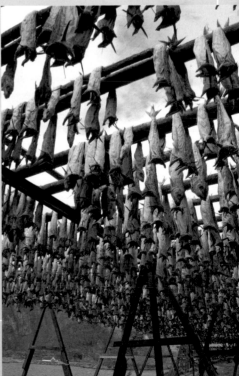

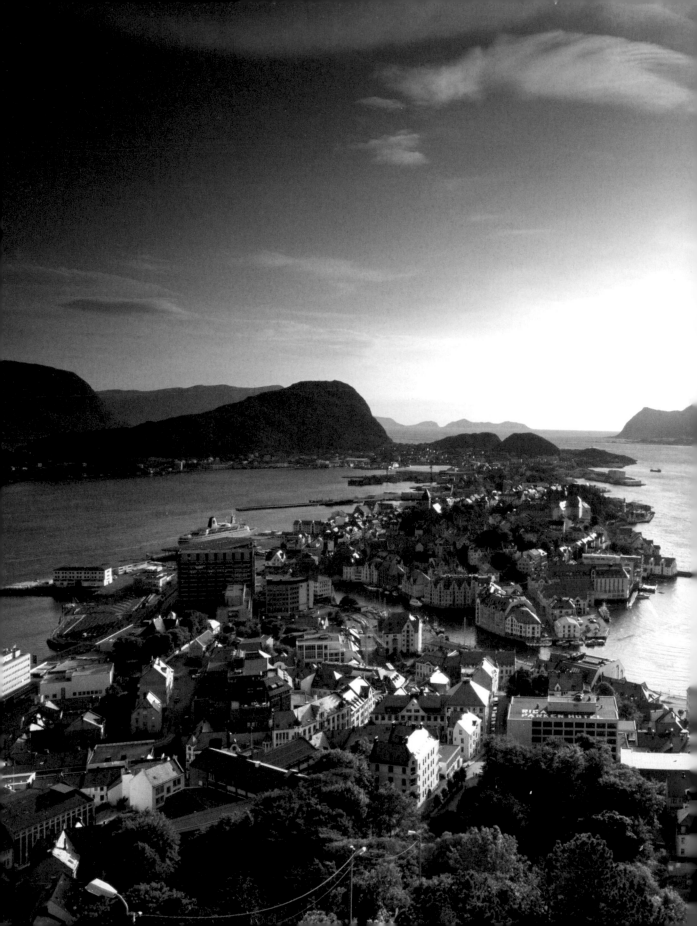

Art and architecture

I'm sure they have very strict rules about playing with matches at the Nyhamna gas plant, and I dare say it's similar a little further south in Alesund because the town is famous for having been totally destroyed by fire. In January 1904 a small blaze started in the town and spread like wildfire does through tightly packed wooden houses. The entire town burnt to the ground and 10,000 people lost their homes, a tragedy that shocked the nation, spurring them to completely rebuild Alesund in just 3 years. And it wasn't a botch job either: the new town was constructed in the cutting-edge design style of the age, Art Nouveau.

Art Nouveau had its roots in the British Arts and Crafts movement so the town bears the influence of our isles but, as the locals will tell you, a lad from these parts had far greater impact. Gange-Rolf or 'Rollo' was a Viking chieftain who around AD 900 invaded the area of northern France now known as Normandy. Rollo was the forefather of William the Conqueror, who certainly made his mark on Britain. As a result of the Norsemen's conquests many people on our islands share an ancient bond of blood with the Vikings.

Besides DNA there's an even more elemental link between our lands, one that's written on the rocks. There are some 200 fjords in Norway and the longest snakes over 120 miles inland, taking the coast deep into the heart of the country. These signature rock sculptures are famous in fiction as the work of planet designer Slartibartfast who, in *The Hitchhiker's Guide to the Galaxy*, got a special award for all the effort he put into designing the coastline of Norway. In reality the architect was ice, a giant sheet of ice that stretched from Norway to Britain, as far south as Norfolk. Over 20,000 years ago, when our countries were in the grip of the big chill, a colossal crust of ice was

◀ Alesund is one of the best examples of Art Nouveau architecture anywhere in the world, set against a backdrop of fjords and the Sunnmore Alps.

grinding away all but the toughest rocks, sculpting the peaks of Scotland, gouging valleys in the Lake District, and forming fjords in Norway.

We think of the ground beneath our feet as immovable – the bedrock we build on – but it isn't solid, it's spongy, and a sheet of ice a mile high forced our flexible landscape into submission as it bent and sank under the weight of frozen water. When the ice melted the rocks relaxed, as if breathing a monumental sigh of relief, and the land literally rose up. We are still feeling the effects today. The north bore the heavy burden longer because the great melt started in the south of Britain working upwards. So as Scotland recovers, the land is rising and – just like a giant see-saw – the south is sinking. There's no need for alarm though, the movement is only a fraction of an inch a year, but with sea levels set to rise every little counts.

The finest fjord

Like Scotland, Norway is on the way up; the rocks are gradually rising out of the water to reveal steep-sided chasms cut by successive ice ages. Picking a favourite of these fjords isn't easy but the general consensus goes with Geirangerfjord as the one that stands out from the pack. The dramatic beauty of this stunning site played a crucial part in securing the surrounding area World Heritage status as a globally important landscape. Geirangerfjord is 9 miles long and up to 700 feet deep. The spectacular Seven Sisters waterfall adds to the attraction as do the nearby glaciers, their clay-rich meltwater colouring the fjords a gorgeous turquoise. What's wonderful about the coast of Norway is that it's possible to see the same

◀ Geirangerfjord in the Sunnmøre region, rightly described as one of nature's masterpieces, is an ongoing sculptural experience that's made all the more unmissable by the Seven Sisters waterfall.

▲ The Vikings vanished into legend but their clinker boat design lives on. To make the craft watertight the planks are bound tightly together with special nails that are secured like rivets, being hammered simultaneously on both ends with a satisfying 'clink'.

forces that shaped much of Britain still at work: water and ice following factures in the rock, carving out this country as they did ours.

In the Geirangerfjord area the faultlines in the bedrock along which the fjords are formed run parallel and perpendicular to the shoreline. These characteristic zigzag cuts penetrate deep inland, creating the signature twisty topography. If you were to follow the ins and outs of every bay and majestic fjord, the trip would be 13,000 miles, that's over half way around the world. And if that weren't enough another hangover from the ice age extends the length of Norway's coast even further. Myriads of micro islands, or 'skerries', are scattered all along the shore. These are the pointy tops of rock channels scoured out by ice. The lumpy landscape that lurks underwater randomly poking its head above the waves makes it hard to know exactly where the land stops and the sea starts.

Master mariners, clinker craftsmen

Norway's twisting, turning waterways represented a challenge that would spur the early boat builders on to greatness, and once the Vikings had mastered their own craggy coastlines they turned their sights to the wider world. One theory suggests the growth of population in the eighth century encouraged expansion, driving the Vikings to leave their Scandinavian shores, but no one really knows why they risked the vast unknown. Whatever their motivation these master mariners undertook epic voyages into uncharted seas: west to Newfoundland in North America and east, navigating down the River Volga, into the Caspian Sea to trade with what is now Iran. And of course they came south to the British Isles using our waterways to penetrate deep inland. The key to their success was the ability to built boats that could ride raging seas and power through placid rivers.

Viking ways of working with wood have survived at a few boatyards, like the one tucked away down the Hardangerfjord at the town of Norheimsund where they specialize in building clinker boats. The Vikings didn't invent clinker construction, but they were supreme practitioners of the art. The technique uses wooden planks overlapped one on top of the other from the solid backbone of the sturdy keel that runs along the bottom of the boat. A key feature of a clinker-built boat is that instead of being fixed to an internal frame the planks support each other, which makes the vessel flexible so that it bends enough to ride rough seas. In addition the flattish bottom of the clinker craft can cope with shallow rivers. The Vikings exploited these advantages to take their terror and trade across wild oceans, then navigate their way along calmer waterways in the heart of the territories they targeted.

Good as clinker boats are, their design has one serious drawback: the lack of an internal frame limits the size of ship you can build. Too big and the hull becomes so flexible it can't hold itself together. Ultimately size did matter and a different style of vessel came to dominate the high seas. Carvel construction starts with a frame over which the planks are fixed edge to edge, making a characteristically smooth hull. The result is a strong design that can take a greater weight of sail than its clinker cousin and produce much bigger ships. The yachtsmen who come from far and wide to test themselves on the southern shore of Norway's Riviera mostly sail in carvel-style craft. Every summer little towns like Lillesand welcome boatmen who've journeyed from Britain; their boats may be different from the Vikings but maybe they share the secret that drove them on their epic voyages: they do it because it's fun.

The city of rain

Bergen has its feet in the sea and its head in the clouds. Back in 2006 it started to drizzle and didn't stop for 85 consecutive days. Exceptional that may be but Bergen is wet, its microclimate created by seven mountains that surround the city, keeping the clouds hanging around. As well as an obsession with the weather we share another link with the burghers of Bergen: 700 years ago the city was Norway's commercial capital, trading with Britain and beyond. Bergen was the northern outpost of the Hanseatic League, a sort of early Common Market. In fact it's been a destination for foreign traders and travellers for almost a thousand years, and I'll bet most of them came by boat.

❤ Bergen's prosperity produced a picturesque port, where authentic reconstructions of the old haunts of the Hanseatic League traders line the waterfront.

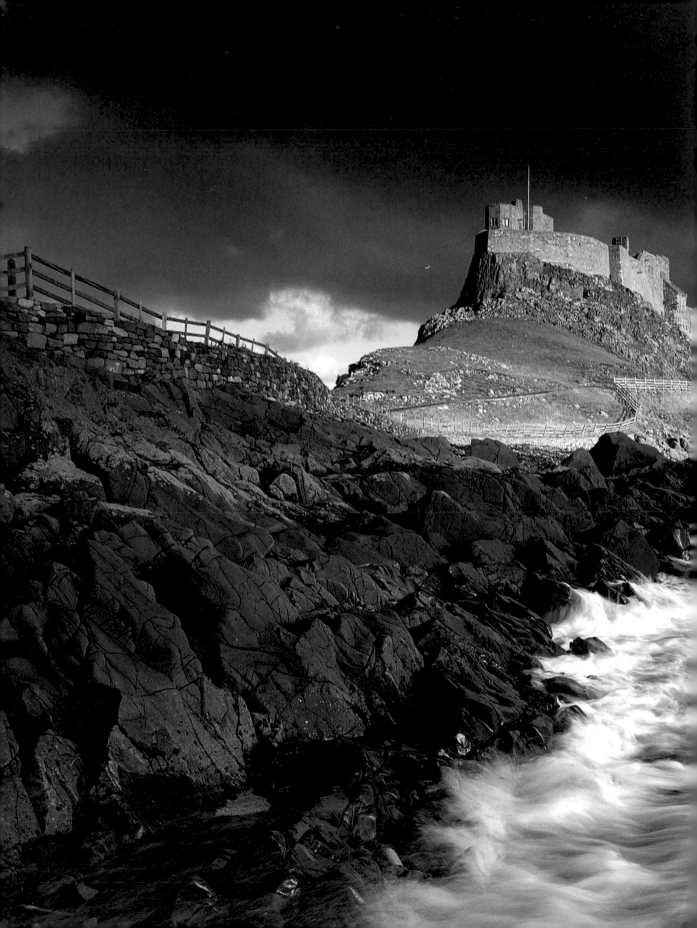

We've crossed from Norway back on to home turf, but the Vikings will pop up again because they were a major force in shaping the history of this coast and helping to create England. The final leg of our journey takes us from the northernmost town in England, Berwick-upon-Tweed, to the maritime heart of its greatest city.

The East Coast: Invasion to Empire

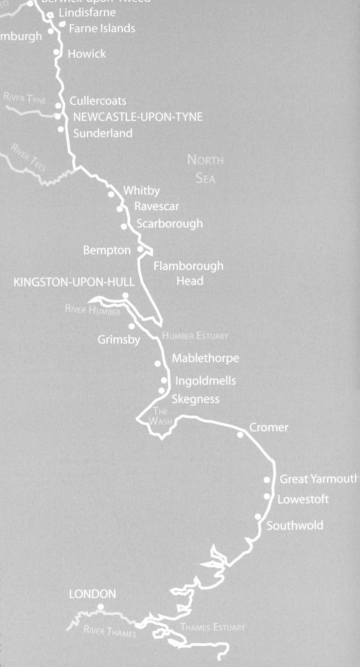

On our way down to London I want to share some special places, where the echoes of the past are still present, and there's a tangible, visceral connection to those who shaped our destiny. This coast doesn't give up its secrets easily; in fact, some of the events along its stretch are so distant they have faded from our memories. The eastern shore was vital to our early adventure as island people and it remained influential as commerce developed with Europe, until eventually new worlds opened up and we turned to face the Americas. Let's travel south in search of landscape that bears the scars of people pushed to fight, to toil and to invent.

England v. Scotland

Berwick sits on the shoulder of England's east coast, a stone's throw from the Scottish border: Edinburgh is just 50 miles away. For a relatively small town it has much to boast about: around 250 listed buildings arranged in a fabulous setting. My abiding memory of Berwick is calmness, as if even today it must remain quiet lest it rouse the anger of sleeping giants who for centuries tore the town apart. In a period of 300 years of conflict between England and Scotland, Berwick changed hands no fewer than 13 times, and for good reason.

◀◀ Lindisfarne Castle on Holy Island was built in Tudor times and renovated at the start of the twentieth-century. It is accessible only at low tide.

Before Edward I captured the town for England in 1296, Berwick was the richest port in Scotland, ideally placed for trade with northern Europe, exporting wool, grain and salmon. Traders from Germany, Flanders and the Baltic States made Berwick a thriving, cosmopolitan centre. That prosperity made it a desirable prize; battles were bitter and bloody, and it's hard to imagine the horror of the ethnic cleansing that took place here

between Englishman and Scot. By 1502 they had fought each other to a standstill, with Berwick in English hands, and the ambitiously entitled Treaty of Perpetual Peace was meant to end the warfare for ever. It lasted just 11 years.

To secure Berwick as English, Elizabeth I built a set of massive ramparts that proved to be the single most expensive project of her reign: more money was spent here than on defending the realm against the Spanish Armada. The finest fort builders of the sixteenth century were the Italians, who developed innovative geometric designs to combat the new threat posed by cannons that could breach traditional stone walls. The layout of the low, thick earth-and-stone ramparts at Berwick was inspired by the *trace italienne*, the Italian 'star forts', whose walls were arranged to provide covering fire between the defenders' cannons. Their imposing presence is an imprint on the psyche of a town that even today, 500 years after the end of hostilities, has sympathies with both sides of the argument. It may be an English town but Berwick Rangers play in the Scottish football league and in a 2008 television poll over half of the people that voted wanted to be part of Scotland.

▲ Beautifully astride the Tweed, Berwick's elegant bridges unite a place divided by nature and – for much of its history – by political strife.

At war with Russia

Given its painful history you might think the people of Berwick would be obsessed with battles between the Scots and English but in fact the war that everyone talks about nowadays is the one between Berwick and Russia. When the Treaty of Perpetual Peace was signed between Scotland and England in 1502 the thorny issue of who got Berwick was fudged in fine diplomatic style by giving the town semi-independent status. This distinction led to the story that when the Crimean War against Russia began in 1853 Berwick was mentioned separately in the declaration of hostilities but not cited in the peace treaty; hence it is still at war with Russia. Strange but fortunately not true; the lawyers had got there first, because the Wales and Berwick Act had been passed in 1746 to ensure that all future laws applying to England would also apply to Wales and Berwick-upon-Tweed. Credit

for the origin of this tall tale about the Russian war has been given to Archdeacon William Cunningham (1849–1919); perhaps he thought the story would brighten up his lectures. It certainly has enduring appeal and is a useful weapon in the armoury of the tourist board: the town has staged a 'war with Russia' weekend. There's no need to worry about Berwick's anomalous position in the UK, it was all tidied up in the Reform Act 1885 when the county of Berwick was included in Northumberland … or was it?

The threat of battles at Berwick eventually ended in 1707 with the Act of Union between the Scots and their 'Auld Enemy' the English. A long time before that though, only a short distance down the coast, it was the appearance of a fearsome new enemy that would actually create the nation of England. In AD 793 the spiritual peace on the Holy Island of Lindisfarne was shattered when Vikings slaughtered the monks, an event that marked the beginning of our fear of and fascination with these seaborne raiders. *The Anglo-Saxon Chronicle* records the 'harrowing inroads of heathen men made lamentable havoc in the church of God in Holy-island, by rapine and slaughter'.

Fear forges a nation

The monks arrived on Lindisfarne in AD 635 on a mission to convert pagan Northumbria and the surrounding kingdoms to Christianity. They used sea routes to take their message around the coast and walked over to the mainland using the land bridge revealed at low tide. I've made my own pilgrimage across that causeway following in the footsteps of those holy men, and I found the island stark and slightly spooky. Standing on the shore you can appreciate the ancient belief that the meeting place of land and sea brings you closer to god. Being compressed between the endless horizon of surf and sky certainly gave me a special moment of reflection if not spirituality. I'm

sure this hauntingly atmospheric landscape must have inspired the monks in their daily devotions. Following the death of their leader St Cuthbert in AD 687 the *Lindisfarne Gospels*, a collection of the beliefs and ideas that came to dominate Britain for a thousand years, were produced in his honour. The beautifully illuminated manuscripts were bound into a book, which lost its jewel-clad leather cover in the Viking raids but otherwise miraculously survived intact, and is now safely locked away in the British Library.

If the Anglo-Saxons were to survive the Viking raids, people who had previously squabbled with each other came to realize that in the face of a common enemy from across the sea they needed to unite. Gradually, as they came together, a new nation was born. In the south Alfred the Great finally defeated the Danish Vikings in AD 878 and went on to style himself as 'King of the English'. It took many more decades, though, to drive the Vikings away from the west coast. In AD 937 Alfred's grandson led an army into battle against an alliance of the Norse King of Dublin and the King of the Scots, with Welsh and Cornish mercenaries possibly thrown in for good measure. Their defeat at the Battle of Brunanburh was a defining moment for our islands: despite the loss of five kings, seven earls and countless warriors on one day, and although the Vikings were not entirely banished, the battle marked the moment when previously disparate kingdoms in the south came together to form the Anglo-Saxon nation. It's odd, given the importance of this epic encounter, that no one knows where it was fought; sites from Devon to Dumfries have been suggested but one recent theory puts it on the Wirral, close to where the Lever Brothers would much later make Sunlight Soap!

◄ Italian by design: Elizabeth I's costly star-shaped fortifications at Berwick were never tested in anger and they retain a pristine, just-finished quality, the trimmed grass giving the feel of a neatly tended memorial, rather than a weapon of war.

Seal heaven

It isn't just monks who seek sanctuary on this coast. A few miles south from Holy Island and a little further offshore are the Farne Islands, a rocky kingdom ruled by the seals. The number of the islands varies between 15 and more than 20 depending on the level of the tide. That's how closely these isles flirt with the water, making them the perfect home for our largest native mammal, the Atlantic Grey Seal, which is equally happy on land or sea. These isolated islands have one of Europe's largest grey seal colonies. Our coastline used to be home to hundreds of thousands of grey seals, but they have been hunted for centuries. A hundred years ago there were as few as 500 left, so in 1914 hunting seals for their fur was outlawed with the passing of the Grey Seals Protection Act, the first-ever legislation to protect a mammal in this country. But that protection was short lived: many blamed the resurgent seal population for the collapse of local fish stocks and Parliament legislated again, hunting grey seals resumed and continued right into the 1980s until public outcry finally put an end to the killing.

▲ Grey seals again rule the waves around our coast and islands. Now that these blubbery beauties are protected species, they can live for up to 35 years.

Hunters had an easy job picking off the seal pups because they sit exposed on the rocks while the adults feed out at sea. The birthing season (August–September) is the best time for modern stalkers, armed with cameras or binoculars to see these animals on land. Rangers also take this opportunity to count the newborn as it's easy to get close enough to mark their coats with dye to indicate which juveniles have been registered. The pups only keep their white fur for about 21 days before shedding it to gain their pristine adult coat free of the dye. It's estimated there are currently some 140,000 grey seals in the waters around the UK – approaching half the world's population – so although they still face problems the conservation of grey seals is a great success story for our coast.

The seals exercise their flippers with a quick once-round the Farne Islands but if you fancy stretching your legs, I reckon the best place around here is just a couple of miles away on the beach at Bamburgh.

BAMBURGH CASTLE

Bamburgh Castle is visible from land or sea for miles along the coast. The site was originally chosen by the sixth-century kings of Northumbria for its commanding position and the fact that it had a natural harbour. The first castle was destroyed in Viking raids but the location was too good to leave to nature. Within fifty years of the Conquest those prodigious castle-builders the Normans had produced another formidably fortified castle that stood until the end of the Wars of Roses. The fate of Bamburgh seemed sealed with the invention of the cannon, and it fell into disrepair. Its final abandonment by James I reflected the decline in fortunes of the northeast coast at the beginning of the seventeenth century as the political importance of the border regions ebbed away. However, Bamburgh was restored by the nineteenth-century industrialist Lord Armstrong as a fantasy castle, which explains why it looks for all the world like Lancelot's Camelot.

There's a good mile or so of great sand with a raised bank of grassy dunes that enclose you in a panoramic theatre of sea and sky: perfect for a brisk walk and 'dog friendly' too. You and your pooch will also take in a fabulous view of the red sandstone castle perched on a basalt crag. Being a movie fan, Bamburgh Castle reminds me of the one shown at the end of the 1961 historical epic *El Cid*, where a dead Charlton Heston, in the part of a legendary eleventh-century knight, has been strapped on to his horse for a defiant ride down the beach towards the enemy in order to rally his troops one last time. I'm sure, like me, you'll be impressed by the grandeur of the castle but ultimately it's just a big, fancy house. Just a little further down this coast is the site of a much more humble home, which, whatever it lacks in the iconic stakes, it amply makes up for in importance.

Britain's first house

A few years ago amateur archaeologist John Davies was out for a stroll around the shore near Howick when he noticed some fragments of flint sticking out of the cliff edge. To you or me they probably wouldn't even register, but John's trained eye recognized that they might be flint tools. I'm still willing to bet he didn't realize just how amazing his find would turn out to be. When experts from Newcastle University started to excavate the site they were astonished to discover the remains of the earliest house found in Britain.

Imagine the time when the great ice sheets that once covered much of Britain were finally melting. As the land became habitable people moved in and the 10,000-year-old house discovered at Howick tells us how our earliest island ancestors started to settle in. Archaeologists have been able to establish a lot about the way the house was constructed around a frame of long wooden poles angled to form a tepee shape. As archaeologist Clive Waddington told us: 'On the outside of the hut, just round the edge, we found these stake holes which were angled towards the apex of the roof. We can measure from the angles of those stake holes what the pitch was. They were around 65 degrees, which made for a really steep roof.'

That pointy roof was probably covered in turf supported by a web of birch and hazel twigs strung between the supporting poles. A series of hearths containing

The Women

Honest toil in the face of mighty forces is a feature of coastal life and for the Victorian women of Cullercoats times were tough. Cullercoats is now part of the urban sprawl around Newcastle, though in the nineteenth century it was a thriving fishing village with a curious claim to fame: men came from far and wide to paint pictures of its hardy womenfolk. They were renowned for their strength and stamina, the result of carrying baskets of fish to sell to neighbouring villages.

Colourful as they seem, tales of resilient women are fairly common around the coast. What drew our attention to these ladies in particular was a wonderful painting called *The Women* by Bamburgh-born artist John Charlton (1849–1917). It depicts a group of villagers, mostly women, hauling a heavy wooden lifeboat in order to launch it to the aid of a stricken ship floundering off the coast in 1861. Everything about this bold, heroic image makes you want to know more.

You'd expect a little artistic licence of course but it turns out that Charlton's painting is a long way wide of the mark: horses were the fillies that did most of the pulling. So what was Charlton up to? Apparently he wanted to honour not only the women of the town but also an artist whose paintings had already made the ladies of Cullercoats internationally famous.

In 1998 Microsoft chairman Bill Gates paid $30 million for *Lost on the Grand Banks* by the painter Winslow Homer (1836–1910). Homer, rather surprisingly, lived in Cullercoats from 1881–2 to paint the fisherwomen. He produced numerous haunting studies of their harsh coastal life. John Charlton was following Homer's brush strokes when, some twenty years later, he painted *The Women* as homage to the master's style. His painting is not a record of events, more an attempt to capture the spirit of a place and its people, and the work has helped to elevate their lives into legend.

burnt hazelnuts discovered inside the house allowed the team to work out that it was occupied for around two hundred years and continually refurbished during its long life. So, forget the idea that Stone Age people were backward cave dwellers: 10,000 years ago people were no less intelligent than we are and in fact they made ingenious use of their resources and were masters of skills lost today.

The early settlers clung to the coast because it nurtured them so well. Out at sea were rich pickings in the form of fish and other marine life, which also attracted birds, and on the shoreline were seals, seaweed and shellfish as well as eggs from the nesting sites of seabirds. Inland the dense woodland where large numbers of animals roamed provided our hunter–gatherers with a natural larder. Evidence from other sites around Britain indicates that Stone Age people weren't just content to take things as they found them; instead they modified the natural environment, for example, clearing the forest by burning trees to provide open areas, making it easier to hunt. Eventually they looked away from the sea and set about clearing vast tracts of woodland – first with stone axes, then with copper and bronze blades – and so the move inland began.

It would be easy to think of life as a series of harsh struggles for those first Britons but maybe another picture is emerging, one of small family groups housed in warm, sturdy homes and living off coastal lands of plenty. Now that that doesn't sound so bad, and there's little evidence of hierarchies in these early societies: no big chiefs, kings and queens and no great organized conflicts or armies; perhaps it was a 'Golden Age'. When we stand on the shore we can connect directly with their experience, walk in their footprints, inhabit their world. On the coast we come back home, to where our story as island people began and – silly as it may sound – when I'm there sensing the presence of our ancestors I hope we haven't let them down.

Life on the edge

Life in the Stone Age may have been easier than we imagined but on this same stretch of coast great shipyards grew and died as workers struggled against a storm of change that blew through their industry. The founder of Standard Oil in the USA, John D. Rockefeller, arguably the richest man the world has ever seen, is quoted as saying: 'I believe in the dignity of labour, whether with head or hand; that the world owes no man a living but that it owes every man an opportunity to make a living.'

Opportunity knocked for the people of the Northeast as powerful industries emerged in the nineteenth century. In 1840 Sunderland had 65 shipyards but little over a hundred years on the 'dignity of labour' had gone from the yards and the region's prosperity dwindled as iron and coal were replaced by oil and steel. The strength of steel would ultimately expose a great weakness in the Sunderland shipyards, and one of the things that would tear them apart was the tiny component that once held everything together, the rivet.

Rivets are small cylindrical plugs of metal used to pin steel structures together. The rivet is heated until it's red hot, inserted into a hole drilled through two steel plates and its ends bashed flat so that it holds the steel sheets together. As the rivet cools it contracts, pulling the plates even tighter against each other. It was used for all sorts of steel structures, not only ships: the famous Tyne Bridge with its majestic metal arch is held together by nearly 800,000 rivets. A good-size cargo ship would contain about half a million rivets so it's easy to understand why ship-building was so labour-intensive and not only did you need a lot of people, you also needed to have a lot of skill.

Riveters worked in teams or 'squads' and a squad might do 900 rivets in a day. First a 'heater' got the rivets cherry red in a stove, then passed them – or often threw them – to a 'catcher'. The catcher's job was to rush the red-hot rivet to a 'holder up' who

WHITBY JET

Whitby lies at the heart of North Yorkshire's Jurassic coast, a 7-mile slice through sedimentary rock formed when the dinosaurs waded through tropical swamps here. The big beasts have gone but a glorious legacy of that age still serves the town well. Whitby has rich deposits of black jet, a substance that can be cut and polished into elaborate items of jewellery. Jet became a 'must have' accessory when Queen Victoria took to wearing it after the death of her beloved Albert. What hung around her neck were lumps of monkey puzzle tree, driftwood that floated out to sea 180 million years ago when Whitby was much closer to the Equator, sank to the ocean floor and after ages of being subjected to great heat and pressure re-emerged from the rock laid down on the seabed as jet. Jet beads have been found in Bronze Age burial places. The shiny stone may have been worn to ward off evil spirits.

inserted the rivet in the hole connecting two of the ship's panels, and the 'riveter' pounded the rivet home. The din of battering metal was so horrendous riveters used sign language instead of calling out the sizes they wanted. The squads were tightly knit self-governing units; they were paid per hundred rivets completed and the money shared between the team so it was in everyone's interest to ensure each team member pulled his weight. And when the men were called up to fight in two world wars, women were trained to maintain production.

The Second World War became the high point of riveting because during the clamour for more and more ships a bright idea was hit upon that blew rivets away. In the dark days of 1940, German U-boats were close to bringing Britain to its knees. We desperately needed more vessels to replace those being sunk, for without them the vital transatlantic supply lines would be cut. So Churchill placed an order for 60 cargo ships and, with British shipyards at full capacity, the contract went to companies in the USA. But the Americans had neither the time nor enough skilled people to put in half a million rivets per vessel. Instead they adopted a faster method

of joining panels, they welded them. Welding had never been used before on such a scale, but the upshot was that ship's hulls were fabricated in a fraction of the time it would have taken to rivet them together. To maximize throughput the whole production process was re-engineered. The Americans had purpose-built massive new shipyards where large sections of a vessel were constructed separately and then craned into position to be welded together. The American genius for mass production meant that soon ships were being built in less than 50 days.

The crack of doom

But the welded ships were not without their problems; some inexplicably and alarmingly broke completely in two. Although the welds were suspected of causing the failure British engineer Constance Tipper discovered the fault lay with the steel, which could become brittle and crack once it encountered the icy water of the Atlantic. The riveted joints between separate plates stopped such cracks growing but on a welded ship there was nothing to prevent them propagating around

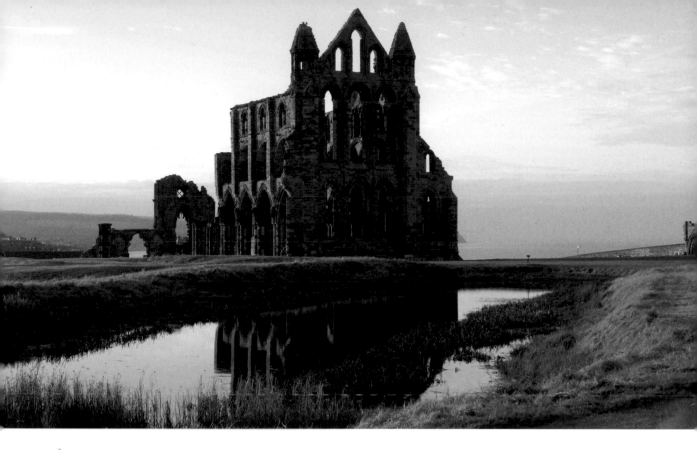

the entire hull. Despite the inherent design fault, over 2,000 ships were produced and only a few suffered catastrophic failures, which caused a vessel to sink. President Roosevelt said this vast fleet of ships would bring liberty to Europe and the 'liberty ships', together with their brave crews, played a vital part in helping to keep Britain supplied and Europe a free land.

The techniques of welding and pre-fabrication used to build these ships would spell the end for riveting. The problem of cracking was solved and the speed of welding together with the strength of new types of steel meant ever-bigger ships could be built, but of course mass production requires lots of space. The old British shipyards didn't have the room to expand, which was a major reason for their struggle to cope with the new welding age. Along with thousands of jobs the camaraderie of the riveter's squads was lost. It's heartbreaking to see how these communities were fractured, but let's not forget how tough their working conditions were: the incessant noise of metal beating metal meant that many heard the ringing of rivets in their ears long after the pummelling stopped. For the old shipyards of the Northeast the rest is silence.

▲ The peace and quiet are deafening at Whitby Abbey where the sense of spirituality is palpable.

Set in stone

Little remains of the shipyards north of Whitby Abbey but the stones here have been standing for around eight centuries although the Abbey itself fell into ruin in 1540 with Henry VIII's dissolution of the monasteries. The Abbey is evidence of the influence Lindisfarne monks wielded all along the Northeast coast. Long before this grand structure was built, the site was developed by St Hilda, the original Abbess, a Saxon princess whose religious training had been with the monks of Holy Island. As Hilda was taking up her calling in the mid-seventh century Christianity was tightening its grip on Britain but different factions had formed; in the South disciples believed in the teachings of Rome, whereas in the North the monks followed the Celtic tradition. In AD 664 they came together at Whitby to sort out their differences and Roman orthodoxy was adopted. Among other spiritual matters the religious heads agreed the method still used to calculate the date for Easter.

The town that never was ...

The gentle folk of Yorkshire looking to take an Easter break beside the sea can head off to classy destinations like Whitby and Scarborough which have been attracting visitors for over 350 years. But nestled between these two holiday hotspots is a resort like no other, Ravenscar, known as 'the town that never was'. Try a little experiment: if you've got a satnav, set it for Marine Esplanade at Ravenscar and your machine will probably recognize the road, but if you were to follow its instructions you would end up in a big, grassy field with no sign of the road, let alone a resort.

Marine Esplanade is there, or bits of it anyway. What remains is covered in years of vegetation although if you look hard enough there are clues to be found. Poke around and you'll find drains, paving stones; there's even an old railway platform. These artefacts are all that is left of a grand scheme hatched by a group of Victorian entrepreneurs who drew up detailed plans for a new resort on the Yorkshire coast. In preparation workmen laid roads, sunk drains and installed a mains-water supply; they even constructed a brickworks, all set to build the new town of Ravenscar. The entire infra-structure was laid out; the plan was to entice people to build their own houses and so a grand, new seaside town would be born. In the early 1900s champagne-fuelled auctions were held at the Raven Hall Hotel and estate company sold Ravenscar plot by plot. But they didn't exactly seal the deal: most new owners only paid a deposit and when they'd sobered up in the cold, grey light of morning their investment perhaps didn't have such a great outlook.

Even the locals will tell you the weather can be a little grim, a 'sea fret', basically low mist, is known to hang over the headland, which is not very conducive to taking the air. If you did fancy a walk on the beach you faced a 500-foot hike down a steep cliff, a challenge if you're wearing good walking boots but I wouldn't try it in one of those long Edwardian skirts … although, to be fair, they did build a monstrous flight of steps for the ladies but it never caught on. Perhaps the clincher was that after all that effort the beach isn't a beach but a collection of rather fearsome boulders and slippery seaweed stuff. Even those who bought plots didn't want to be the first to build and a paralysis of confidence strangled the life out of Ravenscar before it ever got going. If you fancy trying to make a go of it the roads may still exist but I'm afraid you've missed the bus: the National Trust acquired the land in 1977 and so 'the town that never was' will never be.

Strictly for the birds

As far as the genteel Edwardians were concerned steep sea cliffs were strictly for the birds and at Bempton Cliffs the birds don't seem to mind that at all. This is possibly the best seabird-city experience on our shores, and certainly a good site to get a great view. Bempton is an RSPB nature reserve that's home to about 200,000 birds: gannets, guillemots, razorbills, kittiwakes, fulmars and puffins all come and go during the period April–August. During the summer months as many as 100,000 kittiwakes check in here for a high-altitude ledge with a sea view. They are short-stay residents, spending the majority of their time way out in the North Atlantic, so on a rare flirtation with terra firma they take pride in their precarious pads. Most seabirds just pick a ledge and lay an egg but a kittiwake's nest is a relatively substantial structure and they can construct a nest on the narrowest of ledges, even only a couple of inches wide. Kittiwakes put down a firm foundation made of mud and grass taken from the cliff top, on which they sit out the summer until their little ones pluck up enough courage to launch themselves into the sky above the sea.

➤ At first sight, the vertical cliffs of Bempton look an improbable habitat but with a good sense of balance and a pair of wings the ridges in the soft chalk make perfect perches away from predators.

▲ Europe's longest single-span suspension bridge, the Humber Bridge, reduces the road distance between Hull and Grimsby by nearly 50 miles.

The mighty, muddy Humber

Our journey down the east coast comes to a natural pause at the Humber Estuary, a wide incision of water penetrating deep inland like a paper cut in the smooth low-lying coastline. The landscape is open, sometimes remote, with wide vistas over mudflat, marsh and other wetlands, some of it dyked and drained for farming, with urban and industrial concentrations, especially around Hull on its north side but also on its south bank. Some 20 per cent of the land surface of England drains out to sea through this great tidal estuary. Unsurprisingly the Humber has a long and varied history of commerce flowing through its substantial docks, trade with Europe being important early on and connections to the canal system seeing goods travel to the heart of the Midlands in the early 1800s.

By the end of the nineteenth century Hull claimed to be the third-largest port in the land. Wool came in from Australia and New Zealand, whaling ships stopped here for a good while and the fishing industry dominated the city until it too dried up. Yet of all our port cities Hull gets the least recognition; the arterial routes of Britain run north and south bypassing the great city in the east, and as we dash up and down the country it feels as if there needs to be a really good reason to take the M62 and wash up in Hull. It's fitting that two special places with great stories to tell about the importance of the city are themselves largely forgotten and uncelebrated.

Lifeline to freedom

Next to the railway station is an unassuming pub easily missed by the traffic that roars past its door, but over a hundred years ago its bar was a waiting room that connected countless families with a new life in the New World. In the late nineteenth century millions were desperate to escape Eastern Europe and make a fresh start, and for them Hull became a gateway to freedom and opportunity in America. Many were Jews escaping persecution in tsarist Russia where they had been confined to a region along the country's western border. Their brutal repression set in motion a mass exodus. Between 1870 and 1914 for over 2 million European refugees Hull was a lifeline. For many the first stage on a long journey was a train to Hamburg, followed by a 32-hour voyage across the North Sea to Hull. For the émigrés, the city was like an airport transit lounge today, a short stay in limbo between the old life in the east and a new life across the Atlantic. Fear of cholera outbreaks meant those in transit were escorted through town and a purpose-built platform was added to the train station along with a special waiting room that is now a pub. Hard to imagine the anxiety, fatigue and excitement of those who paused here on the brink of a train journey to Liverpool, from where they could board a steamship for America.

GRIMSBY DOCK TOWER

This 300-foot tower takes your breath away, a beacon of beauty above the docks. Completed in 1852 its design is based on the Torre del Mangia, the clock tower on the city hall in Sienna's famous public square, the Piazza del Campo. The handsome Italian-style jacket is made from bricks manufactured on the site and it conceals some ingenious engineering: this tower isn't for telling the time, or even for providing a look-out – and it's certainly not a folly – in fact, it's a power plant. Fresh water from a spring in the Grimsby chalk was sent over 200 feet up the tower in a cast-iron pipe and pumped into tanks with a 30,000-gallon capacity, a huge head of water, which provided enough hydraulic pressure to open and close massive lock gates, operate cranes around the dock site, control the gate of a new railway crossing and provide drinking water.

Perhaps as exhausted families sat in that waiting room, their first brief encounter with British soil, they dared to dream of a life without persecution. This is why millions of people in North America can claim to have a mainline connection to the pub at the end of a platform in Hull.

Out of the spotlight

Away from the docks and the lights of the city, out on the flat, barren marsh of the Humber Estuary close to Cherry Cobb Sands is a series of small concrete pools seemingly spread in a haphazard fashion over a wide area of oppressively flat terrain. With time and patience to explore the layout and geometry of these concrete pools they begin to tell a story of the bleakest time in the history of Hull.

In the early period of the Second World War the blitz of Hull was relentless, second only to London's in its ferocity. Hull's port and industrial facilities and its proximity to mainland Europe made it a prime target for bombers. Much of the city centre and almost all its housing was destroyed or damaged, leaving almost two-thirds of its population homeless. For reasons not recorded, the destruction of Hull was never made public: news reports at the time simply referred to bomb damage to 'a town on the coast'. Desperate times called for fortitude and ingenuity. The curious pools in the marshland are the remains of an attempt to fool Hitler's night-time bombers over the true position of the port. The pools marked out a pattern that mimicked the layout of a dock, and next to the shallow concrete tanks poles supported a light that shone down on the pool of water. The hope was that reflections in the water would trick the bomber crews into thinking that they were seeing low-level emergency lights left on in the docks at night and cause them to deliver their deadly payload harmlessly into the marsh. The decoy was augmented by electric sparks to suggest a passing tram and by blazing oil to look like fires caused by bombs that had already been dropped. The scheme had some limited success as did a host of others tried all over Britain. It's a struggle to find the site at Hull, let alone actually get out to the pools, which I guess is why they survive: the wet, cloying ground and bleak horizon send a chill deep to the bones; this isn't a happy place but it is a memorable one.

The camp Billy built

Leaving Grimsby, we follow the flat, windswept shore southwards down the coast of Lincolnshire, a coast that come rain or shine is always in the holiday mood. Cleethorpes, Mablethorpe and Ingoldmells together boast the highest concentration of caravans in Europe, attracting around 6 million visitors a year. But this region has a bigger claim to fame: it's the birthplace of Butlins. The first camp Billy built was at Skegness, which opened in 1936 and became the template for every holiday camp in the country. Billy Butlin was a gifted entrepreneur with an eye for a winner. He went to the exhibition venue Olympia in 1927, saw a US manufacturer demonstrate dodgem cars, and promptly invested every penny he could in a fleet of dodgems for his funfair at Skegness. Realizing he'd bumped into a big hit he went on to acquire the sole agency for selling dodgems in the UK and all of Europe. Billy built an empire on the thrills and spills of his bumper cars, shrewdly calculating that leisure was about to become an industry as powerful as any on this North Sea coast. In 1938 the Holidays With Pay Act was passed and for the first time millions of ordinary workers had a week's holiday with pay. Billy was happy to relieve them of that money, in return laying on everything for them at the camp and the novice tourists soon learnt to love Butlins.

It's funny to think in the staggeringly long history of our adventure as an island people that we go for the best part of 10,000 years before getting a week off with pay and then finally, when it comes, we flock to Butlins. We seem to have a very powerful urge to go back to where our story began and be beside the sea, but a question remains: how did people get on to these islands in the first place? Towards the end of our journey we find the answer at the charming resort of Cromer.

Discount the first answer you thought of: the people who first came to Britain didn't necessarily come by boat, they walked too. Up until around 8,000 years ago we were joined to Europe by a land bridge and there is evidence of this in north Norfolk. Generally the Norfolk coastline is pretty flat but not around Cromer. Just back from the shore is a 300-feet-high ridge that runs for about 9 miles. The ridge is made up of ice-age material that got carried in front of the great body of ice as it advanced south from Scotland and then dumped at the point where the last of the ice sheets to cover Britain stopped. The ice mass that covered the northern half of Britain was up to a mile thick and all that frozen water came from the sea, which meant that during the maximum period of glaciation, globally the sea was around 400 feet lower than the present-day level because so much water was locked away inside the ice sheets.

Great migrations

With the sea level so low a huge tract of land that is now the bed of the southern North Sea was exposed, forming a land bridge linking Britain and Europe that people and animals crossed. Animal bones dredged up from the North Sea reveal a lost world we wouldn't recognize today: the land between north Norfolk and Holland is known to have been at times barren tundra, and at others a sloppy marshland populated with elephants, hippos and rhinos. The evidence confirms that the climate was once very different and that ice ages – and coastlines – have come and gone over the last 700,000 years.

Great animal migrations didn't stop when we became an island. The water that flooded into the North Sea made the east coast a highway for herring. Vast shoals of the fish would appear around Shetland toward the end of April, heading south and eventually arriving in East Anglia around October. The herring didn't travel alone on their great journey south, for the Scots who made their living from the 'silver darlings' would follow the herring all the way down to Great Yarmouth. The Scottish fishermen came in their boats but during the late eighteenth century the women who processed the

THE SWIMMING POOL,
BUTLIN'S HOLIDAY CAMP, SKEGNESS.

G.7244

Billy Butlin (centre) captured the mood of the late 1930s. Britons were ready to enjoy holidays together, happy to enter knobbly knees or beauty contests.

The success of the Butlins formula was that everything was provided for a captive audience; there was fun to be had, whatever the British weather.

catch had to walk, sometimes carrying children on their backs, and by the end of the season some of them had walked pretty much the length of the east coast. The advent of the railways made life easier for fisherwomen to hop from port to port by train, but gutting, packing and pickling fish by hand in all weathers could never be described as an easy life. For a while the east coast was home to the largest herring fishery in the world (in 1913 over 800,000 barrels of fish were landed in Yarmouth) but the industry was about to topple over the edge, a victim of its own success. The humble fish finger was 'invented' in Great Yarmouth in 1955, a boost to the economy, you might think. But the collapse of fish stocks and changing tastes meant that by 1957 just 72,000 barrels of herring were landed and shortly the migration of the fish and their followers ended.

Southwold's artists

There's a long-standing association between the landscape and art in East Anglia. Flat surfaces, huge skies, unsettled seas, simple horizontal shapes, just ask to be represented in paint. Until the twentieth century Southwold, like so many places on the east coast, was a thriving fishing community but it was transformed into a stylish Suffolk resort that has attracted and become identified with many landscape artists. In the wake of great masters – Gainsborough, Constable, Turner, Charles Rennie Mackintosh – contemporary artists continue to be inspired by the scenery around Southwold and if there is a unifying theme to their work it is the sense of place. And the coast, that fine, ever changing line between land and sea, both inspires and infuriates the artists as they struggle to capture the ephemeral experience of Southwold's shore.

➤ The view of the great outdoors at Southwold is dominated by the sea and the sky, for water and light truly take centre stage here.

The lure of London and the expansion of empire

On this coast it's impossible to resist the pull of London. For centuries traders and invaders, from Roman sailors to Luftwaffe pilots, have navigated up the Thames. The tide too rushes towards London – unable to resist the funnelling effect of the estuary. The Thames is tidal all the way through the heart of London and out the other side, which means, according to the Ordnance Survey definition, that the city centre is on the coast. The city's docks helped to make London the greatest port in the world: when the Royal Albert Dock was opened in 1874 it was the biggest in Britain. Then comes Greenwich, home to the imaginary line from North to South Pole that bisects the world separating east from west. The Prime Meridian is at Greenwich because when Britain ruled the waves it also made the rules. The Prime Meridian, established by astronomer royal Sir George Biddell Airy in 1851, gradually came to be adopted as the worldwide reference line for navigation – even the French, after decades of denial, gave in and recognized it as the maritime benchmark. How galling it must have been to defer to the British, for our final destination is a site that resonates with the echoes of France's most devastating naval defeat.

The Navy, led by Admiral Lord Nelson aboard HMS *Victory*, defeated the combined forces of the French and Spanish at the Battle of Trafalgar in 1805. The future of our islands was at stake, for if Napoleon could achieve naval supremacy an invasion of Britain was likely. Instead Nelson secured a crushing victory, capturing 21 enemy ships and destroying one without any loss of British ships. Nelson paid with his life and there were close to 1,700 others killed or wounded on the British side, although French and Spanish casualties were far heavier. By 1843, when Nelson's Column was unveiled in the London square named after the battle, the true significance of Trafalgar must have become apparent. Queen Victoria had reigned for six years and her Navy roamed the world's oceans without serious challenge and with the wind in its sails it helped propel the British Empire into a golden age. Between 1815 and 1914 it is estimated that 10 million square miles of territory (about 18 per cent of the world's land surface) and around 400 million people were added to make it the largest empire in history; a quite extraordinary expansion of our small island beyond its shores.

Nelson's Column has always been for the tourists but within a whisper of Trafalgar Square is a more poignant place with a genuine connection to the battle, one the great man himself would recognize: the board room of the Admiralty. On 6 November 1805 at around midnight William Marsden was still working at the large mahogany table in the board room. Marsden was the First Secretary to the Admiralty and was accustomed to long days but given the lateness of the hour even he was about to retire when someone hammered on the Admiralty door. It was an exhausted Lt John Richards Lapenotière (despite his name, a British Royal Navy officer), who had raced back from the battle at Trafalgar in his small ship HMS *Pickle*. Now, 37 hours after landing at Falmouth and no fewer than 21 changes of horses to gallop him to London, he was finally ushered into the board room to deliver a message to Marsden that was both joyful and tragic: 'Sir, we have gained a great victory, but we have lost Lord Nelson.' As the two men stood facing one another across the room where Nelson had discussed the plan for the Battle of Trafalgar I imagine for a brief moment time stood still. Over two hundred years later the board room is still there, a silent witness to the triumph that began a new era of the British Empire.

That age of expansion still reverberates around these islands in our language, our culture and our people; the connection to our coast and beyond is never far away, and, remember, wherever you are in Britain you're never more than 72 miles from the sea.

➤ Experiencing HMS *Victory* provides a fitting reminder of the Battle of Trafalgar, and an age when Britain and her Royal Navy ruled supreme.

Gazetteer

I hope you've enjoyed this journey and have discovered some new places. In fact, I hope that you have been inspired to visit some of them, so here is a guide to the features that are open to the public, together with contact details and Tourist Information Centres (TICs).

The sections in this gazetteer reflect the coastlines covered in the chapters and will help you find landmarks, historic buildings and notable sites described in the book. I have also listed places of interest that are not in the book, but are worth visiting on the way to others.

Each entry gives you a guide of what to expect, plus websites and telephone numbers as well as directions where helpful. Opening times and access details are liable to vary, so please do check before leaving.

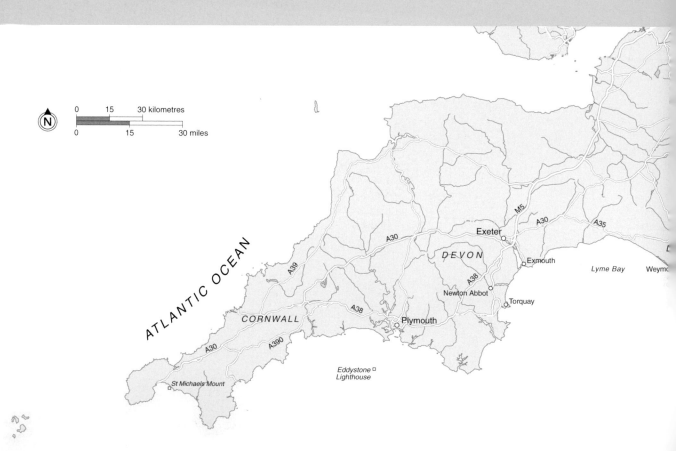

WHITSTABLE, KENT

Whitstable is a fine place to visit during the annual week-long oyster festival in July, where you can witness the re-enactment of the landing of the oyster catch, join in the fun of the parade through town and judge for yourself the best of the grotters.

www.iknow-kent.co.uk
www.wofa.org.uk
TIC 01227 275482

DOVER, KENT

Although best known for its famous cliffs, Dover's castle, secret wartime tunnels, an underground hospital and the Control Centre from which the evacuation of Dunkirk was organized are definitely worth a trip. Visits can be arranged or special world-war battlefield tours are offered on various websites.

The Hovercraft Museum at Lee-on-the-Solent is also worth a visit.

www.battlefieldtours.co.uk
www.hovercraft-museum.org

Dover honoured Captain Matthew Webb's achievement in becoming the first man to swim the Channel in the form of a memorial on the seafront.

www.whitecliffscountry.org.uk
TIC 01304 205108

ROMNEY, HYTHE AND DYMCHURCH RAILWAY, KENT

The world's only 15-inch gauge working railway has a dedicated website, providing a calendar of events, timetables and fares. The line is open most weekends throughout the year and most days from the end of March to the end of October.

www.rhdr.org.uk

HASTINGS, EAST SUSSEX

Apart from its modern seafront arcades and amusements, among them the World Crazy Golf Championships, Hastings has a castle, a lovely Old Town and several museums. The archive collection of the Hastings Museum and Art Gallery includes smuggling on the Sussex coast during the nineteenth century.

The Old Town Hall Museum also hosts a small permanent display on smuggling, covering key moments in the Old Town's history: the clearances of the 1930s, the town as a Napoleonic garrison, as well as the fires, floods and raids of the Middle Ages. See the HMAG website for both museums.

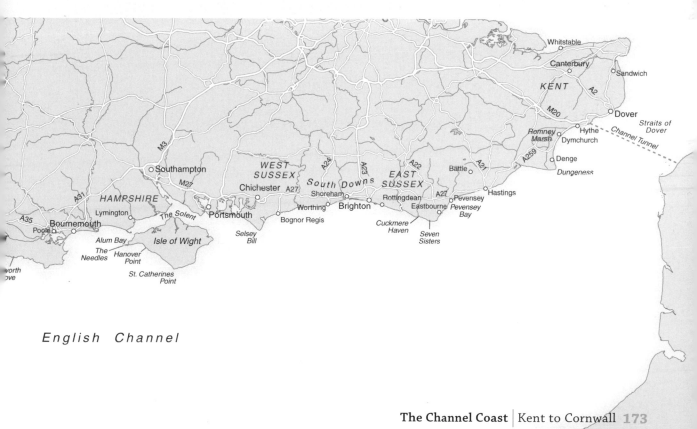

English Channel

Another museum, the Fishermen's Museum, is housed in a former church, built on the beach in 1854. At low tide you can also visit the wreck of the *Amsterdam*.
www.minigolf.org.uk
www.hmag.org.uk

PORTSMOUTH, HAMPSHIRE
If it's maritime history you want, Portsmouth is a great day out. It is the home of the Royal Navy, and the historic ships HMS *Victory*, HMS *Warrior 1860* and the *Mary Rose*.
www.hms-victory.com

The latest icon is the Spinnaker Tower on the waterfront of Gunwharf Quays, with 360-degree views over the harbour, the Isle of Wight and the south coast. The tower has three viewing decks, with the third open to the elements. Café/bar at waterfront level.
www.visitportsmouth.co.uk
www.spinnakortower.co.uk
 023 9285 7520
TIC 023 9252 2944 or Visitor
 Information Service 023 9282 6722

ISLE OF WIGHT
A short ferry ride from Portsmouth, Lymington or Southampton takes you to the Isle of Wight. Round to the south, especially at Hanover Point, cliffs and beaches contain fossils and dinosaur footprints. Exhibits can be seen in the Dinosaur Isle Museum in Sandown, and at the Dinosaur Farm on Military Road on the south of the island, which will organize fossil hunts
www.islandbreaks.co.uk
 01983 813813
www.dinosaurisle.com
www.dinosaur-farm.co.uk

The island is also famous among the yachting fraternity for Cowes Week, the world's premier sailing regatta, now

180 years old, with almost 1,000 yachts taking part in some top-class sailing.
www.cowesweek.co.uk

MAUNSELL ARMY FORTS, THAMES ESTUARY
Currently there are no organized tours but fast trips and cruises around the sea forts can be arranged. Whitstable is the nearest location on land.
Take the M2 to junction 7 then continue on the A299 and turn off for Whitstable. Drive into town to the seafront; there is roadside parking here and Red Sands sea fort is just visible.
www.doctorwholocations.net/locations/ redsandsseafort

SOUND MIRRORS, DENGE, KENT
These 'concrete ears' are now designated a historical preservation site by English Heritage but you can only visit as part of a guided tour.
ajg41.plushost.co.uk/soundmirrors

There's a fine view from the top of the old black lighthouse, open to the public from Easter until the end of October.
www.dungenesslighthouse.com
 01797 321300

You may fancy a look at an imposing white building in New Romney if only because it was built by Sir Clough Williams-Ellis, designer of Portmeirion, for the infamous American actress and journalist Hedda Hopper.
Romney Bay House Hotel, Coast Road, Littlestone, New Romney, Kent TN28 8QY

THE NEEDLES, ISLE OF WIGHT
The Needles, an ancient connection to the mainland, is the most westerly point of the Isle of Wight, a series of chalk stacks protruding into the sea at the end of which is a lighthouse. There's been a lighthouse here since

1785; the current one dates from the 1850s and after extensive restoration work the Old Battery was opened to the public in 1982 (March–November).
www.theneedlesbattery.org.uk/rocket. shtml

EDDYSTONE LIGHTHOUSE, PLYMOUTH HOE, DEVON
A centrepiece on Plymouth's Hoe, Smeaton's Tower has become one of the area's most well-known landmarks. With few exceptions, it's open all year round.
www.plymouth.gov.uk/homepage/ creativityandculture/museums/ museumsmeatonstower.htm

ST MICHAEL'S MOUNT, MARAZION, CORNWALL
A tiny, rocky island with a remarkable history yet still a living, working community of people. The castle, the shops and the restaurants of St Michael's Mount are open to visitors every day of the week except Saturday between 29 March and 1 November. However, all visits are dependent upon weather and sea conditions.
www.stmichaelsmount.co.uk
 01736 710507 or 01736 710265

FOSSIL FOREST, DORSET
East of Lulworth Cove is a great spot to discover the Fossil Forest, filled with 'tufa': the fossilized rings of algae that gathered around tree trunks as a forest flooded nearly 150 million years ago. Access is through MoD land, open to the public most weekends and throughout August but closed during range practice.
www.lulworth.com/education/fossil_ forest.htm

The Gallic Coast

CAP GRIS NEZ, PAS DE CALAIS

From the port of Calais it's only a short drive down the coast to Cap Gris Nez, a great place to stretch your legs and do a spot of Channel gazing, with views right across to England. The clifftop footpath formerly trod by customs officers on the watch for smugglers runs down the coast to Audresselles, a fishing village. Still visible are the earthworks of the fortress built by Henry VIII in the early sixteenth century and the German bunker dating from the Second World War that was liberated by the Canadians in 1944.

LE TOUQUET, PAS DE CALAIS

An elegant resort that was quickly developed at the beginning of the twentieth century with imaginative and attractive villas. One of the most elegant quarters of the town is the Art Deco-designed Westminster, a luxury hotel built for British high society in 1924. The walls are lined with autographed photos of generations of stars and politicians. The bar is still very British; the dining very French. Le Touquet has capitalized on its reputation as a resort with outdoor activities, among which is golf – the town boasts two championship courses and a nine-hole academy layout.
www.opengolfclub.com/touquet/en/
 golf-touquet.html
www.letouquet.com
Office de Tourisme 00 33 321 06 72 00
 www.tourisme.fr/office-de-tourisme/
 le-touquet-paris-plage.htm

DIEPPE, NORMANDY

Dieppe is an old-world resort, an attractive working port with fresh fish landed daily and a photogenic marina lined with restaurants. It's the nearest beach to Paris and a ferry service links it to England at Newhaven, East Sussex.

In August 1942 a largely Canadian force attempted a raid on the German forces occupying Dieppe, a precursor to the full-scale invasion of occupied western Europe, but it was a military disaster: over 900 Canadians were killed on a single day. Lessons, however, were learnt that helped to make the D-Day landings successful.
www.rhli.ca/dieppe/dieppebattle.html

The International Kite Festival (held every even year, in September) is a spectacular sight on the seafront, attracting displays from over 30 countries. There are demonstrations of some remarkable aeolian constructions. The finale is the French acrobatic kite championship.
www.dieppe-cerf-volant.org/dccv/
 ukaccueil.html
www.dieppetourisme.com
 Office de Tourisme 00 33 02 32 14
 40 60

POURVILLE AND ETRETAT

Just around the coast west from Dieppe are the cliffs of Pourville. In the 1880s Claude Monet made a series of paintings of the cliffs from the beach at low tide and several views from the rolling hills looking out to sea. The D75 out of Dieppe takes you right along this stunning cliff top and on to other painterly locations, culminating in the spectacular arches and pinnacles of Etretat. Most famous is the needle and arch at Porte d'Aval, which to some has the appearance of a 'drinking elephant'. Monet captured the sunset at Etretat in 1883; in 1869 it was Gustave Courbet's turn. Access to the beaches is by steep steps at Porte d'Amont and between Manneporte and Porte d'Aval via a tunnel but you'll need to be fit and allow enough time to return before the tide turns. The views of the arches are impressive

from above but do not approach the cliff edge.
www.etretat.net/office_de_tourisme_
 etretat/pages/anglais_espace_pro_
 visites_guidees.php
www.normandie-tourisme.fr

GIVERNY

Monsieur Monet's garden, although not on the coast, is still in Normandy and almost impossible to resist and it's an easy drive.
From either Dieppe or Le Havre, take signs to Rouen then take the A13 from Rouen (direction Paris). Exit at 14 (Bonnières) or 16 (Douain). Follow signs for Vernon or Giverny. Be prepared for crowds. (Open daily between 1 April and 1 November.)
giverny.org

LE HAVRE, NORMANDY

More damage was inflicted here during the war than on any other port in Europe but its near-total destruction led to Le Havre being rebuilt, unusually, to the specifications of just one architect, Auguste Perret, whose famous dictum was 'concrete is beautiful'. It is the largest city in Normandy and the first twentieth-century urban centre in Europe to be added to UNESCO's World Heritage List. Ferry operators link Le Havre to Portsmouth, Newhaven and Rosslare and it has excellent motorway links to Rouen, Paris and beyond. Staying local, the Pont de Normandie, completed in 1995, is an impressive way to drive across the Seine to Honfleur.
www.civl.port.ac.uk/comp_prog/
 bridges1/Normandie.htm
www.lehavretourisme.com
 Office de Tourisme 00 33 02 32 74
 04 04

HONFLEUR, NORMANDY

An old maritime town with impressively preserved timber-framed and slate-fronted buildings (especially in the Vieux Bassin, the seventeenth-century port). Its famous wooden church of Ste-Catherine, is now part of Le Eugène Boudin museum, located in the appropriately named Rue de l'homme de bois.

Eugène Boudin museum 00 33 02 31 89 54 00

www.ot-honfleur.fr

Office de Tourisme 00 33 02 31 89 23 30

TROUVILLE-SUR-MER, NORMANDY

In the 1830s the jet-set turned its sights from Dieppe and relocated to Trouville. The resort became famous for its vast stretch of sand, casinos and gastronomic delights. Painters and literary figures were also attracted, among them Monet, Corot, Proust, Flaubert, Duras and Dumas. The Villa Montebello now houses the collections of the Trouville Museum including works by Charles Mozin and Eugène Boudin. Open Easter–end of September daily except Tuesday.

Villa Montebello 00 33 02 31 88 51 33

www.trouvillesurmer.org

Office de Tourisme 00 33 02 31 14 60 70

CAEN, NORMANDY

A modern university town but with a castle and two abbeys (Abbaye-aux-Hommes and Abbaye-aux-Dames) built in the famous Caen stone. The impressive Château de Caen is also home to the Museum of Fine Arts, Museum of Normandy and a medieval Botanical Gardens. Closed Thursdays.

www.chateau.caen.fr

00 33 02 31 30 47 60/70

THE MEMORIAL PEACE MUSEUM

Opened in 1988, this is regarded as the best museum of the Second World War in France. It also organizes bilingual guided tours to the D-Day Landing Beaches.

www.memorial.caen.fr

00 33 02 31 06 06 45

www.tourisme.caen.fr

Office de Tourisme 00 33 02 32 27 14 10

D-DAY LANDING BEACHES, NORMANDY

Such is the legacy of the Normandy landings the beaches are still referred to by their wartime codenames, from east to west: Sword, Juno, Gold, Omaha and Utah. Physical indications of the invasion that cost 100,000 soldiers' lives are now few, except for the remarkable remains of Mulberry 'B' portable harbour ('Port Winston') assembled on Gold Beach at Arromanches, but visits to the beaches by veterans and their descendants will always be emotional. There are many memorials.

www.france-for-visitors.com/ normandy/d-day-beaches/index. html

D-DAY MUSEUMS

Almost every coastal town has its memorial museum, among them:

MUSÉE DU DÉBARQUEMENT,
Arromanches 00 33 02 31 22 34 31

MUSÉE MEMORIAL D'OMAHA BEACH, ST-LAURENT-SUR-MER

www.musee-memorial-omaha.com

00 33 02 31 21 97 44

CENTRE JUNO BEACH, COURSEULLES-SUR-MER

www.junobeach.org

00 33 02 31 37 32 17

MUSÉE AMERICA/GOLDBEACH, VER-SUR-MER

www.goldbeachmusee.org.uk

00 33 02 31 22 58 58

BAYEUX, NORMANDY

A few miles inland from the Landing Beaches is the home of the famous tapestry (actually embroidery) depicting the story of the quarrel between William, Duke of Normandy (The Conqueror), and King Harold of England, and the ensuing events that led to Harold's defeat at Hastings in 1066. Bayeux was the first French city to be liberated in 1944 after the D-Day landings and, briefly, the capital of Free France. The tapestry is housed in a dimly lit gallery in the Centre Guillaume-le-Conquérant, protected by bullet-proof glass.

Guided Tours 00 33 02 31 51 25 50 or 00 31 02 31 51 25 59

www.chateau-guillaume-leconquerant.fr

Also in Bayeux is the Musée Memorial de la Bataille de Normandie

www.normandiememoire.com

00 33 02 31 51 46 90

www.bayeux-tourism.com

www.bayeux-bessin-tourism.com

Office de Tourisme, Bayeux 00 33 02 31 51 28 28

MONT-ST-MICHEL, BRITTANY

Mont-St-Michel is a joyous sight, perched on a rocky outcrop above shifting sands. The defensive walls and abbey with arcaded cloisters and vaulted halls are technically and visually a medieval triumph over the challenges of this unique site. All the more amazing is that a village is crammed underneath. Open daily, guided tours in French and English. Mass daily at 12:15pm. Expect crowds; there is only one street. Pedestrian access, 350 steps to the abbey. The

island is linked by a natural causeway but there are plans to replace it with a bridge.

www.sacred-destinations.com/france/ mont-st-michel.htm
Office de Tourisme 00 33 02 33 60 14 30

ST-MALO, BRITTANY

The walled port St-Malo was founded, like Mont-St-Michel, as a monastic settlement, possibly as early as the sixth century, on a granite island at the mouth of the River Rance. It was home to pirates and thrived as a commercial port in the sixteenth century through trade with Canada. Today it is a magnet for tourists, its heart restored after wartime bombing. St-Malo is now part of the mainland but its castle and 12-feet-wide ramparts lend it the aspect of a medieval fortified island.

www.ot-montsaintmichel.com
www.saint-malo-tourisme.com
Office de Tourisme 00 33 08 25 13 52 00

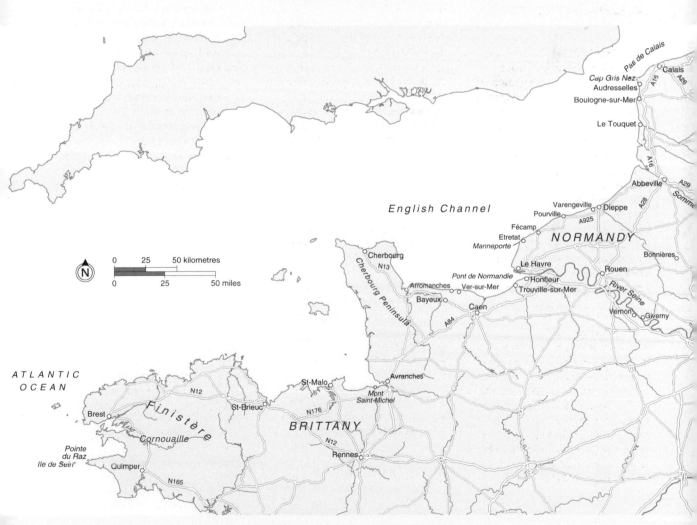

TIN MINES AND ENGINE HOUSES, CORNWALL

Elements of the tin-mining industry are part of the Cornish landscape. The Levant Beam Winding Engine, the oldest to survive in Cornwall, has been restored by the Trevithick Society. From Levant the South West Coast Path runs to nearby Botallack with its Count House and two engine houses. Both are now National Trust properties. O/S location: Levant (*Grid Ref 203: SW368346*); Botallack (*Grid Ref 102: SW364336*). Geevor, a working tin mine in Pendeen until 1990, is now a Heritage Centre.

Levant 01736 786156
Botallack 01736 788588
www.geevor.com
 01736 788662
www.cornishlight.co.uk

TREBETHERICK, NORTH CORNWALL

The north Cornish coast was a favourite haunt for Sir John Betjeman, who is buried in the graveyard of St Enodoc church, Trebetherick, on a headland opposite Padstow. The tiny church is accessible only on foot as it is surrounded by golf course. Take the ferry from Padstow to Rock and enjoy the mile-long walk along the seafront and over the golf course and sand dunes. Alternatively, park at Daymer Bay and walk along the seafront. The poet laureate's grave is marked by a slate headstone (by the Lych gate). *OS Grid Ref: SW9377.*

LUNDY ISLAND, NORTH DEVON

Between March and November you can make day trips to Lundy on the island's own vessel, MS *Oldenburg*, from Bideford and Ilfracombe.

www.lundyisland.co.uk/oldenburg_
 visual.htm
 01628 825925

Chartered boat trips are available with the chance to swim or dive among the sealife around Lundy, including seals. On Lundy itself families with young, elderly or less active or experienced members will enjoy the island's resident mammals, see

www.devonperspectives.co.uk/lundy3.
 html

For a short winter break, helicopter flights operate between Lundy and Hartland Point on the Devon mainland Mondays and Fridays.

www.information-britain.co.uk
 01271 863636
www.lundyisland.co.uk

The walk from Lundy's jetty to the village is steep and not suitable for everyone, particularly if you are also carrying luggage and provisions. There is no resident doctor on Lundy; anyone with a serious medical condition should seek advice before planning a trip. Note that pets are not permitted on Lundy.

ILFRACOMBE, NORTH DEVON

Ilfracombe's unique hand-carved tunnels go through the cliffs to the sheltered beaches and tidal sea pools where children can play on inflatables, snorkel in safety, or explore some amazing rock pools. Facilities for people with disabilities and lifeguards during the season. No dogs. Open early April–October (admission fee). *Follow the brown tourist signs in Ilfracombe itself for the Seafront and Tunnels Beaches. Parking on Wilder Road.*

www.tunnelsbeaches.co.uk
www.visitilfracombe.co.uk/site/things-
 to-do
TIC 01271 863001

LYNTON, LYNMOUTH, AND VALLEY OF THE ROCKS, NORTH DEVON

Eighteen miles east of Ilfracombe are the twin resorts of Lynton, on the cliffs, and Lynmouth at sea level, connected by a water-operated funicular, built by the Victorians. Signposted from Lynton town centre is the Valley of the Rocks. It's less than a mile by road or footpath to this remarkable dry valley to see spectacular weathering and the odd sighting of the wild goat population. *O/S Grid Ref 70449.*

www.cliffrailwaylynton.co.uk
TIC Lynton 01598 752225

STOLFORD, BRIDGWATER BAY

The last fishing family to operate a mudhorse on the flats sell their fish direct.

The Fish Shop, Mudhorse Cottage,
 Stolford, Somerset, TA5 1TW
 01278 652297

PURTON 'HULKS'

Marine historian Paul Barnett offers guided 2-hour walks to explain the history of the hulks in the atmospheric graveyard between the Gloucester & Sharpness Canal and the River Severn north of the Severn Railway Bridge.

www.gloucesterdocks.me.uk
rpm-canal.fotopic.net/c526619.html

BRISTOL CHANNEL EXCURSIONS

The MV *Balmoral*, built in 1949, still sails the Bristol Channel during the summer as well the Irish Sea coast and occasionally across the English Channel.

Waverley Excursions Ltd
 0845 130 4647

ST DONATS CASTLE, GLAMORGAN

The castle is not ordinarily accessible to the public but part of it is open as it houses St Donats Arts Centre, which

offers live performances, cinema and
an educational and exhibition space.

**St Donats Castle, Llantwit Major, Vale
of Glamorgan, CF61 1WF**
01446 799100

CARDIGAN BAY

Bottlenose dolphins have made their
home in Cardigan Bay and if you're
patient you can sometimes catch sight
of them hunting. One of the most
popular viewing points is New Quay,
but they can be seen the length of
the Bay, from Cardigan to the Dyfi
Estuary. The best times of year are
April to September: try early mornings
and evenings when there's increased
traffic on the water as dolphins love to
ride the bow wave of boats.

www.cbmwc.org

PORTMEIRION

North Wales's unique holiday village
on the coast of Snowdonia is one of
its top attractions. It has always
been run on a hotel basis, offering
rooms and cottages but day visits
can also be made. See the website
for full details.

www.portmeirion-village.com

AMLWCH PORT AND PARYS
MOUNTAIN, ANGLESEY

One small port and one
big mountain where visitors
can explore the industrial
workings of Anglesey's
'copper kingdom'. Open all
year round. Guided tours
available. Heritage trails
open all year, Visitor
Centre April–October.

**Amlwch Industrial
Heritage Trust**
01407 832 255

www.copperkingdom.co.uk

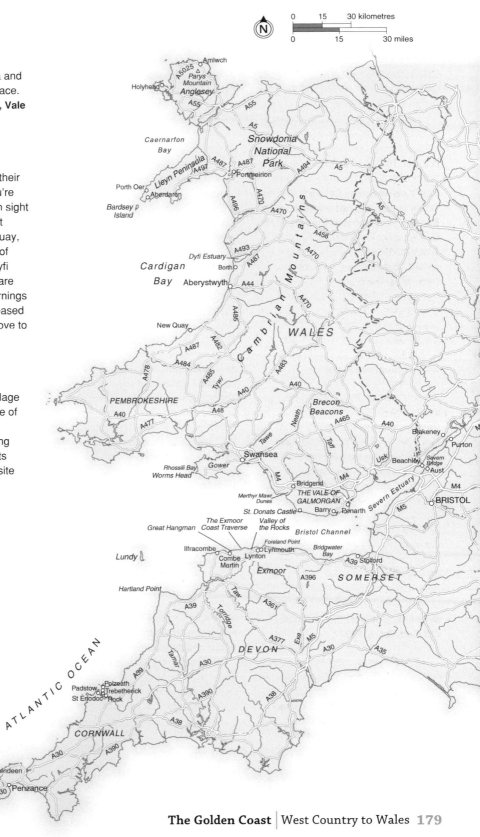

DUBLIN

Dublin is Ireland's largest sea port, mostly handling freight but cruise liners also dock here, as does the world's biggest car ferry, the *Ulysses*. Stop for a poignant moment at Custom House Quay to see the city's Famine Exodus Memorial, emaciated figures sculpted by Rowan Gillespie that appear to be walking towards a ship. You can take a bracing walk on the famous Bull Walls to admire the Bay or a tour through the home of Guinness at the brewery in St James's Gate, ending with a pint of the black stuff. Open daily.

Guniness tour 00 353 1 453 6700
www.tourist-information-dublin.co.uk
www.visitdublin.com
TIC 00 353 1 605 7799

CURRACLOE BEACH, CO. WEXFORD

To follow in the steps of Private Ryan, from Wexford, take the R742 to Curracloe. Head right at the junction in the village and right again. There is a carpark by the wood, from which it is a short walk to the long sandy beach where the movie was filmed. Curracloe has been voted 'Best Beach in Ireland'. Perfect for swimming or strolling.
O/S Grid Ref T1125.

WEXFORD SLOBS, CO. WEXFORD

An internationally important wildfowl reserve that attracts migrant bird populations – and twitchers – In their thousands. Restricted access for people with disabilities.
Visitor Centre 00 353 5 3912 3129

HOOK HEAD PENINSULA AND LIGHTHOUSE, CO. WEXFORD

Southwest Wexford is a celebration of rural Ireland: unspoilt, peaceful and pleasant. Sheltered beaches, fishing villages, birdwatching, angling. The Hook Head lighthouse is a remarkable medieval construction, now fully automated, which is now open to the public all year round. Access by guided tour only, visitor centre.
On the R734 between Wexford and Waterford.
www.thehook-wexford.com
 00 353 5 139 7055

WATERFORD CTY, CO. WATERFORD

Waterford is especially famous for crystal and its Viking past. Waterford Crystal was founded in 1793; the Vikings discovered the town in the tenth century. The Waterford Kite Brooch and other priceless artefacts in gold, bronze, silver and crystal are housed in the Waterford Treasures Museum. Open daily.
www.waterfordtreasures.com
 00 353 5 130 4500
TIC 00 353 5 135 8398

ARDMORE ROUND TOWER, CO. WATERFORD

The famous tower is on a hillside south of Ardmore village about 15 miles southwest of Dungarvan. On the same site is a 'cathedral' containing two ogham stones with curious script.
From Dungarvan, take the N25 southwest to the R673. Follow signs for Ardmore.

WALTER RALEIGH'S HOUSE, YOUGHAL, CO. CORK

The walled town of Youghal was made one of Ireland's cinque ports in 1462, which allowed it certain trading privileges. You can take a tour around Youghal Heritage Trail, which includes Myrtle Grove, the sixteenth-century house where Sir Walter once lived.
www.eastcorktourism.com
 TIC 00 353 24 20170

CORK WEEK REGATTA, CO. CORK

The bi-annual regatta known as Cork Week organized by the Royal Cork Yacht Club is a place to see and be seen. Held in July, even years. Crosshaven Marina, Cork City.
www.corkkerry.ie
TIC 00 353 2 1425 5100

COBH HARBOUR , CO. CORK

Sited on an island in Cork Harbour, Cobh's railway station has been transformed into a heritage centre that graphically depicts the steps of the 2.5 million who emigrated from Cobh to America and the appalling life on board the 'coffin ships'. Spike Island is visible from the town and there are the remains of the jetty from where people were ferried out to the *Titanic*.
www.cobhheritage.com
www.cobhharbourchamber.ie
TIC 00 353 21 481 3301

VALENTIA ISLAND. CO. KERRY

The world's first transatlantic telegraph cable was transmitted from Valentia's telegraph station in Knightstown on Valentia Island. Heritage Centre open April–September.
Access by road bridge from Portmagee. Ferry service from Reenard Point, southwest of Caherciveen, to Knightstown April–October.
Telegraph station 00 353 66 9476411

FOYNES, CO. LIMERICK

If you're in the Shannon region of west Co. Limerick a visit to the Flying Boats Museum at Foynes is a must. Includes a full-scale replica of the 'Yankee Clipper' Boeing 314. Open daily, full facilities including access for people with disabilities.
Located about 22 miles on the N69 coast road from Limerick City to Tralee.
www.flyingboatmuseum.com
00 353 69 65416

CLIFDEN, CO. GALWAY

One small town that boasts two defining moments in world communication: Guglielmo Marconi transmitted the first commercial transatlantic message, and the first aviators to cross the Atlantic landed here.

Clifden Station House Museum
00 353 9 521494
www.clifden.ie

DOWNPATRICK HEAD, CO. MAYO

As if the views from Downpatrick Head weren't enough in themselves, the Céide Fields are the largest-known neolithic farming settlement on earth. Visitor Centre open March–November. *On the R314 10 miles west of Ballycastle, between Killala and Belmullet.*

www.museumsofmayo.com/ceide.htm

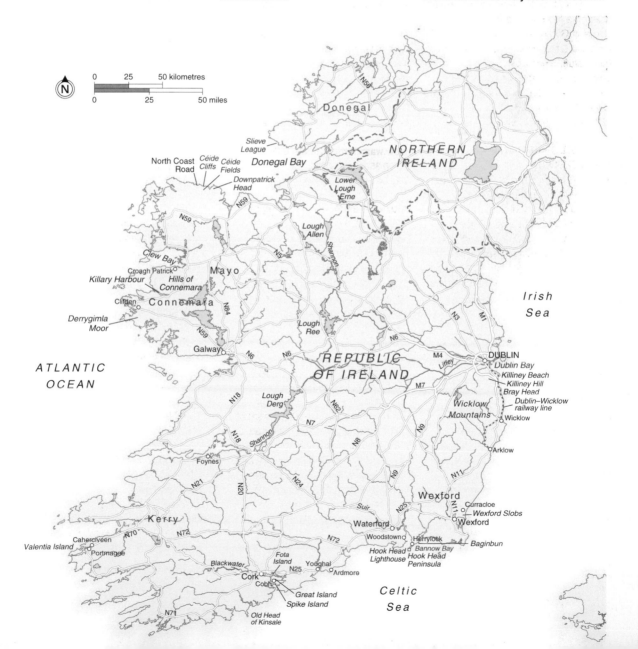

ISLE OF MAN

The Laxey Wheel, the world's largest waterwheel in operation, is on the east coast, near the village of Laxey. It's a short walk (signposted) from the village. Open daily April–October. Limited access (stairs).
On the junction of the B11 and A2 between Douglas and Ramsey
www.laxeywheel.co.uk

The Tower of Refuge for stricken mariners is at the far end of Douglas Bay on a reef known as Conister Rock or St Mary's Isle. Open year round daily. Viewing best from a distance: the reef can be accessed on foot at very low tides but this is dangerous and discouraged! No access for people with disabilities.
Travel to Douglas then park on the promenade.

Take a boat trip to watch for basking shark, sightings common off the southwest coast, especially in June during calm weather. See website for details and to book a boat trip.
www.manxbaskingsharkwatch.com

LLANDUDNO, NORTH WALES

Llandudno's location in a natural coastal bay made it geographically ideal as a purpose-built Victorian seaside town. Its grade II Listed pier has often been selected for filming Victorian and Edwardian dramas.

DEE ESTUARY WILDFOWL, WIRRAL

At Neston and Parkgate up to 400 'twitchers' may be gathered for the hightide birdwatches when the tides cover the marshland up to 32 feet high. There is also an RSPB Reserve at Burton Marsh.
O/S Grid Ref SJ275788.
From Heswall take the A540 towards Chester and follow signs for Parkgate.

Check signs for parking to avoid being stranded at high tide.
www.deeestuary.co.uk
www.rspb.org.uk/reserves/guide

PORT SUNLIGHT VILLAGE, WIRRAL

The Sunlight Vision Museum gives an insight into life for the villagers and workers of late Victorian and Edwardian Port Sunlight with memorabilia and displays. Workers' houses can be visited or rented.
www.liverpoolmuseums.org.uk/ladylever
 0151 478 4136
www.portsunlightvillage.com
 0151 644 6466

LIVERPOOL, MERSEYSIDE

The Albert Dock with its waterfront setting and grade I listed buildings is Liverpool's most visited attraction. It is home to the Merseyside Maritime Museum, exploring the history of the port and its people, and the International Slavery Museum, detailing the legacy of transatlantic slavery. Liverpool's most famous sons are celebrated in 'The Beatles Story' an permanent experience dedicated entirely to the Fab 4. Open daily.
www.albertdock.com
 0151 478 4499
TIC 0151 233 2459

SEFTON SANDS, MERSEYSIDE

The arc of sand between the Ribble and Mersey estuaries is exceptionally rich in dune-system wildlife. Now part of a conservation strategy. Recognized as an SSSI between Southport and Crosby, the dunes at Ainsdale are now a National Nature Reserve.
O/S Grid Ref SD 295106.
www.seftoncoast.org.uk

BLACKPOOL ILLUMINATIONS, LANCASHIRE

Six miles of illumination using over a million light bulbs as well as laser, neon, fibre optic and floodlight display is an awesome sight that keeps Blackpool shining for over 60 nights from September to early November. Thousands gather for the Big Switch On, the first night of the display.
www.visitblackpool.com/blackpool-illuminations

MARYPORT, CUMBRIA

The Senhouse Museum, located overlooking the Solway Firth on the Roman site at Maryport, is home to the oldest collection of Roman artefacts in Britain, including military altar stones and inscriptions and unique examples of Romano-British religious sculpture. The Maryport site is set to be excavated to understand what happened at the beginning and end of the Roman occupation of Britain.
From Maryport head to the north end of town following brown tourist signs showing a roman helmet to Sea Brows.
www.senhousemuseum.co.uk
 01900 816 168

THE WICKER MAN TRAIL, KIRKCUDBRIGHT, DUMFRIES & GALLOWAY

The Wicker Man Trail highlights key locations around Kirkudbright and west towards Stranraer used in the 1973 cult film. The two-day Wicker Man music festival is hosted at Dundrennan, Kircudbright, towards the end of July.
www.sw-scotland-screen.com
www.efestivals.co.uk

THE GOBBINS CLIFF PATH, CO. ANTRIM, NORTHERN IRELAND

Currently, only a short section of this Victorian walk is accessible but plans may get off the ground to reinstate the

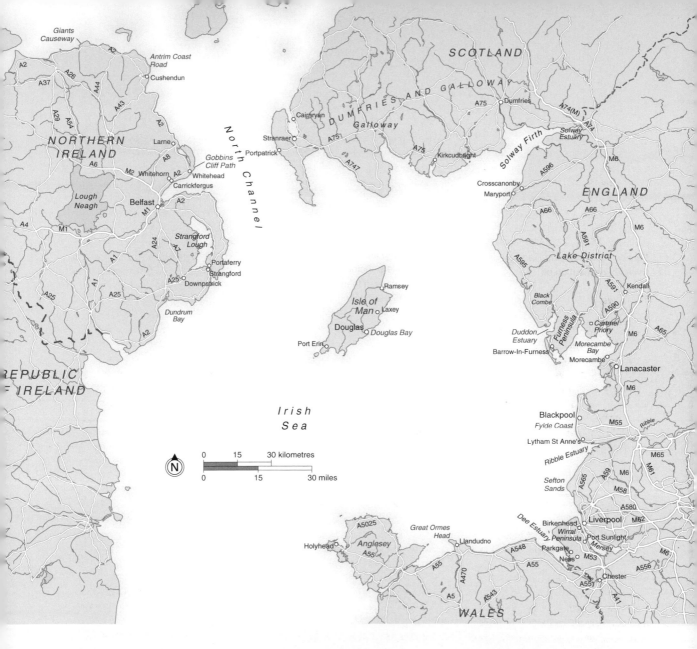

network of paths around the coast
at Whitehead to their former glory,
including restoration of the paths and a
visitors' centre.
*Whitehead is 20 miles from Belfast on
the A2, between Carrickfergus and the
port of Larne.*

STRANGFORD LOUGH, CO. ANTRIM, NORTHERN IRELAND

A haven for bird life on the large
mudflats exposed at low tide but also
increasingly a popular leisure location.

It is a nature reserve, a popular
place for walks and has a wildlife
centre open daily in summer and
some weekends between March
and September.
*Take the A7 from Belfast to
Downpatrick and the A25 to Strangford
and Portaferry (ferry connection
between Strangford and Portaferry)*
Wildlife centre 028 4488 1411

GLASGOW AND THE CLYDE

Symbol of Glasgow's engineering heritage are the supersized cantilever cranes. Finnieston (or Stobcross) Crane is now an identifying landmark on the skyline and a category-A listed structure. Titan is the only one of the five giants to have been opened to the public – summer months only. Guided tours (Fri, Sat, Sun).

www.titanclydebank.com
 0141 952 3771
www.theglasgowstory.com

Take a one-week cruise up the west coast of Scotland on the last steam-driven Clyde Puffer, the *VIC 32*, built in 1943 and now based at the Change House, Crinan, or try the Waverley Paddle Steamer, which still operates out of Glasgow for trips around the West Coast lochs.

www.waverleyexcursions.co.uk
 0141 221 8152
www.highlandsteamboat.com
 01546 510232
www.savethepuffer.co.uk

CRINAN CANAL, ARGYLL & BUTE

'Britain's most beautiful short cut' is an engineering triumph through idyllic scenery. Travel by boat through its 15 locks or enjoy the towpath for short walks or cycling.

www.scotland.org.uk/guide/Crinan_
 Canal

OTTER SPOTTING

Otters are most often sighted along Scotland's northwest coast and the Hebrides; early morning and dusk are good times. Regular sightings are reported on the Isle of Skye (Kyleakin, and Kylerhea) and in Tobermory harbour on Mull. For wildlife boat trips contact:

www.skyeactivities.co.uk
 01470 542 243

www.sealife-adventures.co.uk
 01631 571010 (day)
 01852 300203 (evening and weekend)

EASDALE

Easdale is the smallest permanently inhabited island of the Inner Hebrides. Formerly the hub of the Scottish slate industry it now has a few cottages, a pub, community centre and folk museum and hosts the annual World Stone Skimming Championships on one of its water-filled quarries. Access is by ferry from Gallanach, near Oban, on the mainland or via neighbouring island of Seil, which is linked to the mainland by bridge. The Easdale–Seil ferry operates on demand.

www.undiscoveredscotland.co.uk/
 easdale/easdale/index.html
www.stoneskimming.com

WHALE WATCHING

Tobermory harbour on Mull is also a good place for whales and other cetaceans. Minke whales, dolphins and porpoises are often spotted from the inter-island ferries. The Moray Firth has bottlenose dolphins in 'residence' while orcas (killer whales) are mainly seen around the Outer Hebrides and the isles of Coll, Tiree and Canna.

www.sealife-adventures.com
www.hebridean-whale-cruises.com

SKYE, INNER HEBRIDES

The Skye Museum of Island Life at Kilmuir is a township of thatched cottages depicting life on Skye at the end of the nineteenth century. Open to visitors Easter–October.

www.skyemuseum.co.uk

Fit walkers will want to tackle the Old Man of Storr, a steep (1,000-feet) climb to some of the island's most spectacular views across the Sound of Raasay.

Take the A855 north from Portree for 6 miles; parking by conifer plantation. Allow 3–4 hours.

A trip to the Talisker distillery at Carbost in northwest Skye is a warming distraction (Easter–October, Mon–Sat; November–Easter, Mon–Friday 2–5pm only). Signposted from A87 and A863.

www.taliskerwhisky.com
 01478 614308

Skye is now accessible by road via the Bridge linking the island with Kyle of Loch Alsh and rail connections to Kyle from Fort William and Inverness. From Mallaig you can still sail to Armadale on Skye with Caledonian MacBrayne Ferries; during summer a community-owned ferry operates between Glenelg and Kylerhea.

www.calmac.co.uk
www.skyeferry.co.uk

CANNA, INNER HEBRIDES

Sea eagles are thriving on Canna, the westernmost of the 'Small Isles', and for a good chance of spotting them day cruises are possible from mainland ports: from Mallaig six days a week with Caledonian Macbrayne, and from Arisaig with Arisaig Marine. From Skye AquaXplore operates a rigid inflatable boat (RIB) service to Rum and Canna.

www.calmac.co.uk
 01687 450 224
www.arisaig.co.uk
www.aquaxplore.co.uk
 01471 866 244

ST KILDA AND MINGULAY, OUTER HEBRIDES

Visiting isolated islands such as St Kilda is not easy but you can join a working-holiday group, charter a boat or join one of the cruise ships that visit the island annually. For details contact

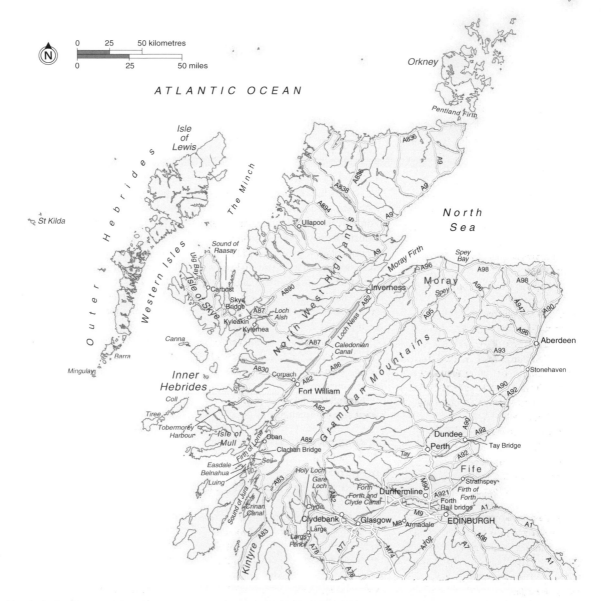

ATLANTIC OCEAN

Orkney

Pentland Firth

Isle of Lewis

Isle of Lewis

North Sea

Outer Hebrides

The Minch

St Kilda

Sound of Raasay

Ullapool

Moray Firth

Spey Bay

Western Isles

Ug Bay

Isle of Skye

Carbost

Skye Bridge

Kyleakin

Kylerhea

Loch Alsh

Inverness

Moray

Spey

Canna

Caledonian Canal

Loch Ness

Barra

Mingulay

Inner Hebrides

Corpach

Fort William

Aberdeen

Stonehaven

Coll

Tiree

Tobermory Harbour

Isle of Mull

Grampian Mountains

Easdale

Belnahua

Luing

Seil

Firth of Lorn

Oban

Clachan Bridge

A85

Holy Loch

Gare Loch

Dundee

Perth

Tay

Tay Bridge

Fife

Strathspey

Firth of Forth

Sound of Jura

Crinan Canal

Forth and Clyde Canal

Clyde

Dunfermline

Forth Rail bridges

EDINBURGH

Kintyre

Clydebank

Largs

Largs Pencil

Glasgow

Armadale

North West Highlands

National Trust for Scotland.
www.kilda.org.uk
 0131 243 9334

Likewise it is possible to visit Mingulay from neighbouring Barra, 12 miles to the north. Barra Fishing Charters offers island tours, wildlife spotting and private charter.
www.barrafishingcharters.com
 0187 1890384

THE CALEDONIAN CANAL
One of the most impressive sections to visit is the ladder of eight lock gates known as Neptune's Staircase. To see how the ladder raises craft 70 feet above sea level in just 500 yards, follow the A830 north (Road to the Isles) from Fort William to Mallaig; the staircase is signposted just before Corpach. There's also a cycle path that runs alongside the canal.
O/S Grid Ref NN1176.

EDINBURGH AND THE FORTH
Towering over the Firth of Forth, the Forth Rail Bridge is every bit as impressive as the Eiffel Tower. Perhaps the best views of its magnificent structure are from one of the train carriages, travelling 150 feet above the Forth itself.

The docks area of Edinburgh is Leith, home to the Royal Yacht *Britannia*, former royal 'residence' and now open to the public for self-guided tours.
www.forthbridges.org.uk
www.royalyachtbritannia.co.uk

FAROE ISLANDS

Few people will fail to be swayed by the landscape of the Faroes. A good road network serves almost all the settlements and the 18 islands are joined by tunnel, bridge or dams over narrow sounds. Ferry and helicopter links connect the smaller islands and settlements; most visitors travel by air from Denmark, Iceland and Norway but also from Aberdeen and London. The Faroese have their own airline, Atlantic Airways, linking the most westerly of the large islands, Vágar, with ten European destinations.

St Olav's Day is held on 29 July, honouring the patron saint of the Faroes with an annual festival in the capital, Tórshavn, in his honour, culminating in a colourful rowing-boat race. It's a manifestation of fellowship, a street party on top of the world, with processions, dancing and communal singing long into the night.
www.faroeislands.co.uk
www.Denmark.dk/FaroeIslands

LOFOTEN ISLANDS, NORDLAND, ARCTIC CIRCLE

Visitors to the Lofoten Islands today go to experience the exceptional scenery, peaceful surroundings and genuine atmosphere of fishing communities. You can travel around the islands by ferry, bike, bus or car, or scuba-dive off the shores. The Hurtigruten (see next entry) stops daily on its north- and south-bound voyages. Traditional red-painted fishermen's cabins have been transformed into holiday homes and the attractions for tourists include orca whale safaris (you can swim with them too), deep-sea fishing trips and an experience of the 'living' Viking Museum at Borg, where from mid-June to mid-August you can enjoy a Viking banquet, join a rowing trip on

a reconstructed long boat or simply absorb the authentic re-creation of Viking life. Open May–Sept daily and during winter only 1–3pm on Fridays. The Lofoten War Museum at Svolvaer tells the story of Operation Claymore and displays rare memorabilia from the Second World War. Open May–Sept.
Viking museum www.lofotr.no/Engelsk
War museum www.lofotenkrigmus.no
www.visitnorway.com

THE HURTIGRUTEN

The ferry that began as a 'coastal express' delivery service linking isolated northern communities with southern Norway now runs the entire length of Norway, offering expedition cruises through some of the most dramatic landscapes on earth.
www.hurtigruten.com

SALTSTRAUMEN SOUND, BODØ

The Saltstraumen is a sound 20 miles east of the city of Bodø which is famous for its maelstrom generated by the world's strongest tidal current. The current is created when the incoming tide forces water through Saltstraumen into the Skjerstad fjord. It occurs approximately every six hours and is strongest around the new and full moon. Sea-rafting on this super current is an option for extreme-sports enthusiasts. An abundance of fish makes this narrow sound very popular with anglers, a fact not lost on our ancestors for traces of settlement from 10,000 years ago were found in the area, some of the oldest archaeological finds in Norway. Bodø is also known as the sea-eagle capital: a great place to spot these majestic hunters. Timetables for the maelstrom are available from the tourist office.
www.visitbodo.com
 Tourist information 00 47 75 54 80 00

TRONDHEIM

The city founded by the Viking king Olav Tryggvason in 997 rapidly became Norway's centre of power and is still its coronation city: Stiftgården, the largest timber mansion in all Scandinavia, is the official royal residence when Norway's first family visit Trondheim. Today it is renowned for its educational and research institutions and remains an important centre of trade. Trondheim hosts the bi-annual International Student Festival and the world's longest rag week, which lasts for 25 days, with rock concerts, theatres and review shows.
www.trondheim.com
 Tourist information 00 47 73 80 76 63

GEIRANGERFJORD, MØRE OG ROMSDAL, SUNNMØRE

Northeast of Bergen, Geirangerfjord is still almost without equal, a narrow slit of turquoise water between sheer snow-capped mountains (reaching 4,600 ft high and a further 1,640 ft below sea level) with numerous waterfalls cascading down its sides. Many cruise ships, dwarfed by Norway's most gorgeous fjord, include it in their excursions but you can get a panoramic view from on high. The village of Geiranger is at the top of the fjord, approached by a single road, which affords a stunning view of the fjord from every dizzying hairpin turn. There are also short ferry trips from Geiranger through this majestic fjord.
www.fjellro.no
www.visitnorddal.com
www.fjord-tours.com/geiranger

THE ATLANTIC HIGHWAY, MØRE OG ROMSDAL, NORDMØRE

The Atlanterhavsveien, as they say in Norway, is an exhilarating roller-coaster of a road connecting the island of Averøy via a series of island hops to Eide on the mainland.

From Molde, take state highway 64 through Eide and on to the island of Averøy or, from Kristiansund, travel by ferry over to Averøy and follow signs for Molde. A tourist-information booth opens in summer at the toll stop.
www.atlanterhavsveien.no/e_index.html

ALESUND

Alesund is a captivating place: a 'new town' success story, built in the Art Nouveau style, elaborate with spires and towers and colourful facades, that makes it a pleasure to stroll through. The Art Nouveau Centre documents Alesund's unique architectural history.
www.jugendstilsenteret.no (Art Nouveau Centre)
www.visitalesund.com
 Tourist information 00 47 70 15 76 00

BERGEN

Bergen has many attractions within its confines, as well as being within sailing distance of some of the loveliest natural wonders of the southwest Norwegian coast. Bryggen, the old Hanseatic League wharf, is one of the country's best medieval settlements and features on UNESCO's World Heritage List. A typically Bergen experience is a wander through the 'smau' – narrow alleyways lined with wooden houses – and a visit to the fish market. Of the many museums, one is dedicated to Norway's most famous composer Edvard Grieg. His former home is filled with mementos and the interior remains as it was in 1907. Concerts are held in summer.
www.kunstmuseene.no (Edvard Grieg Museum Troldhaugen)
www.visitbergen.com
 Tourist information 00 47 55 55 20 00

Streymoy
Vágar
Tórshavn
Sandoy
NORTH ATLANTIC OCEAN
Faroe Islands
Sudheroy

0 20 kilometres
0 20 miles
N

0 50 100 kilometres
0 50 100 miles
N

Arctic Ocean
Lofoten Islands
Borge
Svolvaer
Bodø
Hålogaland
E6
Svinøya
E6

Norwegian Sea

SWEDEN
Trondheim
E6

Ormen Lange gas field

Averøy Kristiansund
Atlanterhavsveien Nordmøre
Nyhamna Eide
Aukra Molde
Alesund MØRE OG ROMSDAL
E136 E6
Geirangerfjord
Seven Sisters Waterfall
to Easington

NORWAY
E6

Hermansverk
E39
E16
E6

North Sea

Vossavengen
Norheimsund
Bergen
Hardangerfjord
E134
OSLO
E18
E16
E6

Stavanger
E39
E18
Lillesan
Kristiansand Arendal
Skagerrak

DENMARK

The East Coast

BERWICK-UPON-TWEED

Between 1296 and 1482 only Jerusalem was besieged more times than Berwick. The ongoing threats of Scottish attack meant the medieval stone walls and Tudor earth ramparts were incorporated into defences in the sixteenth century. To reduce the cost of this ambitious enterprise, much of the town was abandoned outside the fortifications, and today you still need to pass through Scotsgate to reach the north of the town. Berwick's castle was demolished in the nineteenth century, to make way for the railway, but the military barracks remain and house the borough's museum (open Apr–Sept, Wed–Sun, 10–5).
www.berwickmuseum.org.uk
01289 301869
www.fortsiloso.com/underground/
berwick.htm#ramparts

Berwick was one of English painter L. S. Lowry's favourite haunts and now boasts its own Lowry Trail, a six-mile walk through the town, which includes the Elizabethan fortifications and the 28-arch railway bridge over the Tweed designed by Robert Stephenson in the 1840s.

LINDISFARNE, NORTHUMBERLAND

The population of this Holy Island of just over 160 persons is swelled by the influx of over 650,000 visitors each year. The fairytale castle was built in 1550, and the island is accessed via a 3-mile causeway exposed twice daily at low tide, meaning that opening times vary with the tides. On open days the castle opens for 5 hours, either 10–3 or 12–5. There are also special events – see website for details.

The Lindisfarne Gospels, an illuminated Latin manuscript of the gospels of Matthew, Mark, Luke and John, was produced on Lindisfarne in the late seventh or early eighth century. The original of this astonishingly well-preserved manuscript is held at British Library, London, but you can view a copy on Lindisfarne itself.
Open Bank Hols (inc. Scottish Bank Hols). For a copy of the tide tables and detailed opening times see online.
www.lindisfarne.org.uk
01289 389244

FARNE ISLANDS SEAL SANCTUARY, NORTHUMBERLAND

An estimated 4,000 Atlantic or grey seals reside around the Farne Islands and can be viewed basking on the rocks. The islands are also a famous seabird sanctuary. For information on the special daily cruises that tour the islands to observe the seals and nesting birds on the cliff faces, call:
01665 720 308.

BAMBURGH CASTLE, NORTHUMBERLAND

Built above majestic sand dunes (and a dog-friendly beach), its ramparts tower over the Northumberland coast with outstanding views of Lindisfarne and the Farne Islands in one direction and the Cheviot Hills in another. Saved from ruin by Lord Armstrong's late-Victorian restoration, the castle is still home to the Armstrong family. The life and works of the 1st Lord Armstrong are brought to life in the unique museum housed in the old laundry building. Open every day from March to November.
www.bamburghcastle.com
01668 214515

CULLERCOATS

John Charlton's painting *The Women* hangs in the Laing Art Gallery, Newcastle.

New Bridge Street, Newcastle upon Tyne NE1 8AG.
www.twmuseums.org.uk/laing
0191 232 7734

ZETLAND LIFEBOAT, REDCAR AND CLEVELAND

On 7 October 1802, the Zetland lifeboat arrived at Redcar to begin an illustrious career. It remains at Redcar, and is the oldest surviving lifeboat in the world. Visit RNLI Redcar:
01642 484 491

WHITBY, YORKSHIRE

The remains of this abbey, first founded in AD 657 by St Hilda, are breathtaking. Check the website for details of particular events held in the summer.
Open daily 1 Apr–30 Sept, 10–6; 1 Oct–31 Mar 10–4 (Mon, Thu, Fri, Sat, Sun).
www.whitbyabbey.co.uk or www.
english-heritage.org.uk/server/
show/ nav.17360
01947 603568
TIC 01947 602674

FLAMBOROUGH HEAD, BRIDLINGTON, YORKSHIRE

This is easily the best place in England to see seabirds. Over 200,000 birds colonize the chalk cliffs from April to August. Reserve open all year round. Visit centre open daily 10–5 (Mar–Oct) and 10–4 (Nov–Feb).
www.rspb.org.uk/reserves/guide/b/
bemptoncliffs/index.asp
01262 851179
TIC 01262 673474

A lighthouse was first built on the headland in 1669 but never lit, with the current lighthouse following in 1806. Open daily (except Tues) Apr–Sept; and daily (except Mon, Tues) in Oct. *Flamborough Head Lighthouse is located about a mile from the village of*

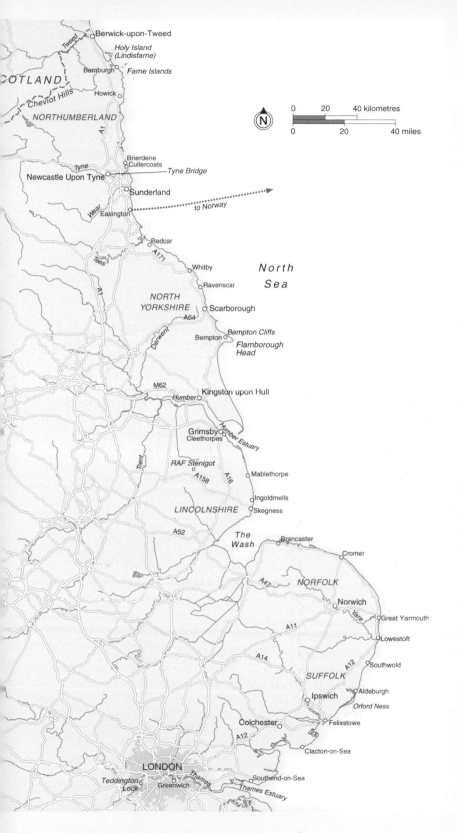

Flamborough on the B1259.

SKEGNESS, LINCOLNSHIRE

The site of the first-ever Butlins is
still open in Skegness, although the
entertainment today is more likely to
be spa breaks and talent shows than
knobbly-knee contests.

**www.butlins.com/resorts/skegness/
index.aspx
01754 762 311
TIC 01754 899887**

CROMER, NORFOLK

Cromer has one of the first piers to be
built in the twentieth century. In 1990,
when storms destroyed an amusement
arcade the decision was taken not to
replace it and seven years later a
100-ton rig collided with the pier,
leaving its lifeboat station and theatre
isolated. Today the pier continues as a
place to promenade or enjoy a summer
season show or Sunday concert.

**www.cromer-pier.com
01263 512495
TIC 0871 200 3071**

ROYAL OBSERVATORY,
GREENWICH, LONDON

The Royal Observatory was
commissioned by King Charles II in
1675 for the study of astronomy and
to fix longitude. Visitors come to stand
on the famous Greenwich Meridian
Line, 0 degrees longitude, which
has provided the reference line for
Greenwich Mean Time since the late
nineteenth century. The Observatory
now houses part of the National
Maritime Museum (open Mon–Sun,
10–5) and holds a collection of time
pieces, ranging from sundials to
atomic clocks. Adjacent is the new
planetarium, which uses the latest in
space-exploration technology.
Royal Observatory, open daily 10–5.

**www.nmm.ac.uk/places/royal-
observatory
020 8312 6565**

Index

I couldn't begin to list all the people who've contributed to *Coast* since we started in 2004 but this book owes a debt to all of them, the programme teams, Open University colleagues, presenters, contributors and viewers. I'd particularly like to thank the original series editor, Gill Tierney, for giving me the best job in television, William Lyons for his support with the continuing *Coast* adventure, and my mum for nurturing an enquiring mind. For getting all this down on the page a 21-gun-salute goes to *editor extraordinare* Stephanie Evans: she was a beacon of hope in choppy waters and ably assisted by supplying much appreciated additional material.

Above all, my contribution to *Coast* and this book wouldn't have been possible without the love and patience of my partner Kathryn; it's for you babe. **Steve Evanson**

BBC Books would like to thank the following individuals and organisations for providing photographs and for permission to reproduce copyright material. While every effort has been made to trace and acknowledge copyright holders, we would like to apologise should there be any errors or omissions. Abbreviations: t top, b bottom, c centre, l left, r right, tl top left, tr top right, tc top centre

Page 1 Mike McFarlane/Alamy; pp.2–3 PearlBucknall/Alamy; p.6 Travel Ink/Getty Images; pp.8–9 David Goddard/Getty Images; p.11t David Martyn Hughes/Alamy; p.11b Robert Harding World Imagery/Corbis; pp.13–14 Getty Images; p.15 © Michael Rich/Andrew Grantham; pp.16–17 Getty Images; p.18 Mark Phillips/Alamy; p.19 Lonely Planet Images/David Tipling; p.20 Alain Le Garsmeur/Corbis; p.21 britainonview/SplashdownDirect.com/AlanJamesPhotography; p.23 SSPL/National Railway Museum; p.24 Getty Images; p.25 Ronald Grant Archive; pp.26–28 Jason Hawkes/Corbis; p.29 Kos Picture Source Ltd/Alamy; pp.30–31 Jose Fuste; p.33 Brian Harris/Alamy Raga/Corbis; p.35 Topfoto; p.36 Camille Moirenc/Hemis/Corbis; p.37 Musee Marmottan, Paris/Giraudon/The Bridgeman Art Library; p.38 Hemis/Alamy; p.39 Matt Purciel/Alamy; p.40l DEA/L. Romano/Getty Images; p.40r Holmes Garden Photos/Alamy; p.43tl Image courtesy of the Lapworth Museum of Geology; p.43tr © Peter Lofts Photography/National Portrait Gallery, London; p.43b Bettmann/Corbis; pp.44–45 Paul Thompson Images/Alamy; pp.46–47 David R. Frazier Photolibrary, Inc./Alamy; p.47r www.jasonhawkes.com; p.48 Amanda Hall/Robert Harding; pp.50–51 Michael Busselle/Getty Images; p.53 BL Images Ltd/Alamy; pp.54–55 Lee Pengelly/Loop Images/Corbis; p.56 Adam Woolfitt/Robert Harding World Imagery/Corbis; p.57 Dae Sasitorn/Ardea; p.58 Richard Klune/Corbis; p.59t TravelStockCollection – Homer Sykes/Alamy; p.59b CountryCollection – Homer Sykes/Alamy; p.60tl Mary Evans Picture Library; p.60tc World History Archive/Alamy; p.60tr John Birdsall/PA Photos; p.60b Mr Standfast/Alamy; pp.62–63 Mary Evans Picture Library; p.64 Paul Glendell/Alamy; p.65 Mary Evans Picture Library; p.66 g bell/Alamy; p.67 Photo courtesy of Steve Hartley; pp.68–69 Dave Newbould/Photolibrary Wales; p.69r © Portmeirion Ltd; pp.70–71 Rick Strange/Alamy; p.73 Robert Harding Picture Library Ltd/Alamy; p.74 Michael Diggin/Alamy; p.76 John Daniels/Ardea; p.77 Dreamworks LLC/The Kobal Collection/James, David; p.78 Richard Cummins/Corbis; p.79 Waterford Treasures Museum; p.80 The Irish Image Collection/Corbis; p.81 Robert Bateman/Robert Bateman Photography; pp.82–83 Skyscan.co.uk/© K. Dwyer; p.84 The Irish Picture Library/Father FM Browne SJ Collection; p.85 Mary Evans Picture Library; p.86l Corbis; p.86r Topfoto; p.87 Getty Images; pp.88–89 Joe Cornish/Getty Images; pp.90–91 Robert Harding Picture Library Ltd/Alamy; pp.92–93 Jim Richardson/Getty Images; p.95 nagelestock.com/Alamy; p.96 Jeff Rotman/Alamy; p.97 Paul Thompson/Eye Ubiquitous/Corbis; pp.98–99 Darren Staples/Reuters/Corbis; p.100 Julie Marland/Alamy; p.101 British Lion/The Kobal Collection; p.102 Getty Images; pp.104–105 Jonathan C. K. Webb/webbaviation.co.uk; p.106 Mary Evans Picture Library/Mary Evans ILN Pictures; p.107 The Print Collector/Alamy; p.108 Topfoto/Woodmansterne; p.109 NTPL/Joe Cornish; pp.110–111 JoeFoxIOM/Alamy; pp.112–113 David Robertson/Alamy; p.115 Mary Evans Picture Library; p.116 AA World Travel Library/Alamy; p.117 Granger Collection NYC/Topfoto; p.118 Niall Benvie/Corbis; p.119 Tom Kidd/Alamy; p.120 Duncan Maxwell/Getty Images; p.121 Roger Ressmeyer/Corbis; pp.122–123 Sue Anderson/ScottishViewpoint; pp.124–125 Ronnie Cramond/Northern Light Charters; p.126 Getty Images; p.127 British Museum, London; p.128 Potor Horree/Alamy; p.130 Courtesy of the University of St Andrews Library, JV-164; p.131 Lordprice Collection/Alamy; pp.132–133 Gordon Hulmes/Alamy; p.135 By permission of The Imperial War Museum (H_010569); pp.136–137 Lonely Planet Images/Grant Dixon; p.138 By permission of The Imperial War Museum (D_001429); p.139 Lonely Planet Images/Grant Dixon; p.140 By permission of The Imperial War Museum (N_000481); p.141 By permission of The Imperial War Museum (MH_027178); p.142 David Robertson/Alamy; p.143l Adam Silver/Alamy; p.143r A. B. Flint/Alamy; pp.144–145 Free Agents Limited/Corbis; p.146 Anders Blomqvist/Alamy; p.147 Courtesy Hardanger Fartøyvernsenter; pp.148–149 Art Kowalsky/Alamy; pp.150–151 Roger Coulam/Alamy; p.153 Troy GB images/Alamy; p.154 © Skyscan Balloon Photography/English Heritage Photo Library; p.156 Steve & Ann Toon/Getty Images; p.157 Troy GB images/Alamy; p.158 Tyne and Wear Museums; p.160 © V&A Images, Victoria and Albert Museum; p.161 Simon Hadley/Alamy; p.163 britainonview/John Whitaker; p.164 eye35.com/Alamy; p.165 ICP-Pano/Alamy; p.167tl Getty Images; p.167tc Trinity Mirror/Mirrorpix/Alamy; p.167tr Pictorial Press Ltd/Alamy; p.167b Mary Evans Picture Library; pp.168–169 Michael S. Yamashita/Corbis; p.171 Mike Booth/Alamy.

Published to accompany the BBC television series *Coast*.
Executive producer: William Lyons
Series producer: Steve Evanson

10 9 8 7 6 5 4 3 2 1

First published in 2009 by BBC Books, an imprint of Ebury Publishing. A Random House Group Company.

The Random House Group Limited Reg. No. 954009.

Addresses for companies within the Random House Group can be found at www.randomhouse.co.uk

ISBN 978 1 846 07779 1

Commissioning editor: Muna Reyal
Project editor: Christopher Tinker
Copy-editor: Stephanie Evans
Design: Nicky Collings
Picture researcher: Sarah Hopper
Maps: Martin Darlison at Encompass Graphics
Production: David Brimble

Colour origination by Dot Gradations, Wickford, Essex.
Printed and bound in Germany by Firmengruppe APPL, aprinta Druck, Wemding

To buy books by your favourite authors and register for offers, visit www.rbooks.co.uk

The Random House Group Limited supports The Forest Stewardship Council (FSC), the leading international forest certification organisation. All our titles that are printed on Greenpeace approved FSC certified paper carry the FSC logo. Our paper procurement policy can be found at www.rbooks.co.uk/environment

A CIP catalogue record for this book is available from the British Library